The Impressionists

Portraits and Confidences

The Impressionists
Portraits and Confidences

by

Pascal Bonafoux

with writings, letters and witness accounts
by the painters, their friends, and writers
and critics of the Impressionist period

SKIRA

Weidenfeld and Nicolson
London

© 1986 by Editions d'Art Albert Skira S.A., Geneva

First published in Great Britain in 1987 by
George Weidenfeld & Nicolson Limited
91 Clapham High Street, London SW4 7TA

ISBN 0-297-79043-9

Printed in Switzerland

A man can achieve nothing on his own, unless he has very powerful gifts, and even then... You can't invent an art all by yourself, in some spot in the country, with no criticism, no terms of comparison, no firm conviction.

Boudin.

The public, in relation to genius, is a clock running slow.

Baudelaire.

Ah, what torture painting is!

Monet.

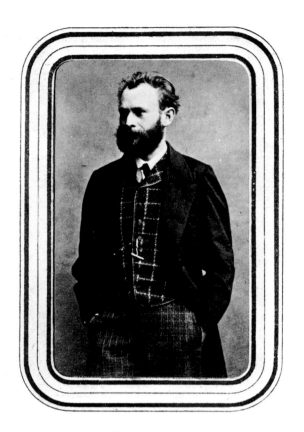

Edouard Manet

born in Paris in 1832

Berthe Morisot

born in Bourges in 1841

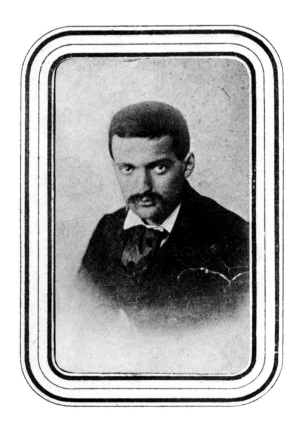

Paul Cézanne

born in Aix-en-Provence in 1839

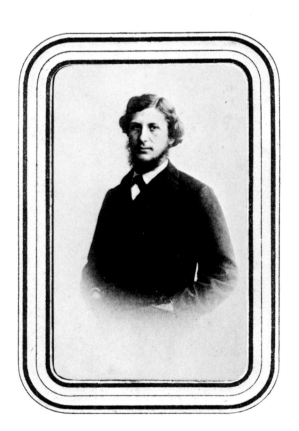

Frédéric Bazille

born in Montpellier in 1841

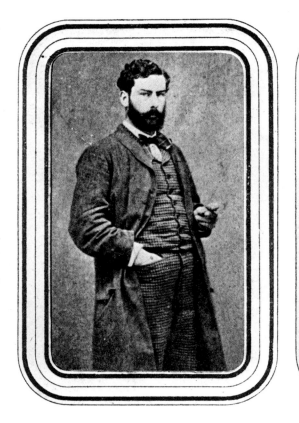

Alfred Sisley

born in Paris in 1839

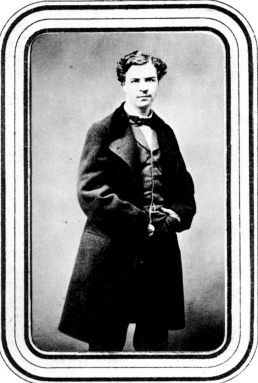

Auguste Renoir

born in Limoges in 1841

Claude Monet

born in Paris in 1840

Camille Pissarro

born at St Thomas (West Indies) in 1830

Edgar Degas

born in Paris in 1834

Painting alone

Ruefully, Cézanne wrote: "I believed it was possible to do good painting without drawing attention to one's private existence. To be sure, an artist desires to better himself intellectually as much as possible; but as a man he must remain obscure." Rebuffing a journalist, Degas snapped: "You haven't come to count the shirts in my closets, have you! That's private, that is!" And he further groaned: "Oh my God! A crowd around our paintings—why? Is there a crowd in a chemist's laboratory? Of course not. A chemist works in peace. *We* belong to everyone. What torture!"

Just as they had once been scorned and reviled, so the Impressionists were talked about, analyzed, adulated. But as a hostile public had once refused to see them, so they were hidden by the clouds of their glory. Painting is not the province of myth any more than it is the outcome of theoretical imperatives. And the ups and downs of a painter's life are not painting, which is the affair of the studio alone. The mixture of challenges, prepossessions and misgivings which are the stuff of painting are not to be told in words or demonstrated. These pages will leave the man Cézanne "obscure," and in them will not be found the number of shirts owned by Degas. They are not a history of the Impressionists; they are not a theory about Impressionism. Taken together, the portraits the Impressionists sketched of each other, the remarks and writings all of them left behind, make up the archives of the challenge they mounted. We are here concerned only with what is essential. We are concerned only with painting.

No theories

Pissarro: "I remember that, although I was full of fervour, I didn't have the slightest inkling, even at forty, of the deeper side to the movement we were pursuing by instinct. It was in the air!" Not a word about theories from Manet, who confided to Antonin Proust: "I have a horror of the useless, but the trick lies in seeing only what is useful. We have been perverted by the cookery of painting. How can we get rid of it? Who will give us back the simple and clear? Who will deliver us from the affected and ornate? You see, my friend, the truth lies in going straight ahead, without bothering about what people will say." Monet was unequivocal: "Paintings aren't made with doctrines." He went on in the same vein and wound up: "I have always been repelled by theories. My only merit lies in having painted directly in front of nature, seeking to render my impressions before the most fleeting effects, and I remain deeply sorry to have been the cause of a name given to a group, most of whom had nothing of an Impressionist about them."

Those who practised Impressionism did not define it. Pissarro: "*Aestheticism* is a form of romanticism, more or less backed by cunning: a way of charting a *crooked* path. The hope was to make of Impressionism a theory of pure observation, without loss of either fantasy, or liberty, or grandeur—everything that makes great art. But not puffery to put sensitive souls in a swoon." Cézanne wrote: "More is said, and perhaps better said, about painting by sticking to the subject than by devising purely speculative theories in which one very often loses one's way." Irrevocably, he declared: "To have ideas and expound them is not my business." Renoir took the same line: "I arrange my subject as I wish. Then I start to paint the way a child would. I want a red that will ring out like a bell. If it isn't like that, I add reds and other colours until I get it. I am no cleverer than that. I have neither rule nor method. Anyone is welcome to examine what I use or to watch how I paint. He will see that I have no secrets. Today people want everything explained; but if a painting could be explained it would no longer be a painting; it would no longer be art. Do you want me to tell you what, for me, are the two qualities of art? It must be indescribable and inimitable... The work of art must seize you, envelope you, sweep you away. That is the way for an artist to express his passion; it is the current that springs from him and carries you away in passion."

This passion is primarily one of sensuality. "It's not enough for a painter to be a skilful worker; he must be seen to enjoy stroking his canvas." And Renoir confides further: "A painter, you see, who has a feeling for nipples and buttocks is a saved man."

Farewell to History

And what does the "model," the subject or motif, matter to these painters? It isn't the "model" that makes the painting. "What is new lies not in the subject but in the way of expressing it," wrote Pissarro. As did Bazille: "For that matter, in my opinion the subject isn't very important, as long as what I have done is interesting from the point of view of painting. I have chosen the modern era because it is the one I understand best, the one I find more alive for living people; and for that reason I will be rejected. If I had painted Greek and Roman women I should be quite easy, for we haven't got past that stage: people will surely appreciate any qualities my painting may have in a peplos or a tepidarium, but I very much fear that my satin gown in a drawing-room will be turned down." It did not matter which past was referred to: the Past alone was thought worthy of being painted. In the present, all that was painted were still lifes (but do objects and flowers belong to any one period?), rural scenes and animals (the Earth and the seasons are timeless), portraits (the greatest painters have left some worthy of History) and landscapes (Nature does not belong to Time). The

markets of accepted subjects shied away from the present. The past alone had its place on the line and conferred nobility. It served the Empire: the sacred and legitimate lineage. For its part, the aristocracy, railed at or not, would not dream of surrendering the privileges of its descent. As for the bourgeoisie, it had a penchant for pastiche. After all, why did the nineteenth century need to invent its own style, when it had already brought Progress? And it was in the name of Progress that the bourgeoisie invented the copy and worshipped what was ancient—relegated and consigned to oblivion and the scrap-heap for centuries because it was out of fashion. Who, then, could wish to wipe the slate clean of that Past? Who? To paint contemporary life was to condemn oneself to triviality, to vulgarity.

Yet their disdain of History, the only reference for what was then considered high art, was disdain neither of the old masters nor of the museums. All the Impressionists had done copying. But they broke with an exhausted tradition that took the subject as the sole gauge of value. Their paintings told no story; therefore people had no eyes for them. "Where did these bohemians come from? Wolves, assuredly, since they wore no collar. Almost classical, yet quite simple, their paintings looked odd: no one ever knew why," remarked Gauguin. And Cézanne: "What's needed is to do Poussin over again, according to nature. Everything is in that." Degas: "What I'm doing is the result of reflection and the study of the old masters." Reflection, thinking about art, did not mean that it was necessary "to see only makers of theories in artists whose sole aim has been to paint, like the old masters, with bright and joyful colours," explained Renoir who, using the plural, recalled: "For us, the great line of investigation has been to paint as simply as possible."

On masters and nature

Pissarro wrote: "Our masters are the primitives, because they are naive and skilful," while Degas asserted: "You must copy and recopy the masters, and it is only after you have passed all the tests of a good copyist that you can reasonably hope to paint a radish from nature." Necessary as it was, the study of earlier painting could last only for a while. Cézanne: "Couture told his pupils: *Keep good company*. In other words, *Go to the Louvre*. But after you have seen the great masters who repose there, you must hasten to leave and to quicken in yourself, by contact with nature, the instincts, the sensations of art that dwell within us."

"To paint a radish from *nature*." "To do Poussin over again according to *nature*." Nature, one of the most abstract and ill-defined ideas in painting, haunted all of them. "I am seeking... but nature! how to make light out of colours."

Nature, the model, was unappeasable. Renoir concluded: "The truth is that, in painting as in the other arts, there is not a single procedure, however small,

which lends itself to being formularized. There is in painting something (in addition) that cannot be explained; that is essential. You come before nature with theories, and nature dashes everything to the ground." Cézanne: "If the strong feeling for nature—and I certainly have it intensely—is the necessary foundation for any conception of art, and one on which rests the beauty and greatness of future work, knowledge of the means by which to express our emotion is no less essential, and is acquired only by very long experience." Nature, albeit necessary, is not enough; and recourse to a theory is vain.

"The beautiful, the ideal, art—it is not easily defined. Why does a Flandrin painting which is so well done, so correctly drawn, such a perfectly executed piece, leave us cold and unmoved, whereas Ingres, whose portraits are skimpy and painted, in Degas's phrase, like a door, delights us and fills us with enthusiasm? Why?" There was only one point of reference, inexpressible as it was inexplicable. It was sensual, and sensual alone. It lay in the very handling of the paints. At sixty-three Cézanne wrote to Vollard: "I have made some progress. Why so late and so painfully? Is Art in fact a priesthood demanding the pure-hearted, who give themselves to it completely?" And the humble words and passionate patience of Renoir, Monet, Pissarro, were no different.

Nature, though necessary to painting, is not the criterion by which to judge it. Cézanne: "Art is a harmony parallel to nature. What is one to think of fools who tell you that the artist is always inferior to nature?" And Geffroy tells how Monet sighed: "Since the appearance of the Impressionists, the official Salons which used to be brown have become blue, green, pink... English sweets or chocolates... It's always confectionery." But it was not painting. And at the end of the century Gauguin, who took part in the Impressionists' last four shows, noted: "They are the official painters of tomorrow; more terrible, in a way, than yesterday's."

The "little rejected painters" were finally "official" when they had all separated from each other, years after they had spent more than two decades together facing sarcasms and insults, rejections and poverty.

Painting in the singular

The name Impressionist, a word of mocking scorn, became a title of glory lumping them together. But considering them together means to miss seeing them individually.

They were of the same generation: Pissarro was born in 1830, Manet in 1832, Degas in 1834; Monet, Bazille, Renoir, Berthe Morisot, Sisley and Cézanne, between 1839 and 1841. And their paintings were singular. Degas had nothing in common with Cézanne, just as Manet had nothing in common with Pissarro. Each devised his own language. All that they shared was a purpose and a fate.

"I shall not tell their story, everyone knows it," wrote Gauguin. "I mention it merely to record one of the great influential efforts made in France by a few only, with their sole strength and talent, struggling against a formidable power made up of the Official, the Press and Money."

That trinity was embodied in the Pompous Bourgeois, and "originality is the bugbear of the Pompous Bourgeois" (Zola). It was for Him that the young men entering the Ecole des Beaux-Arts in 1855 were expected to paint. Edouard Manet, twenty-three years old, was in Couture's studio when, in the spring of that year, Edgar Degas, twenty-one years old, entered Lamothe's studio. In the autumn Camille Pissarro enrolled: he was twenty-five and had just arrived from St Thomas in the West Indies. Cézanne was still a schoolboy at Aix-en-Provence, as was Monet at Le Havre. Renoir was finishing his apprenticeship in the Paris porcelain factory of Lévy Frères and attending evening classes in drawing in the Rue des Petits-Carreaux.

What Impressionists?

"At the start we were a group. We stuck together, reassured one another. And then, one fine day, there was no one left," observed Renoir. Cézanne gave warning: "Better beware of the Impressionists. All the same, they see things as they are." And Vollard tells how Degas fumed: "Don't speak to me of the Impressionists. They ought to be..." "And," recounted Vollard, "taking a cane from the hands of one of the persons present, he took aim with it."

What did they have in common, these men who admired, distrusted, respected or condemned each other? Duret: "It is to them we owe painting in bright colours, forever rid of white or red lead, bitumen, chocolate, tobacco juice, burnt fat and pan-crust." Zola: "What they have in common is a kindred vision. They see nature in bright colours, without the bitumen and sienna gravy of the Romantic painters." An exclusion—that of bitumen from their palette—had brought them together: not a programme. For the rest, "each, fortunately, has his original characteristic, his individual way of seeing and conveying reality," wrote Zola as early as 1876.

Their history of interdependence was woven out of what they rejected and what game they were tracking: they shared discoveries, challenges and doubts. But their differences were not as sharp as their rejection of tobacco juice was final. Conformity was not for them. As Renoir put it: "The rules of Impressionism are laid down by the masters of criticism... Always eager to try and saddle you with a set of formulas and methods. In order to please them we should all have had to have the same palette."

The words of enthusiasm, respect or anger which Manet, Degas, Pissarro and the rest spoke before each other's works are of crucial importance in showing,

without need of further demonstration, that we must not be taken in by that name: Impressionist. "This designation," wrote Zola in 1879, "seems to me an unhappy one, but it is undeniable that these Impressionists—since they insist on that name—are at the head of the modern movement."

Courbet had touched on the same point: "I have been styled a Realist, just as the men of 1830 were styled Romantics. At no time have such names given a fair idea of things. Were it otherwise, the works themselves would be superfluous." So it was with the Impressionists. The name was the banner of a combat, marking their solidarity at a time when they were condemned and rejected, lampooned in song and despised.

Their rare partisans were poets or novelists; there were few critics who stopped at being critics. Although Pissarro wrote, "Besides, I distrust theories by literary men about painting and drawing, for they rarely have any instinct for them," it was to Théodore Duret that he owed this remark in 1873: "If I had a piece of advice to give you, I would say: don't think either of Monet or of Sisley." Each had to paint alone.

That was what Albert Wolff, one of the most hostile critics, never saw. In April 1882 he wrote in the *Figaro*: "Renoir or Claude Monet, Sisley, Caillebotte or Pissarro, the note is the same. The curious thing about these Independents is that they are as much the creatures of habit as the painters who don't belong to their brotherhood. When you have seen one painting by an Independent you have seen them all. They are signed with different names, but come from the same factory."

The opposite was true. It was up to each, on his own, to render "the sharp and profound impression of the place, the moment, the season, the hour."

There was no method, formula or recipe for meeting this challenge which motivated their painting and imposed on it a new condition, that of being a quest. The sole requirement was talent. "For talent, in sum, what is talent, eh? Quite simply, and that is true for all the arts, no more so for painting than for any other —it is the gift, small or great, of novelty, you understand? of novelty which an individual carries within himself: that faculty of putting into what you do something of the design which you and you alone detect in the lines that exist in life; the strength and, I should say, the courage to dare a little of the colour you see with your Western vision of a nineteenth-century Parisian; with your own eyes" (Jules and Edmond de Goncourt, *Manette Salomon*, 1867).

The Impressionists were united and solitary. Monet to Bazille: "It would be better to be alone, and yet, completely alone there are things one cannot guess. In short, all this is frightening and it is a hard task."

It was that solidarity and that solitude which their letters, their spoken words and their portraits place in evidence. They painted together; and just as they set up their easels in front of the same subjects, so they painted each other as well. They were not only models for each other's portraits; they also posed as pic-

nickers or oarsmen. They shared the same studios. They were found in the same cafés: at the Guerbois, at the Nouvelle Athènes. They introduced each other to the few patrons and collectors they met. They swapped canvases. They bought each other's paintings. They gave each other advice, judged each other's work. No such shared endeavour is to be found in the previous history of European painting. Neither the Pre-Raphaelites nor the Nazarenes, in this same century, can be likened to them. With them ends a history of painting which, by way of myths, goes back to Apelles, Parrhasios and Zeuxis. They, who looked back to the primitives, are the primitives of an art which is our own. Their solidarity and their diversity are its basis. It is this secular epiphany that they share.

This sharing had but a single focus: painting. It was the heart of the matter. Through their portraits, their letters and statements, something of the intensity and boldness of their vision can be glimpsed and understood. But Gauguin gives us warning when he reports what he heard: "Cézanne says with his southern accent, 'A pound of green is greener than half a pound.' They all laugh: he's crazy! Not so crazy as they think. His words have another meaning than the literal one, but why bother explaining the rational meaning to them? It would be casting pearls before swine." Renoir was no explainer either: "Before a masterpiece, I'm content to enjoy it."

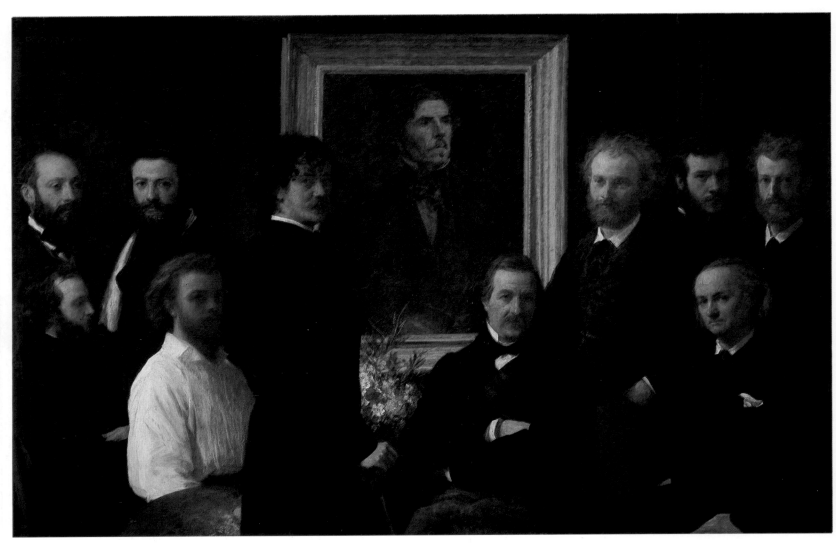

Fantin-Latour: Homage to Delacroix, 1864.

Together

Ten men brought together in 1864 by Fantin-Latour pose in front of the portrait of Delacroix. Beards and moustaches: Baudelaire alone, seated on the right, is clean-shaven. The first instalment of Baudelaire's *L'œuvre et la vie d'Eugène Delacroix*, published in *L'Opinion Nationale* (2 September 1863), begins: "I had the good fortune to be associated quite young with the illustrious deceased, and in that relationship, from which respect on my part and indulgence on his did not preclude mutual trust and familiarity, I was able to derive the most precise ideas not only regarding his method but also the innermost qualities of his great soul." Nearby, one hand in his pocket, stands Manet. "My profession as a painter impels me to observe attentively the faces, the physiognomies that meet me as I move along, and you know what pleasure we draw from this faculty which makes life more alive and meaningful in our eyes than it is for other men." *The Rope*, a Baudelaire story which first appeared in the *Figaro* (7 February 1864), was dedicated to Edouard Manet. And the words just quoted, which begin this story of a painter whose young model hanged himself in his studio, are no doubt similar to others actually spoken by Manet. Alexander, the model for several of his paintings, did hang himself in the studio which Manet had begun sharing with Balleroy in 1856. The suicide put Balleroy to flight; he went elsewhere to paint his hunts, his packs of hounds fanning out over the countryside.

Between Balleroy and Manet, in Fantin's portrait, is Bracquemond: one of those, Baudelaire stated in *Le Boulevard* (14 September 1862), who restored to the art of etching "its old vitality." Seated, arms folded and legs crossed, is Champfleury, on the appearance of whose first stories in 1848 Baudelaire wrote: "Champfleury, in making his debut as a writer, has dared to be satisfied with nature and have unlimited confidence in her." He never lost that confidence. Legros, with a scarf draped over his shoulder, illustrated Duranty's novel *Le Malheur d'Henriette Gérard* (1860) with four etchings: he was described by Baudelaire as "a man of vigorous mind." Duranty (seated, far left) was a close friend of both Manet and Degas.

Standing with his hand on the knob of a cane and holding gloves is Whistler. Baudelaire admired his etchings, "subtle and wide-awake like improvisation and inspiration." Fantin and Whistler were inseparable ever since they had met at the Louvre where they were copying the masters (Whistler made a copy of Ingres' *Angelica*).

Painters, novelists, poets: not one of these writers who was not a critic of art, and not one who was only a critic of art. They met on the common ground of their admiration for Delacroix. But it was not only respect for him that united them: they were "controversial artists paying tribute to the memory of one of the greatest controversial artists of the day" (Duranty).

"Ah! we've all sopped it up, that romantic gravy. Our youth dabbled in it too much; we paddled in it up to the chin. We need one hell of a washing" (Zola).

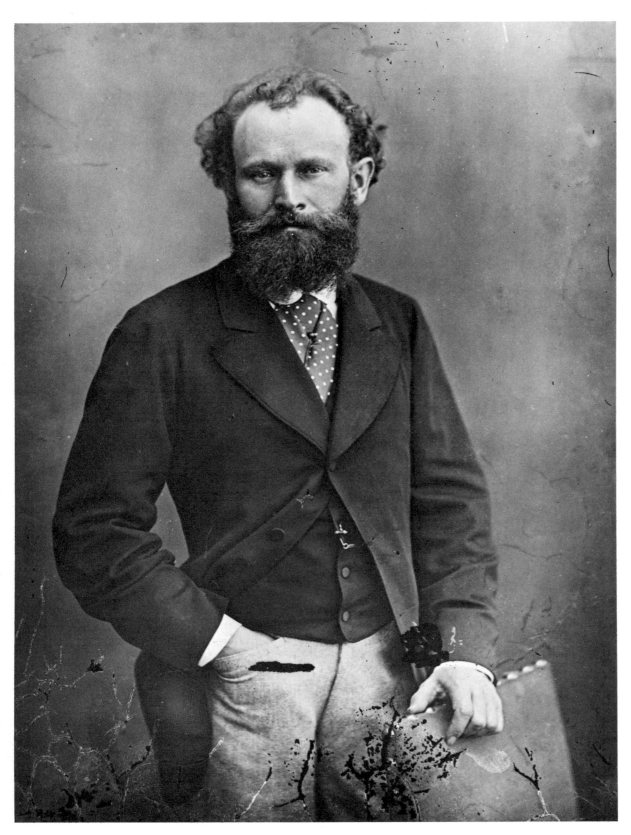

Nadar: Portrait of Manet, c. 1865. Photograph.

Aspiring to the rank of a liberal art, painting declared itself an affair of the mind, *cosa mentale*. (That change went back to the Renaissance.) Allegorical subjects, references to rediscovered pagan texts—never mind if they remained obscure and unintelligible: initiation sealed the votary's lips—and appeals to Neo-Platonist philosophy laid the foundations of painting's allegiance to literature. The hierarchy of genres decided on by the Academies did not detract from this. But the rules reduced exacting demands to insipid norms. The pattern of a gesture—what did it matter whether the Scripture was sacred or profane, Holy

Painting in the present
Baudelaire
Manet

I must say a word to you about yourself. I must try and make your own merits clear to you. It's really outrageous what you expect. *They make fun of you; their pleasantries annoy you; they fail to do you justice*, etc., etc. Do you think you are the first man to find himself in this position? Have you got more genius than Chateaubriand and Wagner? But they were made fun of, too. They didn't die of it. And to keep your pride down, I may add that these men are paragons, each in his own line, and in a very rich world; while *you are only at the top of an art that is decaying*. I hope you won't mind my blunt way of treating you. You know how much I value your friendship.

Baudelaire, letter to Manet, 11 May 1865.

I know that Manet will not find it easy to understand my view of the matter. Painters always expect to have an immediate success. But really, he has such brilliant and sprightly faculties that it would be a pity if he lost heart. He will never quite make up for the shortcomings of his temperament. But he does *have* a temperament, and that's the main thing. He does not seem to realize that the more unfair they are to him, the stronger his position will be, provided he doesn't lose his self-possession. You will know how to tell him all this smilingly, without hurting his feelings.

Baudelaire, letter to Madame Paul Meurice, 24 May 1865.

Many years later Renoir recalled Baudelaire's *Fleurs du Mal*: "One of the books I most dislike! I can't think who the devil gave it to me!"

Ambroise Vollard, *En écoutant Cézanne, Degas, Renoir*, Paris, 1938.

One man who knows what he's about is Baudelaire. His *Romantic Art* is first-rate. He makes no mistake about the artists he appraises.

Cézanne, letter to his son Paul, Aix, 13 September 1906.

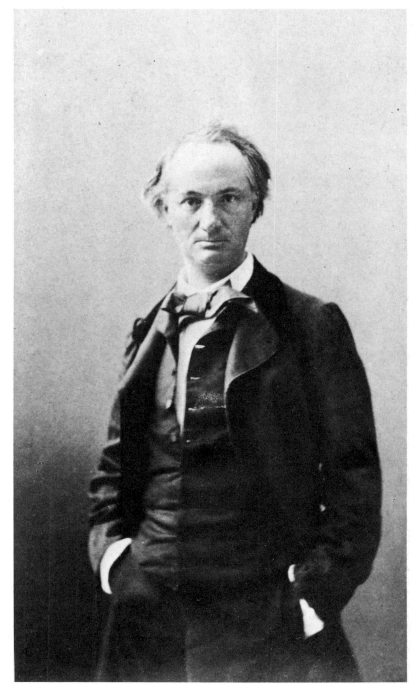

Nadar: Portrait of Baudelaire, 1862. Photograph.

Writ, record, chronicle, or epic poem?—and the illustration of a Destiny sanctified by History freed painting from itself. When in subjection, it had to be read. The Salon was like a library. What the art lover was after was not what he could see but what he could read. Baudelaire, in urging Manet to take the contemporary world as his model, was not setting him a subject. That particular subject being *illegible*, he was dismissing it. The scandal was that, then, only painting remained. For the art lover whose culture—his supreme, exclusive value—was thus written off, painting became mere uncouth daubing.

When we met in early days, brought together by an unknown force, and took each other's hand, swearing that we would never be parted, none of us inquired about the wealth or the home life of his new friends. What we were looking for was the wealth of heart and mind, and above all that future which stretched before us and which to our youth seemed so brilliant...

I'm expecting Cézanne and hope to recover my good spirits of yore, once he is here with me.

Zola, letter to Baptistin Baille,
Paris, 20 February 1860.

Cézanne: Letter to Zola, 30 June 1860.

A strange question you put to me. Here certainly, as anywhere else, a man can work, if he has the will to work. Paris offers you in addition an advantage that you won't find elsewhere: the museums where you can study the old masters from eleven o'clock till four. You could divide up your time as follows. From six to eleven you will go to a studio and paint from the living model; then lunch, and from twelve to four you will copy any masterpiece you like, either in the Louvre or the Luxembourg Museum. That makes nine hours of work; I think that's enough, and in that way you will soon be doing well. As you see, we'll have all evening free and we can make use of it as we see fit, with no harm to our studies. Then, on Sunday, away we'll go a few miles outside Paris. There are some charming spots to see, and if you like you can set down on canvas the trees under which we'll have our lunch. Every day I make up charming dreams which I hope will come true when you are here: the work of poetry, as we love it. I'm lazy when it comes to working like a slave, the work that only occupies the body and stifles the intelligence. But art, which occupies the soul, delights me, and it is often when I'm nonchalantly lying down that I'm working most. There is a crowd of people here who do not understand that, and I don't care whether they understand it or not. After all, we are no longer boys, we've got to think of the future. Let's get down to work, it's the only way to push ahead.

Zola, letter to Cézanne, Paris, 3 March 1860.

1858: Zola returned to Paris, Cézanne stayed in Aix-en-Provence. They now kept up their conversation in letters. Like all adolescents they needed to find themselves. By July 1860 they knew, at the age of twenty, that there was no time left for shilly-shallying. They had to make a living. Zola, who was still Italian (he did not become a naturalized Frenchman until the autumn of 1862), with no father and no degree, worked as a clerk at the docks. Cézanne began to study law in accordance with the wishes of his banker father. But their aspirations went beyond the pen-pusher's oversleeves and the barrister's robes. Decisions were urgent. The studio or the bar? Ledgers or literature? Zola wrote and told Cézanne of the motto he had adopted: All or Nothing. It was like a challenge. All, for the moment, belonged to the world of dreams; nothing was what was left.

Loyalty and incomprehension

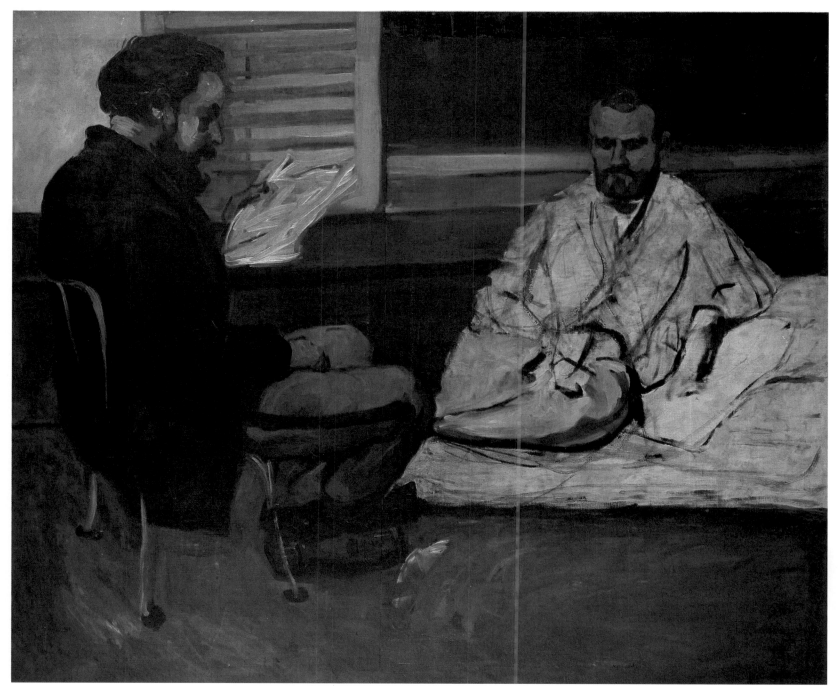

Cézanne: Paul Alexis Reading to Zola, 1869-1870.

1861: Zola, out of work, fretted and read; Cézanne tirelessly sought to persuade his father that painting was all that mattered to him. When at last Cézanne arrived in Paris, Zola discovered a Cézanne he had not known. The pair had their first misunderstandings. The old intimacy was lost.

In years to come, both in Aix and Paris, Cézanne fell back on Zola's complicity, and Zola did not refuse him. He lied, he paid, he wrote on Cézanne's behalf. But their very works were strangers. The stubborn, dissatisfied Cézanne was all doubts and impossible demands. He went over every canvas again and again, obstinately, despairingly. Each day Cézanne discovered a kind of painting that continued to elude him. Zola, by the age of twenty-eight, had the Rougon-Macquart cycle in his head and was mapping out twenty-five years' work.

I was attracted by the idea of endless rides in the sun, raiding parties, crackling rifle fire, slashing sabre, nights in the desert under the tent, and when my father summoned me to stay home I was proud and defiant. I drew a bad number and was called up for military service. I applied for an African regiment and away I went. I spent two charming years in Algeria. I was always seeing something new, and in spare moments I kept trying to paint it. You can't imagine how much I learned, how much it sharpened my eye. I didn't realize it at first. The impressions of light and colour that I received there only sorted themselves out later. But it was there that the seeds of my future work were sown.

Monet, interview in *Le Temps*, Paris, 27 November 1900.

Open air, light, the moment
Monet

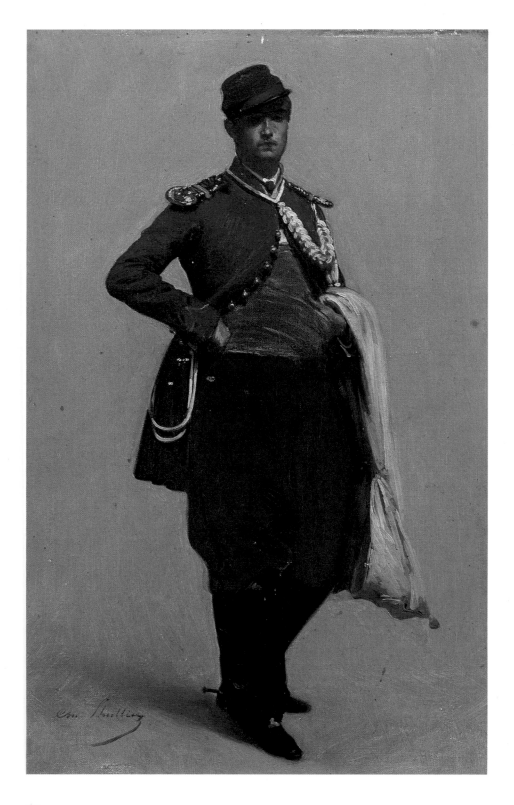

Charles Lhuillier: The Military Man (Portrait of Monet), 1860.

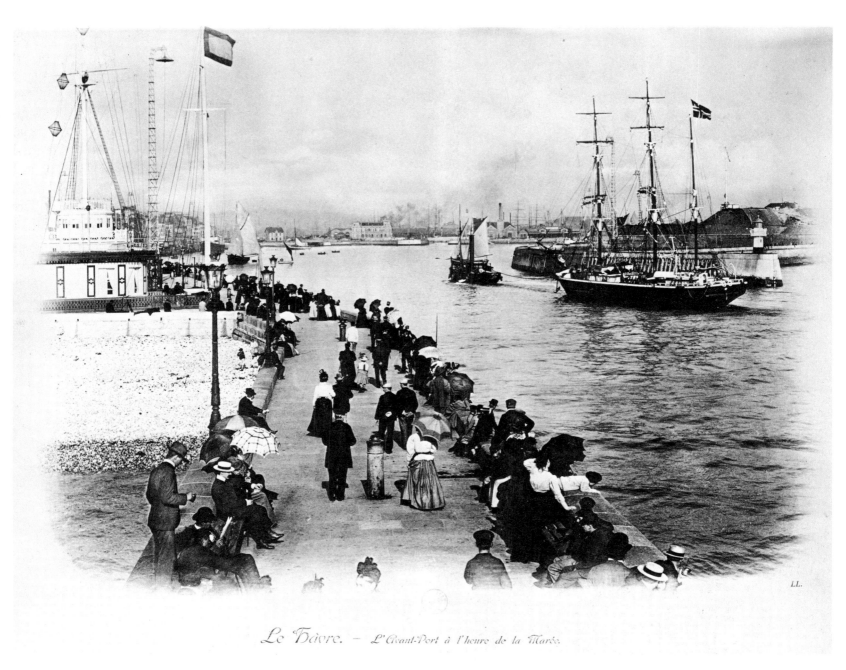

Le Havre, the harbour at high tide. Photograph.

Monet came to painting by way of Boudin, Algeria and Jongkind.

Not yet twenty, he had done no more than caricatures of local notables when Boudin persuaded him to take up painting. The first studio Boudin opened to him in 1859 was the valley of the river Lézarde, north of Le Havre, for painting meant painting in the open air. In 1861, having drawn an unlucky number in the conscription lottery, Monet decided to anticipate his call-up for the seven years of military service by volunteering for the African Rifles. It was a painter's choice. Africa was the Orient of Frère, Marilhat and Delacroix. He landed at Algiers in June, stepping into a new world of light and colour. A year later typhoid fever sent him back to France. Convalescing in Le Havre, he met a new friend of Boudin's, Jongkind. Now there was no question of his re-donning his uniform, and his aunt Madame Lecadre paid for a substitute.

For Jongkind, as for Boudin, the only studio was the open air. So it had been for Jongkind's masters: Ruisdael, Koninck, Van de Velde, Van Goyen, Hobbema. And so it was with the models of his seascapes, the skies that pour out light, the wide horizons with their piled-up clouds. He painted them in Holland as he

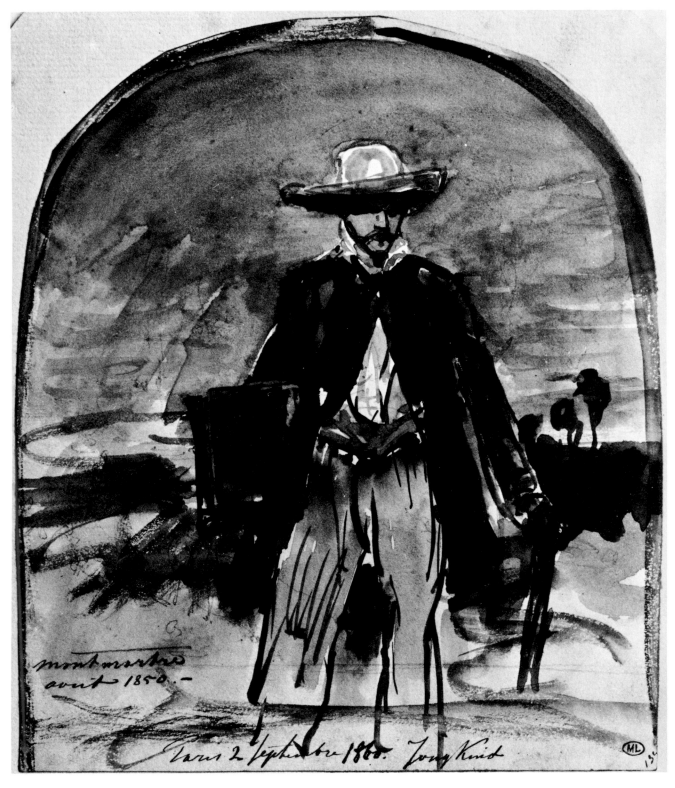

Jongkind: Self-Portrait in Sunlight, 1850. Drawing.

painted them in Normandy and Brittany, and he painted the banks of the Seine as he painted those of the Scheldt and the Meuse. He filled sketchbooks with swift, free watercolours that seized fleeting effects. From 1862 on, those watercolours and canvases constituted an essential reference for Monet, just as Jongkind's enthusiasm constituted an example.

In 1859 Boudin set up Monet's easel in the open air. In 1861 the light and colour of North Africa swept away the insipid, corseted light of the academic studio. In 1862 Monet discovered, through Jongkind, that in the open air the subject is not the landscape but the moment.

Jongkind
Boudin
Monet

In the end all these clouds, with their fantastic and luminous forms, this chaotic gloom, these immensities of green and pink suspended and piled one upon the other, these gaping furnaces, the firmaments of black or purple satin, frayed, rolled up or torn asunder, these horizons in mourning or streaming with molten metal, all these depths and splendours went to my brain like a heady drink or the eloquence of opium.

Baudelaire, *The Salon of 1859.*

Jongkind, the great artist who with Delacroix, Corot and Courbet exerted most influence on the whole modern movement, on the Impressionists in particular.

Paul Durand-Ruel, *Memoirs.*

Renoir on Jongkind:
I've never met with a more cheerful disposition than his. One day we were sitting on the terrace of a café. All of a sudden Jongkind sprang up and planting himself in front of a bewildered passerby said:
– Don't you know me? I'm the big Jongkind! (He was a stalwart fellow.)

Ambroise Vollard, *En écoutant Cézanne, Degas, Renoir*, Paris, 1938.

I trust you are working hard. You must set to it with a will, in earnest, since you are giving up medical studies. There are a good many of us in Honfleur at the moment... Boudin and Jongkind are here, and we all get on swimmingly. I'm sorry indeed that you aren't with us, for in such company there is much to learn, and nature is beginning to look so fine. It's yellowing, it's getting more varied. In a word, it's beautiful.

Monet, letter to Bazille, Honfleur, 1864.

Jongkind asked to see my sketches, invited me to come and work with him, explained to me the why and wherefore of his manner and, thereby completing the instruction I had already received from Boudin, he became from that moment my true master. To him I owe the final education of my eye.

Monet, interview in *Le Temps*, Paris, 27 November 1900.

Boudin: On the Beach, 1863. Watercolour and pastel.

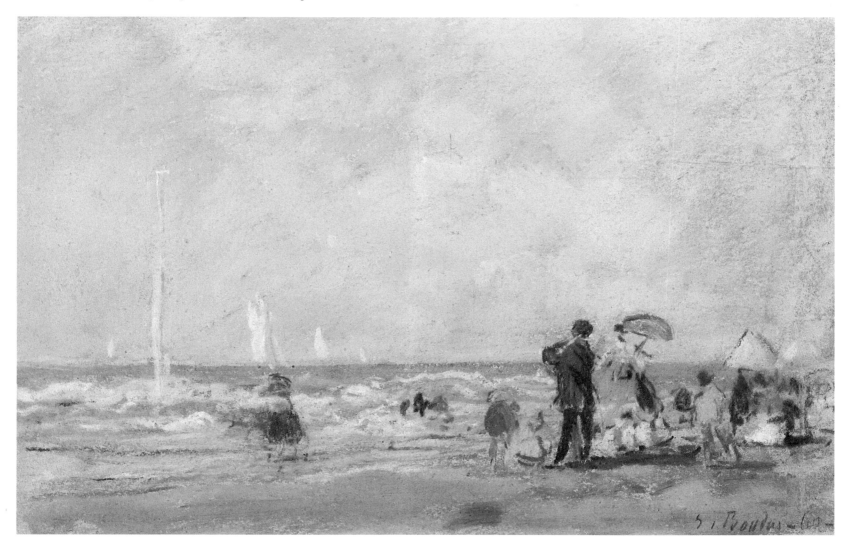

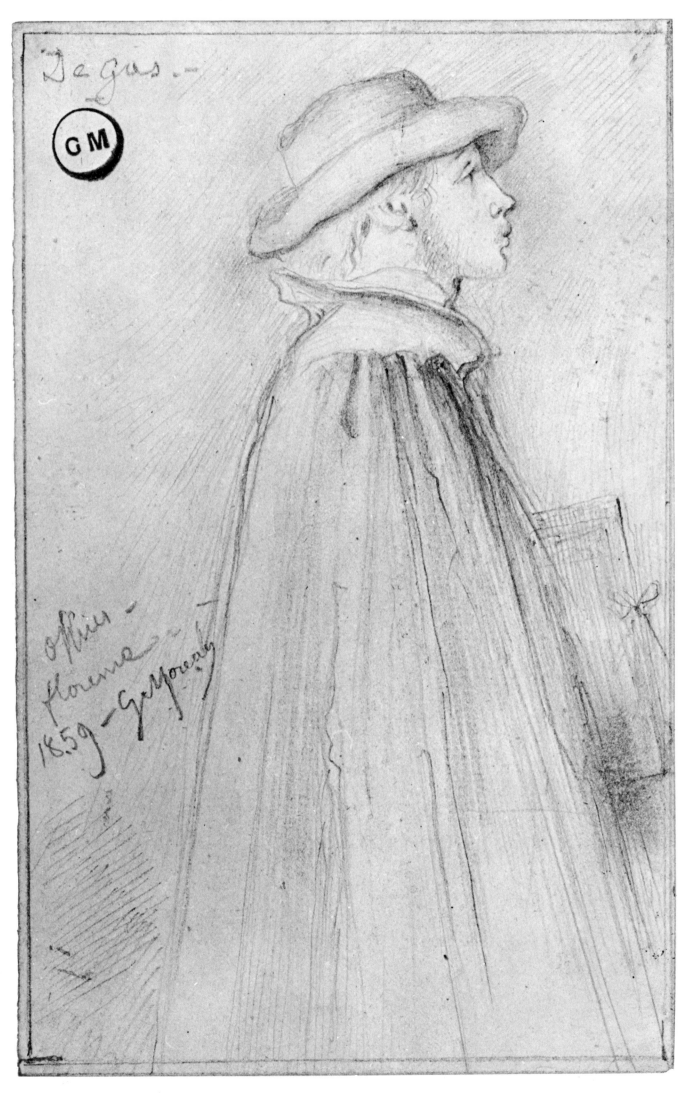

Gustave Moreau: Portrait of Degas in the Uffizi, 1859. Drawing.

26

Looking to Italy

Degas
Gustave Moreau

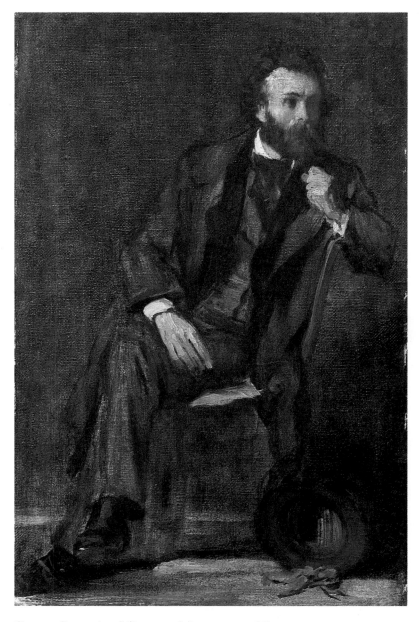

Degas: Portrait of Gustave Moreau, c. 1860.

Being at a loose end here, the best course is to spend my time studying my craft. I could undertake nothing on my own. Great patience is called for on the hard path that I have entered on. I had encouragement from you. How I miss it here; again I begin to lose heart a bit as in the past. I remember the talk we had in Florence about the moods of sadness that come over anyone who takes up art. In what you said, there was less exaggeration than I thought. For these dismal moods have very little compensation. They increase with age and progress, and youth is no longer there to console you with further illusions and hopes. Whatever one's affection for one's family and passion for art, there is a blank that even art cannot fill up. You understand me, I believe, though I do not express myself well enough.

Degas, letter to Gustave Moreau,
Florence, September 1858.

There is one thing that must be said for the French School in Rome: if it does nothing for a man's talent, it does a lot for his education; if it does not inspire the painter, it does mould and shape the man. Here at the Villa Medici, the inmates lead a common life; they rub shoulders in an academic club; rough natures are smoothed by contact with civilized natures; what the well-born teach, the others gain; what the lettered impart, the unlettered learn. Such is the French School at the Villa Medici. Out of men of the common people, it makes men of the world, whom their five years' sojourn there educates and polishes and raises to the required standards of present-day society.

Edmond and Jules de Goncourt,
Manette Salomon, Paris, 1867.

Degas on Gustave Moreau many years later:
A hermit who knows the train timetables.

Quoted by Ary Renan, *Gustave
Moreau*, Paris, 1900.

He would have us believe that the gods wore watch chains.

Quoted by Paul Valéry, *Degas,
Danse, Dessin*, Paris, 1938.

Impossible to become a painter without visiting Italy. (The classic case was Ingres, who as a prize-winning student attended the Académie de France in Rome, set up by Napoleon in the Villa Medici at the beginning of the century.) Degas, in Italy from 1857 to 1860, copied pictures, frescos and mosaics in Rome, Naples and Florence. As did Elie Delaunay, who won the Prix de Rome in 1856 and was an ex-pupil of the Lamothe studio at the Ecole des Beaux-Arts, through which Degas had passed the year before. These two, together with Bonnat who came from the Cogniet studio, Gustave Moreau who at thirty was the oldest of

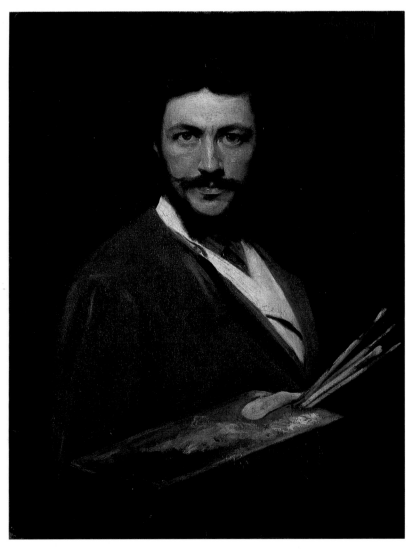

Carolus-Duran: Self-Portrait, 1869.

Tissot: Portrait of Degas, c. 1860? Etching.

And then I did not want to wait any longer without telling you better than by word of mouth how much I thank you and how touched I was by the cordial kindness you showed me during the last days of my illness, and by your coming to say good-bye. That touched me very much indeed and I am more thankful than ever to have an acquaintance such as you—there, I have spoken my mind to you frankly.

James Tissot, letter to Degas,
Venice, 18 September [1860?].

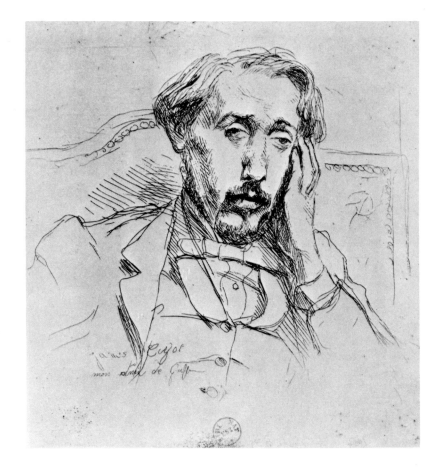

the group, and Bizet, a Prix de Rome music scholar, called themselves the "Cald'arrosti" ("hot roast chestnuts"), using the Roman street cry as a password rather than as the title of a manifesto. At the Café Greco and in director Schnetz's rooms in the Villa Medici the "Cald'arrosti" talked painting. And that meant talking about the old masters and the copies that had to be made. Such were the certainties Degas shared in Rome. (Some years later Rome was visited by his studio colleagues Charles-Emile-Auguste Durand, who adopted the more "artistic" Latinized name of Carolus-Duran, and Jacques Tissot, who

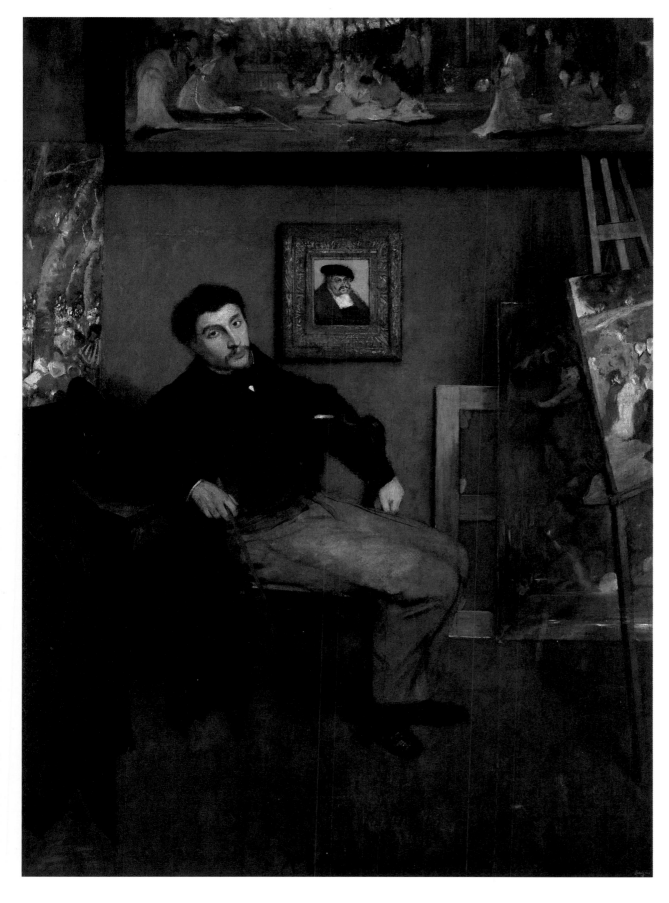

Degas: Portrait of
James Tissot, 1868.

after a successful English career renamed himself James and held the masters of
northern Europe in equal reverence, as witness the Cranach portrait of
Frederick the Wise that Degas painted behind him.) In Florence with Gustave
Moreau, Degas heard a different kind of talk at the Café Michelangiolo in the
Via Cavour, where the Macchiaioli met. Florence was itself a museum of the
Renaissance, and there Fattori, Abbati and Signorini were looking for a new
kind of painting. Their patches (*macchie*) of colour captured light effects in a new
way. The angry mockery they provoked was a source of pride to them.

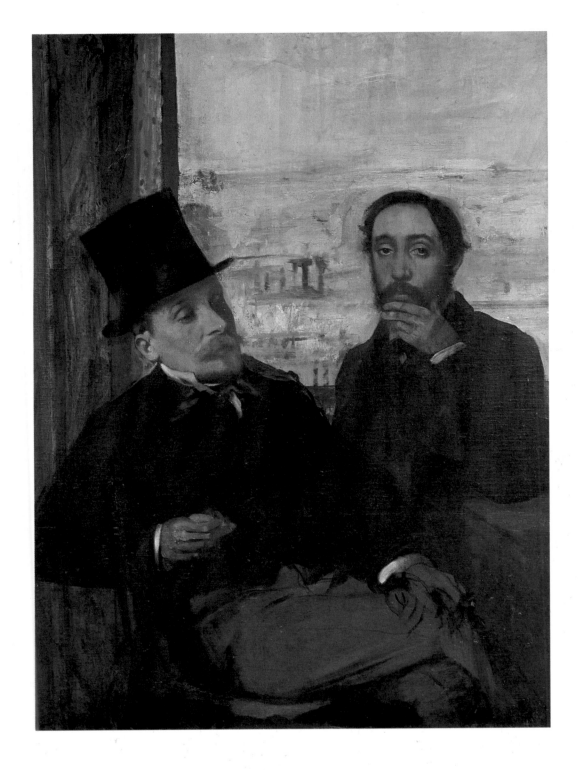

Degas: Self-Portrait
with Evariste de Valernes, c. 1864.

I was or I seemed to be hard with everyone, through a sort of
passion for brutality, which came from my uncertainty and
bad humour. I felt myself so ill-made, so ill-equipped, so
weak, while it seemed to me that my art *calculations* were so
right. I was sullen with everyone and with myself.

Degas, letter to Evariste de Valernes,
Paris, 26 October 1890.

Knowing that painting was a legacy, Degas discovered that it was also a quest.
Bonnat, Delaunay, Degas, Moreau and Tissot all received the same training at
the Ecole des Beaux-Arts. They went from museum to museum, copying the
same works. From then on their styles diverged completely. They made opposite
choices. In simply fulfilling commissions, painting submitted to demands extrin-
sic to itself. Recognition of the subject or the model was on a par with recognition
of the painter. Curiously, that recognition took account only of the text or model
posing and the person painting; it eluded painting as such. Portraits, for paint-
ers, were a trap, offering a more direct avenue to praise and remuneration than

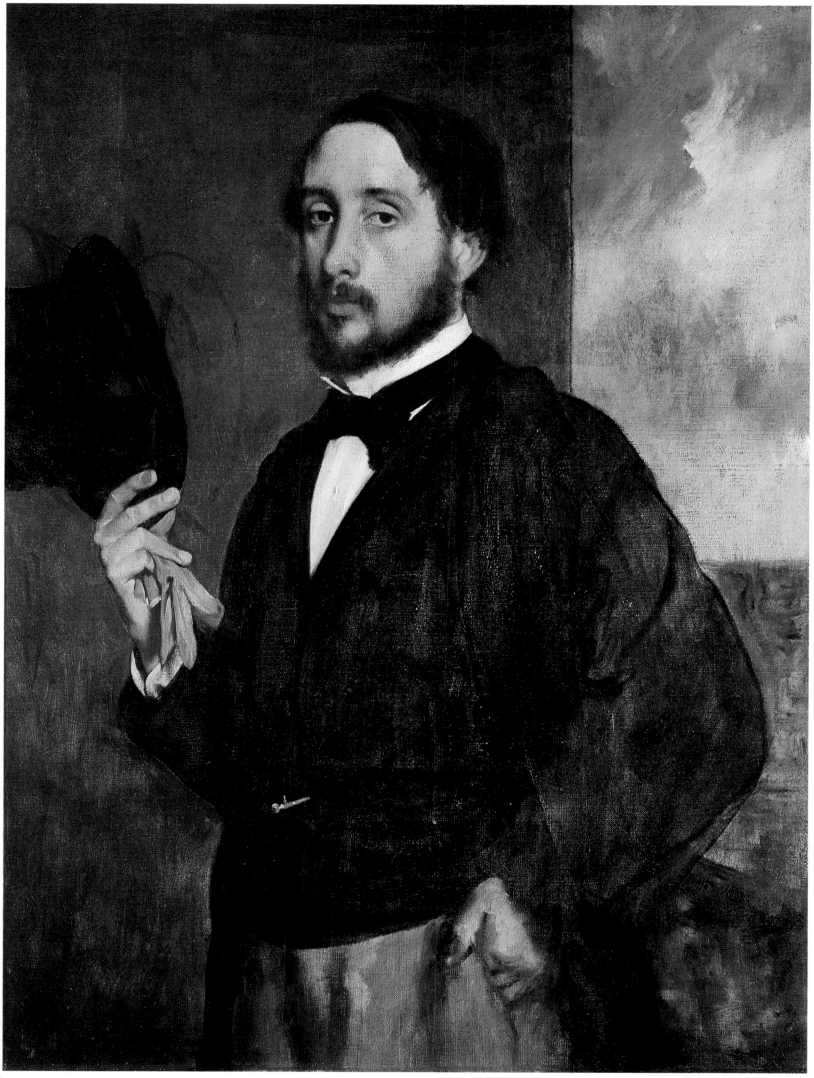

Degas: Self-Portrait, c. 1862.

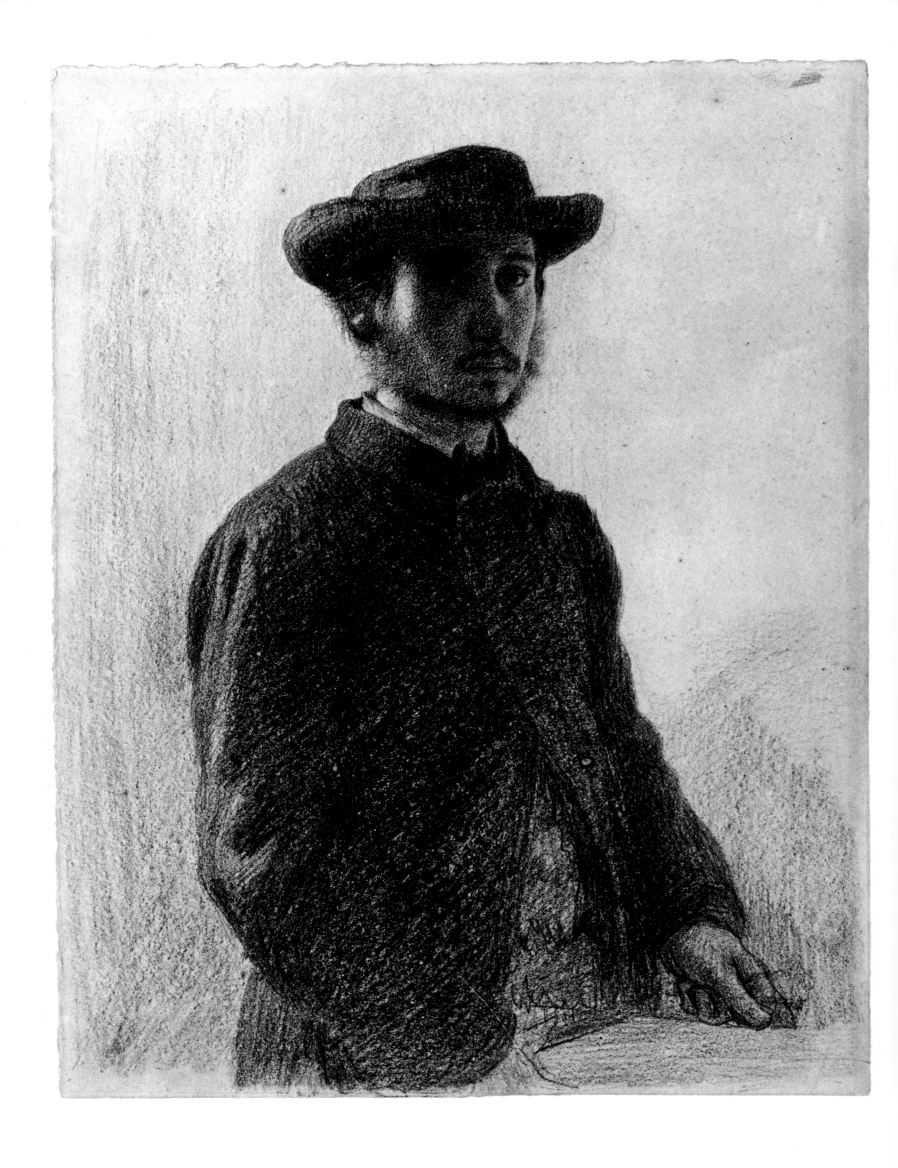

32

As I cannot analyze Bonnat's seventeen pictures in detail, I will content myself with a general opinion of his talent. Since Courbet, as I have noted, we have had no sturdier worker than Bonnat. Only he is deficient in elegance. One is brought up short sometimes by his tarry, cadaverous, or chalky tones. His brush deforms nature. Jealous of him, his fellow painters dismiss him roughly and unfairly as a bricklayer. This word hits off his style, which is recognizable among a thousand. From a distance, it is not so striking as it is from close up. But he is still a youngish man, who goes on perfecting his manner each year... His is a powerful talent, still growing.

Zola, "L'Ecole française de peinture à l'Exposition Universelle de 1878," in *Le Messager de l'Europe*, St Petersburg, July 1878.

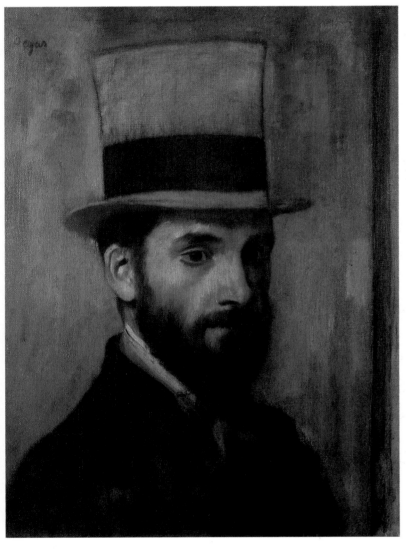

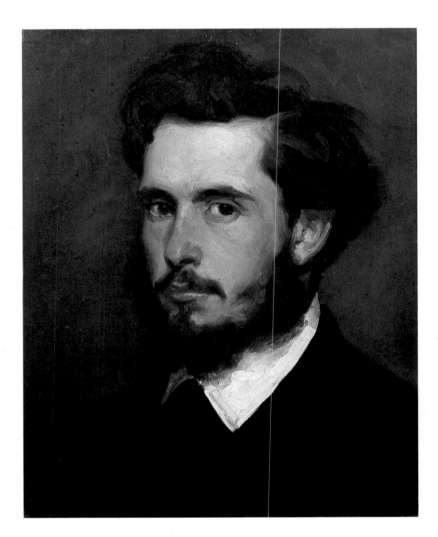

Carolus-Duran: Portrait of Monet, 1867.

Degas:
Portrait of Bonnat, c. 1863.
◁ Self-Portrait with Soft Felt Hat, c. 1857. Conté crayon.

any other genre. A person commissioning a portrait demanded a likeness and a respectable signature: a portrait *of* So-and-so, signed So-and-so (he had no use for a portrait *by*...).
Degas, Manet, Cézanne, Monet and even Renoir distrusted portraits. Not that they had no wish to paint them, but they could not accept doing so at the expense of painting itself. They painted portraits only of the men and women they had asked to sit for them. With few exceptions it was not the sitter who commissioned the portrait.

The Salon des Refusés

On 12 April 1863 the jury, having deliberated for ten days, completed its examination of the works submitted for the Salon. The members of the jury were Heim, Picot, Schnetz, Couder, Brascassat, Cogniet, Robert-Fleury, Alaux, Flandrin, Signol and Meissonier (Ingres and Delacroix, though also members, had not attended the sessions). With the Comte de Nieuwerkerke in the chair, they delivered their verdict. From more than 5,000 works submitted, only 2,217 had been accepted. There was a public outcry, echoes of it even reaching the emperor. On 20 April Napoleon III made an unexpected visit to the Palais de l'Industrie with his aide-de-camp, General Lebœuf, and asked to see some of the works selected by the jury. Afterwards he visited the storerooms where the unsuccessful pictures had been stacked, turning some of them round to look at them.

On 24 April the liberal daily, *Le Moniteur Universel*, announced: "Numerous complaints have been made to the emperor concerning the works of art turned down by the Salon jury. Wishing to let the public judge whether or not such complaints are justified, His Majesty has decided that the rejected works shall be exhibited in part of the Palace of Industry. This exhibition will be optional, and artists not wanting to take part have only to inform the management, which will then seek to return their works to them with all speed." There was a second outcry, the precise converse of the first. Now the jury was itself to be judged. Henry Courmont, a high Beaux-Arts official, put it to the emperor that there was a risk of the members of the jury taking offence and resigning as a body. The Academy, however, did not react.

Count Nieuwerkerke assured the committee formed by the more determined of the *refusés* that the management was indeed preparing the twelve rooms set aside

for the "Exhibition of non-accepted works [*ouvrages*; they were not even graced with the name of *œuvres*]," as it was officially called. It was to open on 15 May, a fortnight after the Salon. Entrance would cost 1 franc, as for the Salon, and be free on Sundays. Artists who did not wish to take part must collect their works by 7 May at the latest. "After that date any art objects not withdrawn will be exhibited," the *Moniteur* made clear on 28 April. The management was loath to publish a catalogue.

The incomplete, 68-page catalogue rushed out by the Marquis de Laqueille and sold for 75 centimes outside the Palais de l'Industrie (its sale inside was banned) included only 697 items. It pointed out that a substantial number of artists "have not felt obliged to hold their works over for the counter-Exhibition." More than a thousand *refusés* deserted, preferring absence to public disgrace. At the Salon works were as usual exhibited in alphabetical order. The 1,200 rejected pictures, described in the press as "proscribed," "outcast," even "damned," and of course as "daubs," were hung in the order in which they had been submitted.

The Salon des Refusés opened on 15 May 1863. "It was very well presented, in fact the accepted paintings were not more richly housed: tall hangings of old tapestries at the doors, the lower wall covered with green serge, seats upholstered with red velvet, white sheeting beneath the glazed ceiling bays, and, as one looked down the rooms, the same general appearance, the same gold frames, the same bright patches of canvas. But there was a special kind of gaiety here, a flash of youth that one did not fully apprehend at first. The already dense crowd was increasing by the minute, for people were deserting the official show and flocking here, driven by curiosity and a lively desire to judge the judges, delighted immediately on entering by the certainty of seeing some very agreeable things." And what did they find? "The walls were lined with a blend of the best and worst in a jumble of genres, the dotards of the historical school rubbing shoulders with

crazy young realists, the straight simpletons all in amongst the braggarts of originality, a dead Jezebel who looks as if she has been putrefying in the cellars of the School of Fine Arts and nearby a *Lady in White*, a most unusual vision seen by a great artist, an enormous narrative *Shepherd Looking at the Sea* with, opposite, some *Spaniards Playing Tennis*, a flash of light of brilliant intensity. On the bad side it was all there, military pictures full of lead soldiers, pallid antiquities, bituminous medievalisms. But from this incoherent collection, particularly from the landscapes, nearly all of which strike a sincere, true note, but also from the portraits, most of which are interestingly treated, there emerged a fine flavour of youth, intrepidity, passion. If there were fewer bad paintings in the official Salon, the average there was unquestionably more trite, more feeble. Here one felt one was in the midst of a battle, and a lively one at that, fought with zest." What, then, was the verdict? "Granted, there was much that was clumsy and puerile, but what a delightful feeling generally, what a quality of light was here, a delicate, silver-grey, diffused light alive with all the dancing reflections of the open air! It was as if a window had been thrown open in the old bitumen kitchen, in the reboiled varnishes of tradition, and the sun had come in and the walls were laughing to see such a spring morning! Was this not the long-awaited dawn, a new day breaking for art?"

The official Salon was a very different affair. "Gilt frames filled with shadow offered a series of starched, dark things, studio nudes yellowing in a cavernous daylight, the whole classical legacy, history painting, genre painting, landscape, all steeped in the same dirty oil of convention. The works oozed mediocrity, typified by a uniform smudginess of tone in this decorous setting of an art grown thin-blooded and degenerate."

Few would have subscribed to Zola's opinions. The emperor's decision had appeared to threaten the Institute. Indeed, Louis Leroy wrote in *Le Charivari* (20 May): "If the jury can defend itself by showing the unspeakable deformities

unhesitatingly submitted to it, we ourselves can judge it in our turn and condemn it." And the next day Edouard Pelloquet declared that "the unfitness of the Institute to continue its role is beyond dispute." But such views were the exception.

In the *Revue des Deux-Mondes* (15 June) Maxime Du Camp drew his conclusions from the emperor's decision: "Never have the jury's labours received more striking ratification, and we can be grateful to it for having attempted to spare us the sight of such lamentable things." In *Le Courrier Artistique* (16 May) Edouard Lockroy agreed: "The exhibition of rejected artists will undoubtedly be a triumph for the jury." One knew now what to go by. As Castagnary put it in *L'Artiste*: "Before the exhibition of rejected artists one was incapable of imagining what a bad painting was. Today we know. We have seen, touched and taken note."

Following this public confirmation the jury resumed its task, which had to do with more than art. The number of submissions increased year by year, and those aspiring to the supreme accolade of acceptance by the Salon were not all products of the Ecole des Beaux-Arts; some came from private academies and the many drawing-schools. The myth of Bohemia, a medley of insouciance, cynicism and the picturesque, attracted a generation susceptible to Romantic illusions, falling back on idleness and calling it inspiration. In slashing the entry the jury was asserting its prerogatives at the same time as it eliminated bad painters who could look forward only to a career of disappointments and bitterness.

The dogmas of art were not so very different from moral dogmas. And there was an order of beauty as there was a social order. Not to accept the one was not to accept the other. The purge of 1863 was artistic as well as moral and social.

The Salon des Refusés was the first and last of its kind. The emperor's sensational step had proved that the Empire was liberal. No need to prove it twice.

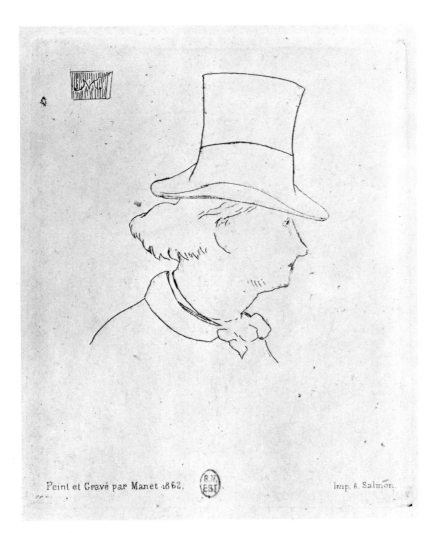

Manet: Portrait of Baudelaire, 1862. Etching.

At a time when the poet made up his face outrageously, Manet exclaimed, "What a fool he is to coat himself with paint, but underneath it is genius!" Baudelaire was always with him when Manet went to the Tuileries garden, doing studies in the open air, under the trees, of the romping children and the nursemaids flopping into chairs. The strollers would cast curious glances at this elegantly dressed painter, setting out his canvas, taking up his palette and painting as calmly as if he had been in his studio.

<div align="right">

Antonin Proust, *Edouard Manet,*
Souvenirs, Paris, 1913.

</div>

Manet is a pupil of Goya and Baudelaire. He is already hateful to the bourgeois: that is a step in the right direction.

<div align="right">

Charles Monselet in *Le Figaro,* Paris,
24 May 1863.

</div>

An exasperated art-lover went so far as to threaten violence if the *Concert in the Tuileries* were left any longer in the exhibition room. I understand this man's anger. Imagine a whole crowd under the trees of the Tuileries, maybe a hundred people, moving in the sunlight; each figure is a mere dab of paint, barely defined, and in it the details turn into lines or black dots. If I had been there, I would have asked this art-lover to stand back at a respectful distance, and he would then have seen that these dabs of paint were alive, that the crowd was speaking, and that this canvas was one of the artist's characteristic works, the one in which he answered best to his eyes and temperament.

<div align="right">

Zola, "Une nouvelle manière en
peinture: Edouard Manet," in *Revue du*
XIXᵉ Siècle, Paris, 1 January 1867.

</div>

A concert (there were two a week) in the gardens of the Tuileries Palace, where the emperor lived. Seated on the new wrought-iron chairs that had recently appeared in the parks of Paris, blue bonnet-strings tied in large bows beneath their chins, are Madame Loubens, holding a half-opened fan, and Madame Lejosne. Manet, grasping the knob of his walking-stick, stands on the left near Champfleury, one of the fathers of Realism, and behind Albert de Balleroy, with whom Manet shared a studio in the Rue Lavoisier for several years. It was at the Lejosnes' in 1861 that Manet met Baudelaire, who is seen in profile behind Madame Lejosne, talking to Théophile Gautier, the "flawless poet" and Baudelaire's "most dear and most revered master and friend" to whom he had dedicated "these morbid flowers," as he called *Les Fleurs du Mal.* Baron Taylor, the Inspector of Museums, is in conversation with them. Fantin-Latour appears behind Baudelaire's hat, and the hatless seated figure is Zacharie Astruc, who at twenty-seven was a composer, poet, sculptor, journalist and painter. Astruc and Baron Taylor shared a passion for Spanish art, and it was on a *Group of Thirteen Figures* then attributed to Velazquez that Manet based his composition.

When Manet is in high spirits, he paints the *Concert in the Tuileries*, the *Spanish Ballet* or *Lola de Valence*; pictures, that is, which reveal his abundant vigour, but which in their gaudy red, blue, yellow and black are the caricature of colour, and not colour itself. In short, this kind of art may be fair enough, but it is not wholesome.

Paul Mantz in the *Gazette des Beaux-Arts*, Paris, 1 April 1863.

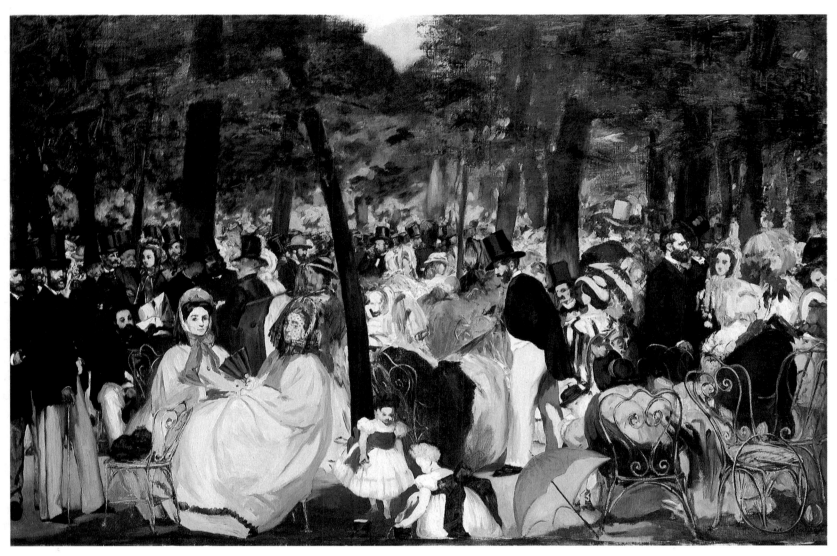

Manet: Concert in the Tuileries, 1862.

Behind Astruc is Aurélien Scholl, the personification of boulevard life. Without him the Café Tortoni, where each evening Manet showed his studies to an attentive circle, would not have been the meeting place of everyone who mattered in Paris. Scholl's pen *was* a sword, and his cutting words got him involved in duels that were the talk of the town. Also on every Parisian's lips, since 1858, were the melodies of Offenbach's *Orpheus in the Underworld*, and Offenbach is seated in front of a tree on the right, looking towards the slightly stooping back of Eugène Manet, the painter's younger brother. Standing on the right, his top hat raised in a salute, is Charles Monginot, like Manet a pupil of Couture's. *Concert in the Tuileries* was a manifesto that did not belong solely to the studio and to painting; it was the scene of "modern life" that Baudelaire had called on him to paint, and it was a bid for recognition. Now thirty, Manet was painting the fashionable world of which he wished to be a part. Yet the world to which he aspired could not tolerate this kind of painting. Both subject (life in the present could never be anything but common) and treatment (an unacceptable motley) were repugnant to it. Manet's ambitions were irreconcilably in conflict.

"But what about that man there, fully dressed, in the middle of those naked women. Who ever saw anything like it?"
At that, the other two burst out. After all, weren't there plenty of pictures like that in the Louvre? And then, if people had never seen anything like it, by God they would see it now. Damn it, who cares what the public thinks?
Keeping his temper under the vehemence of this outburst, Dubuche quietly went on saying:
"The public won't understand. The public will think it indecent. And it *is* indecent."

Zola, *L'Œuvre*, Paris, 1886.

Cherries and figs
Manet

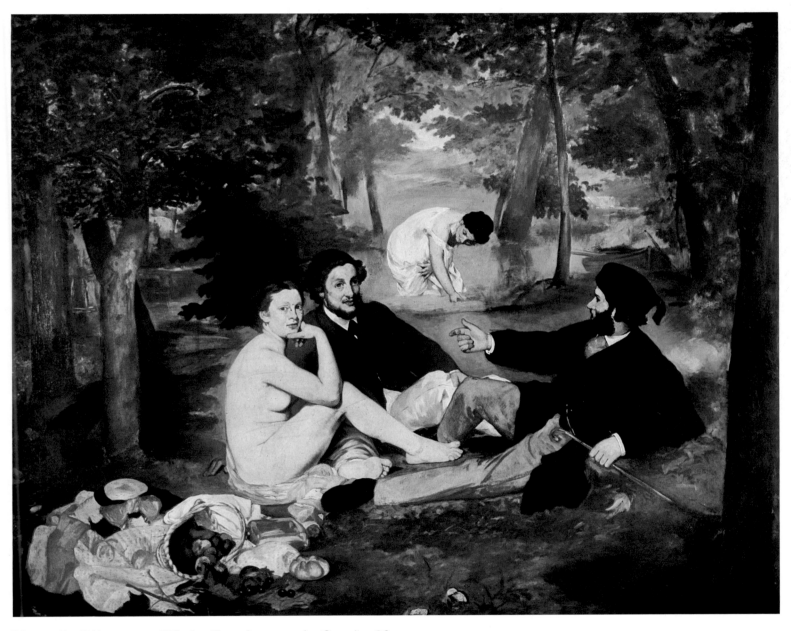

Manet: Le Déjeuner sur l'Herbe (Luncheon on the Grass), 1863.

Manet's light-filled woodland scene was the scandal of the Salon des Refusés. It was pure provocation. Who could recognize any trace of Giorgione's *Concert Champêtre* or Raphael's *Judgment of Paris* as engraved by Marcantonio Raimondi, which were supposed to have served as models for the painting? The academic nude was above immodesty, but to be undressed was indecent. A naked woman with two men in jackets was surely taking licence a step further than the *Bathers* that Courbet had shown at the 1853 Salon. Manet himself had provided the proof: the rowing-boat behind the student on the right was the same one that Courbet had moored behind his *Young Ladies on the Banks of the*

40

The *Déjeuner sur l'Herbe* is Edouard Manet's largest picture, the one in which he has realized the dream of all painters: to set lifesize figures in a landscape. We can see how powerfully he has overcome this difficulty. Here is some leafage, a few treetrunks, and in the background a stream with a woman in a shift bathing in it. In the foreground are two young men sitting opposite a second woman who has just come out of the water and is drying her bare skin in the open air. This naked woman has scandalized the public, who can see only her in the canvas. Good heavens, how indecent! A woman without a shred of clothing between two men fully clad! Nothing like it had ever been seen. And this belief was a delusion, for in the Louvre there are fifty pictures or more in which we find clad and naked figures together. But no one will take the trouble to be scandalized in the Louvre. The crowd moreover took good care not to look at the *Déjeuner sur l'Herbe* as a true work of art should be looked at. All it saw in it was some people picnicking on the grass, after a bathe, and it assumed that the artist had expressly chosen a bawdy and eye-catching subject, whereas he was simply trying to obtain some vivid contrasts and forthright masses. Painters, and Edouard Manet in particular, a painter who analyzes, do not have that preoccupation with the subject which worries the crowd so much; the subject for them is a pretext for painting, while for the crowd only the subject exists. So it is that the naked woman in the *Déjeuner sur l'Herbe* is only there to give the artist a chance to paint some flesh. What has to be seen in the picture is not a luncheon on the grass, but the whole landscape, with its intensities and its refinements, with its broad and solid foreground and the lightness and delicacy of the background. What has to be seen is this firm flesh modelled in broad sweeps of light, these strong and supple fabrics, and above all this delightful figure of a woman in the background, forming an adorable patch of white amidst the green leaves. What must be seen is this large picture as a whole, this corner of nature rendered with such an apt simplicity, this admirable achievement into which an artist has put the rare and special elements that were in him.

Zola, "Une nouvelle manière en peinture: Edouard Manet," in *Revue du XIXᵉ Siècle*, Paris, 1 January 1867.

Manet: One of the greatest artists of the day. Nothing in his *Déjeuner sur l'Herbe* is more enjoyable than the large landscape, so youthful and vivid in all its features; it seems to have been inspired by Giorgione. I have spoken of forthrightness: that is the dominant note in this full-bodied, manly art, which rings out like orchestral brass and has the boldness of genius.

Zacharie Astruc in *Le Salon de 1863*, Paris, 23 May 1863.

Degas to Manet:
Now you are as famous as Garibaldi!

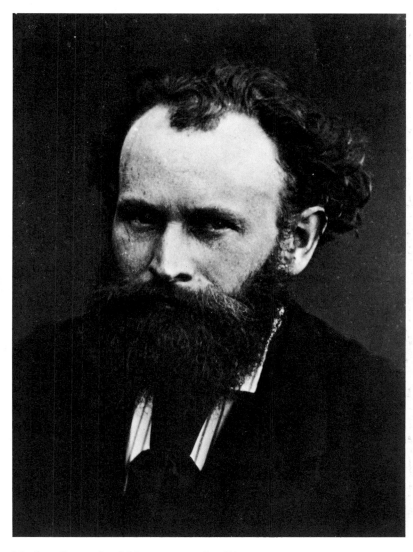

Nadar: Portrait of Manet, c. 1865. Photograph.

Seine, another scandal that had blown up in 1857 because one of the young ladies was exposing her bustle, chemise and corset.
Manet had now taken up that immodest dishabille on his own account. He was being deliberately provocative. A naked woman between two fully dressed men could not be anything but shocking. Aware of this, Manet included a symbol of the incompatibility reflected in his picture, a still life of some fruit spilling from a basket onto the discarded dress in the left foreground. But cherries and figs belong to different seasons: cherries ripen in June, figs in September. The whole picture was not contemporary with its time.

With Manet and our school, a generation of painters came forward just as the work of destruction begun in 1789 was being completed.

Ambroise Vollard, *En écoutant Cézanne, Degas, Renoir*, Paris, 1938.

Some people gave Manet out as an ill-natured man. No one was kindlier, better bred, more reliable in his dealings. Never have I heard him say an ill word about any one. He never wronged an artist or anyone else. He was feared because he had such a telling way of putting things, in words of singular originality: the words of a child of Paris, of a child of genius, which left their mark ineffaceably on anything mean or ridiculous. He was a master of that cheerful mockery in which a touch of disdain was faintly felt. A blitheness flowed out of him: a communicative blitheness, infectious as his whole laughter-loving philosophy.

So have I always seen him. His was a sunny soul, and I loved the man.

J. de Nittis, *Notes et Souvenirs*, Paris, 1895.

Polite formulas
Manet
Degas
Bazille

At that time Manet was a muscular man of medium size. He had a jaunty step, with a swagger to it that gave him a peculiar elegance. However much he exaggerated that swagger and affected the drawling intonation of the Paris street-boy, he never succeeded in being vulgar. He was, and you felt him to be, a man of breeding.

Under a broad brow, the nose was straight and strong. The mouth, turned up at the corners, fell easily into banter. The gaze was bright and clear. His eyes were small, but moved restlessly. When he was very young, his long, naturally curling hair was combed straight back. At eighteen, he was already losing his hair in front, but he had grown a beard. This softened the features in the lower part of his face, while his extremely fine hair harmonized the upper part. Few men have been so charming...

He had a way of smacking his tongue; with him, the highest expression of admiration. Before a Jongkind, Whistler, Bracquemond, Desboutin or Guys, before Claude Monet's early landscapes, before the Degas's, Pissarros and Sisleys, the studies of Berthe Morisot and Mary Cassatt, before the Gauguins, Renoirs, Cézannes and Caillebottes, he emphasized that smacking more or less, but it was in front of nature most of all, when some aspect of it charmed him, that he made that smacking noise forcefully, like a horseman spurring on his mount.

Antonin Proust, *Edouard Manet, Souvenirs*, Paris, 1913.

Degas: Portrait of Manet, 1864-1866. Pencil and wash.

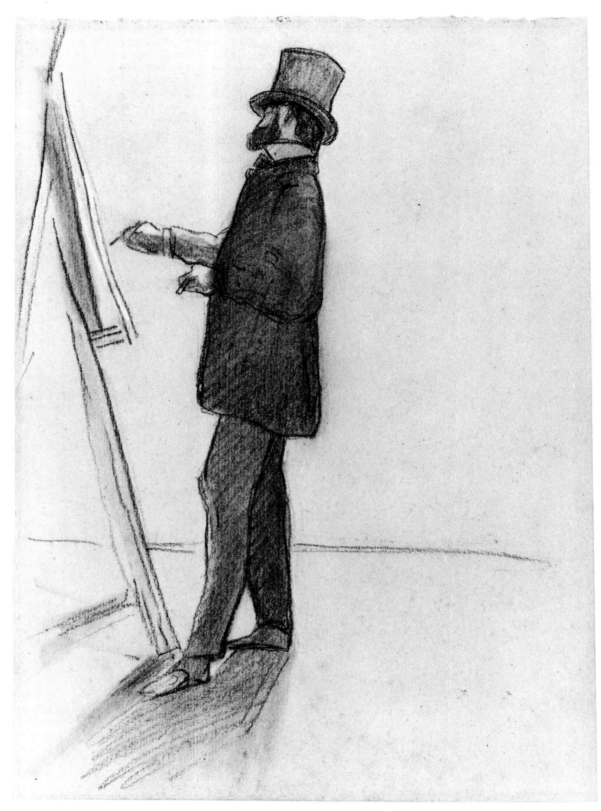

Bazille: Portrait of Manet at his Easel, 1869. Charcoal.

The men of money and power distrusted unruly young artists. Degas did not have to persuade his family, but Manet and Bazille gave up the naval and medical careers they had been expected to pursue in order to paint.

The certainties and standards in the education of Manet, Degas and Bazille were the same, like the conventional do's and don't's endlessly reiterated in the studio stereotypes they all went through; and, when they began to paint, their private incomes or allowances meant that they did not *have* to sell their work. This privilege formed the basis of their self-assurance. None of them, however, painted with his education or with his private income: their painting disregarded the polite formulas demanded by the Salon.

How I wish you were here! I should like to have your opinion about the choice of my landscape, and for my figures. Sometimes I'm afraid of going wrong.

Monet, letter to Bazille, Chailly, 5 May 1865.

I really wonder what you are up to in Paris in this fine weather. Here at Chailly in the Forest of Fontainebleau it's lovely, and every day I discover finer things. It drives me crazy, I'm so keen on doing everything: my head is bursting! It's appallingly difficult to work out just one thing completely in every way. Most people seem satisfied if they can hit it off approximately. Well, old chap, I'm not one of them! I want something better, and so I scrape the paints off and start in again. I can only do what I want and understand, for it seems to me, when I look at nature, that I see her all set out and written down. And then, when you come to grips with it, what a puzzle it is! Which only goes to show that one has got to concentrate on this and nothing else. Only by observation and thought can you win through. So let's go on toiling away.

Monet, letter to Bazille, Chailly, 15 July 1865.

You promised to help me with my picture. You must come and pose for one or two figures; otherwise I may spoil my picture. I am in despair. I fear my picture may go wrong without you, and that would be doing me a real disservice after promising that you would come and pose for me.

Monet, letter to Bazille, Chailly, 16 August 1865.

At stake

Monet
Bazille
Camille

I have only come to Chailly as a favour to Monet; otherwise I would have been with you in Montpellier long ago, and with the keenest pleasure. We've been unlucky with the weather. Since I've been here, it has been awful and I've only been able to pose for him twice. Now the weather is quite fine. Monet is working hard and will need me for the next three or four days. So to my great regret I've got to postpone my departure again. As soon as he has finished, I'll be off.

Bazille, letter to his parents, Chailly, 1865.

Monet: Le Déjeuner sur l'Herbe (Luncheon on the Grass), 1865-1866 (cut down by Monet in 1884).
Left side of the composition and central part.

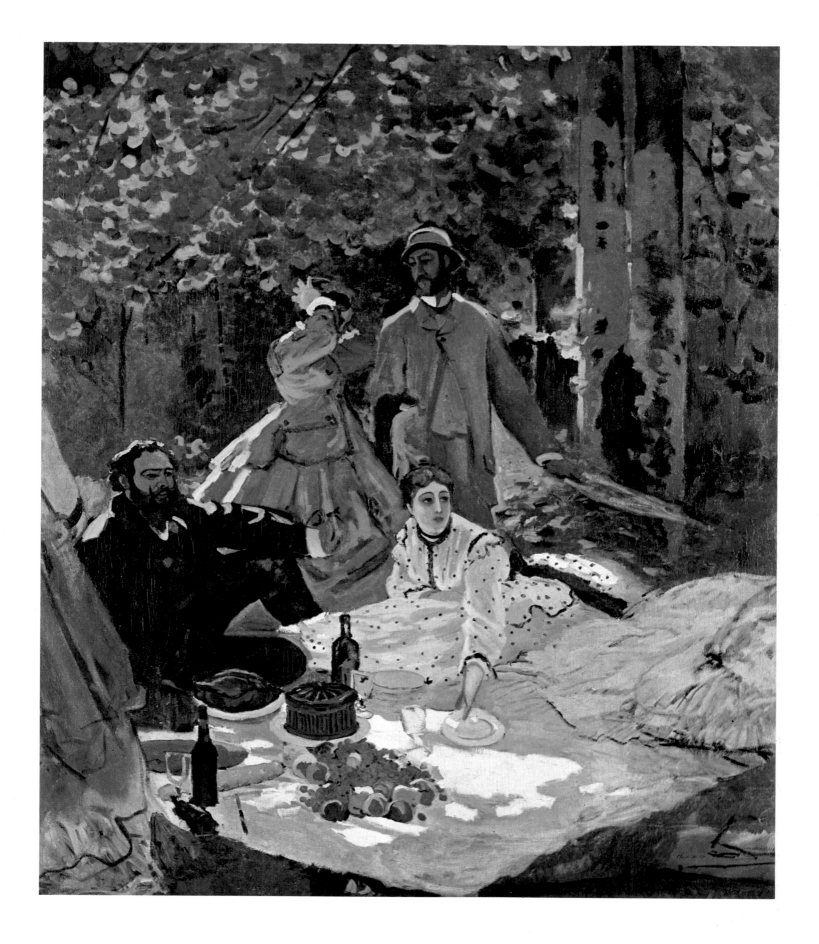

This *Déjeuner sur l'Herbe* was a challenge. From early May 1865 Monet was at Chailly, on the edge of Fontainebleau Forest. A stream of letters called Bazille to order. "Mobilized" to sit for a number of figures, he agreed to do so. (Sometimes Monet's letters arrived unstamped at 6 Rue de Furstenberg, the Paris studio the pair were renting together, and Bazille had to pay the postage. But if Monet could not afford stamps, how was he going to pay a sitter?) In fact Monet was looking for more than a sitter; he wanted the advice of a painter. Was the setting suitable? Did the composition come across? Bazille did not join him until late August. He sat, outdoors, for four of the seven men in the picture.

I do not know Monsieur Monet. I do not think I have ever seen any of his canvases before. Yet I feel as if I were an old friend of his, and this is because his picture tells me a whole story of energy and truthfulness. Yes, indeed, here is a temperament, here is a man in this crowd of eunuchs. Just look at the canvases next to his and see the sorry figure they cut beside this window thrown open on nature. There is more than a realist here, there is an able, delicate interpreter who knows how to register every detail without lapsing into dryness. Look at the dress. It is solid, yet it falls softly and freely, it is alive. It tells you who this woman is. This is not a doll's dress, not one of those muslin frills that you dress up a dream with. This is genuine silk.

<div align="right">Zola, "Mon Salon" in <i>L'Evénement</i>,
Paris, 27 April-20 May 1866.</div>

Among the first-rate painters I would name Claude Monet. He has sucked the milk of our time, he has grown up and will grow still more in his adoration of what he sees around him. He loves the horizons of our towns, the grey and white patches made by houses seen against the clear sky. He loves busy people in their overcoats hurrying through the streets. He loves the horse-races and aristocratic carriage-drives. He loves our women, their sunshade, their gloves and fine clothes, even their false hair and face powder, everything that makes them the daughters of our civilization.

<div align="right">Zola, "Mon Salon" in <i>L'Evénement</i>
<i>Illustré</i>, Paris, 2 May-16 June 1868.</div>

Monet: Study for Le Déjeuner sur l'Herbe (Luncheon on the Grass), c. 1865. Black crayon.

Monet painted his studies. His rooms at the Lion d'Or inn serving as a studio, he made an overall oil sketch of the composition. Back in Paris in the autumn, after weeks ruined by rain and by an accident that had laid him on his back, all he had was his oil sketch measuring 4 by 6 feet. And only a few months in which to rework it on the scale he wanted, which was that of *The Painter's Studio* and *A Burial at Ornans* by Courbet (to whom the bearded man seated behind the cloth bears a curious resemblance). His painting was to measure 13 by 20 feet. What was at stake? Getting the jury to accept an open-air painting, a contemporary scene, and getting himself accepted at the age of twenty-five without the scandal of a nude such as Manet had exhibited at the Salon des Refusés in 1863.

A green dress

Monet
Camille

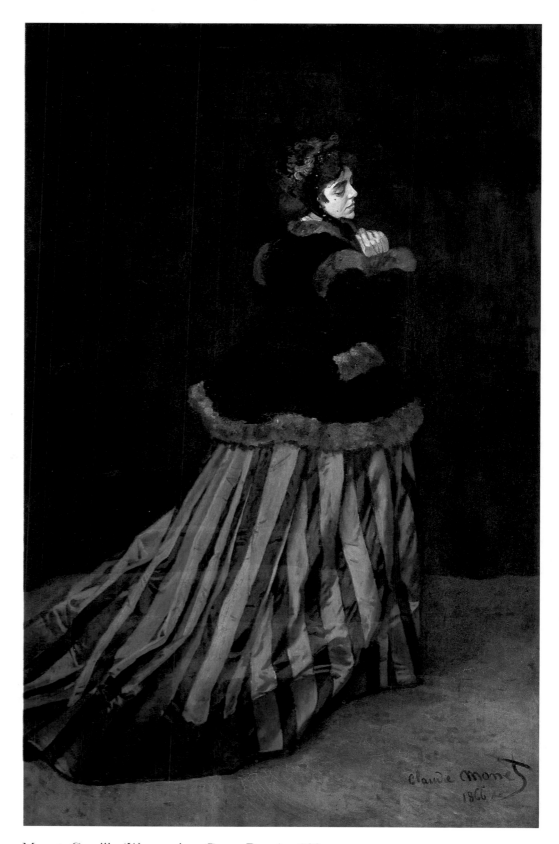

Monet: Camille (Woman in a Green Dress), 1866.

Monet decided against submitting his *Déjeuner sur l'Herbe* to the Salon. He show-
ed two other paintings, *The Road from Chailly to Fontainebleau* and *Camille*, and his
success was scandal-free. His vigorous rendering of the dress was accepted as the
work of Carolus-Duran or Stevens was accepted. Yet *Camille* is no more a fashion
plate than a portrait. Seen from behind, with her head turned to one side, she
echoes the posture of the woman in a shawl standing in front of the table on
which Baudelaire is seated in Courbet's picture, *The Painter's Studio*. The re-
ference indicates both a debt and an ambition. The realism and unshakeable
integrity of Courbet were exemplary. *Camille* heralded a kind of painting based
not on received wisdom but on original research.

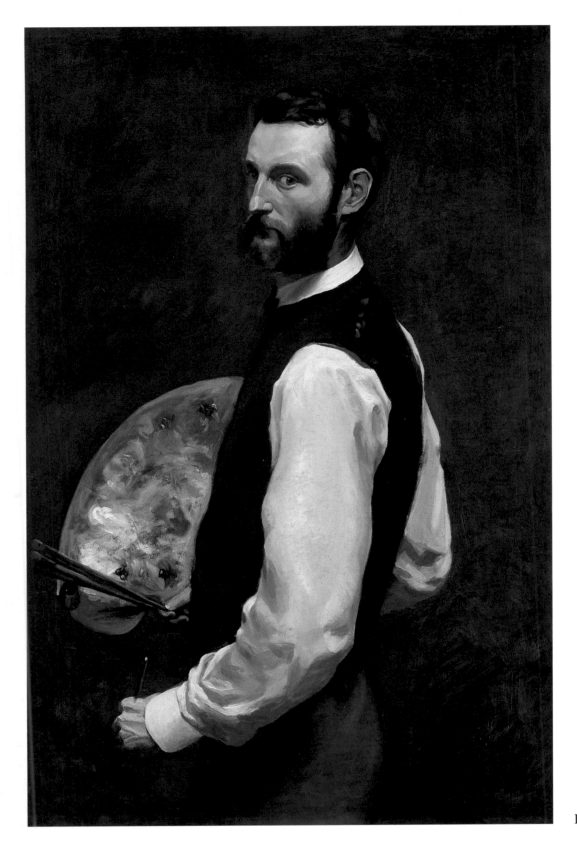

Bazille: Self-Portrait with Palette, 1865.

For years Bazille was Monet's mainstay. Monet needed a model for the *Déjeuner sur l'Herbe* he painted at Chailly-en-Bière in 1865. Bazille came and sat for him, and Monet in turn posed on the grass for Bazille. When Monet was hurt, Bazille, who had studied medicine, took care of him (though the decisive argument for keeping Monet immobile was the portrait Bazille painted of him lying in a room of the Lion d'Or inn). Monet needed props. It was probably Bazille who lent him the green dress for Camille, which Bazille had hired for a picture of his own. At the beginning of 1867 Monet had no studio. Bazille took him in at Rue Visconti, where he was already putting up Renoir. Monet was short of money. Bazille bought his *Women in the Garden*—rejected by the 1867 Salon—for

The news, since my last letter, is that Monet has dropped in on me with a collection of magnificent canvases. He will have a spare bed with me till the end of the month. Here then, with Renoir, are two needy painters staying with me. My flat is like a regular infirmary, and I'm delighted. I have plenty of room for them, and they are both so cheerful.

Bazille, Paris, c. 1866-1867.

I don't think I've told you yet that I'm giving hospitality to one of my friends. a former pupil of Gleyre's, who has no studio at the moment. Renoir is his name and he's a hard worker. He takes advantage of my models and even helps me in part to pay for them. It is pleasant for me not to spend my days entirely alone. At the moment I'm doing the portrait of one of my friends [Sisley?], which I shall send in to the exhibition together with the picture of Méric.

Bazille, letter to his parents, Paris, 1867.

Bazille: The Improvised Ambulance (Monet after his Accident in the Inn at Chailly), 1865.

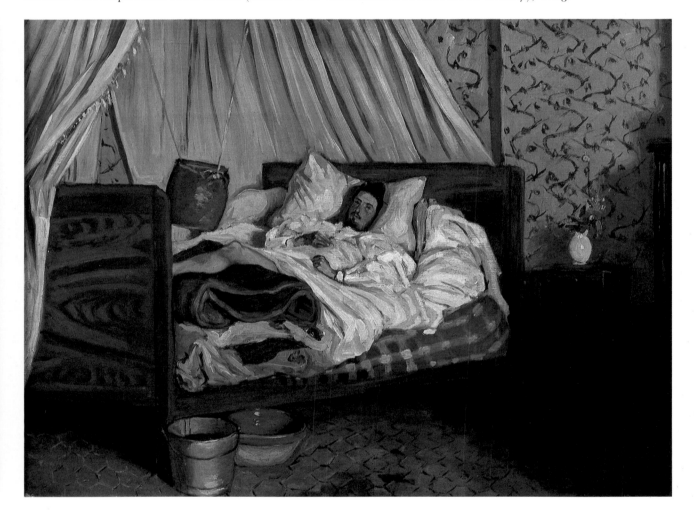

2,500 francs and agreed to pay Monet 100 francs a month. (For years Monet left a trail of debts and pawned paintings. His *Déjeuner sur l'Herbe*, left to a creditor, mouldered in an Argenteuil cellar for fifteen years. In Ville-d'Avray an unpaid landlord demanded some paintings as security. Monet slashed them, which did not stop the creditor selling the lot for 120 francs.) In letter after letter Monet went on pestering his benefactor. Monet's family refused to accept his relationship with Camille Doncieux. Courbet was to be a witness at their wedding on 28 August 1870. Meanwhile, in August 1867, it was at Pissarro's house that Camille gave birth to Monet's first son, Jean. Julie Vellay, Pissarro's companion, was the child's godmother. The godfather was Bazille.

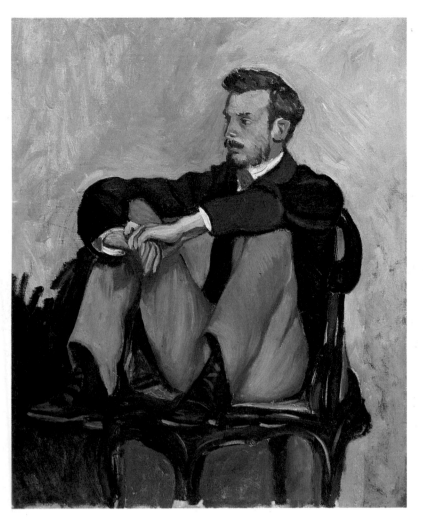

Bazille: Portrait of Renoir, 1867.

Renoir:

If I chose Gleyre's studio, it was because there I could be with my friend Laporte, with whom I had been close from childhood. I might well have gone on painting blinds if Laporte had not pressed me to join him. It happened, however, that our old comradeship failed to last; our tastes were too different. But how grateful I am to Laporte for having urged me to take the step that led me to become a painter, and also to meet Monet, Sisley and Bazille!

This man Gleyre was an estimable Swiss painter, but he could be of no help to his pupils; his one merit was that he left them free. I was soon fast friends with the three men I have just mentioned. One of them, Bazille, an artist of great promise, died young in the first battle of 1870. Justice has still not been done to his work.

Renoir:

When the war came, I was just getting to be somewhat known. I had even done a portrait of Bazille which, by good luck, was noticed by Manet. He did not much care for my painting, but even so when he would keep saying at the sight of one of my pictures, "No, this is not up to the *Portrait of Bazille,*" that implied that at least once I had painted something not so bad after all.

Ambroise Vollard, *Auguste Renoir*, Paris, 1920.

A community of artists

Bazille
Renoir

Bazille painted Renoir's portrait. And Renoir did one of Bazille. The artist, seated, is painting a dead bird with its wings spread, his still life *Heron and Jays*. The jays laid on a cloth on either side of the curve of the heron's neck are no more than blobs of colour as yet. Behind Bazille are canvases turned to the wall and, on the wall, Monet's *Snow-Covered Road at Honfleur*. Renoir has painted a portrait of Bazille painting a still life in front of a Monet landscape. (And the portrait was later owned by Manet.)

The three young men had met, together with a fourth, Sisley, in Gleyre's studio, as art students. All they had in common was a desire to paint. Bazille and Sisley received allowances from their families. Not so Renoir, who at thirteen had had to begin an apprenticeship as a porcelain painter. Later he had to paint fans and colour coats of arms for his brother Henri, and at eighteen he had worked in a shop decorating blinds. It was the free drawing-classes at a local school and some assiduous copying at the Louvre that got him a place at the Ecole des Beaux-Arts. Nor did Monet have an allowance. His private life and his debts had exhausted his family's patience.

Both the scrupulous, proud pauper Renoir and the indigent spendthrift Monet received house-room in Bazille's studio at 20 Rue Visconti, between the Art School and the Institute. All about twenty-six years old, they were painters in spite of rebuffs, constraints and pressures of all kinds. Solidarity was their whole strength as well as the pledge of their ambition.

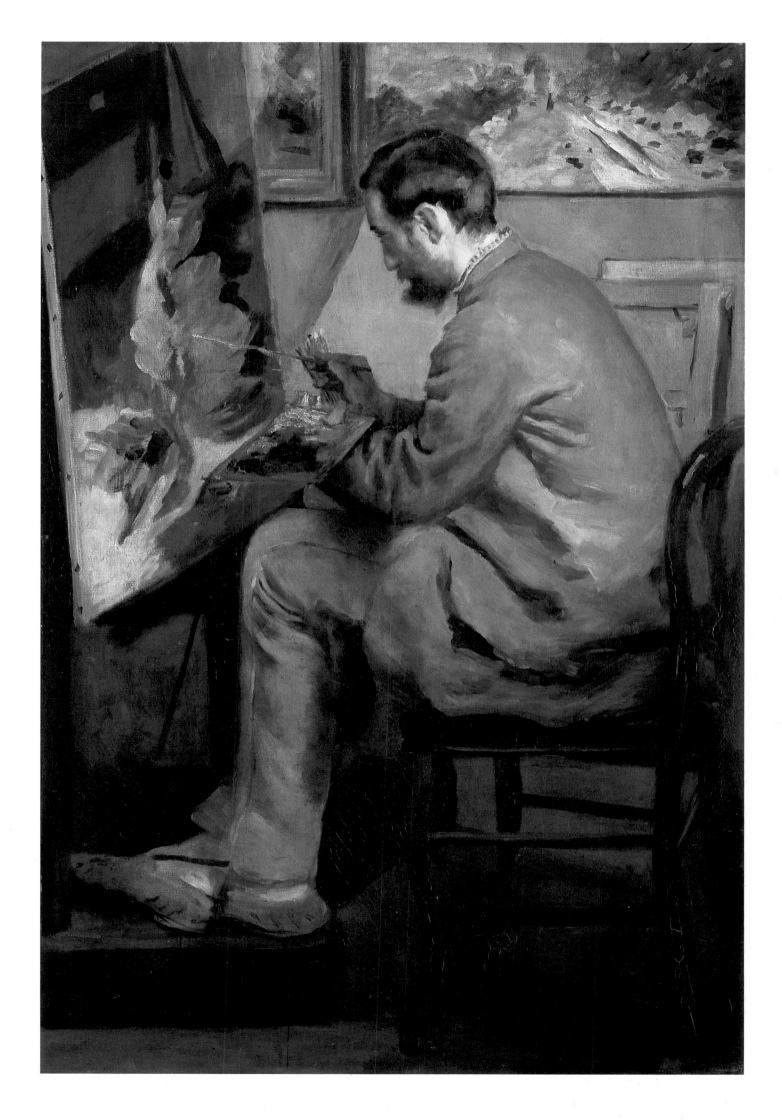

Renoir: Portrait of Bazille at his Easel, 1867.

I am said to be the priest of a new religion. And what religion is this? Is it the one whose gods are all the independent and personal talents? Yes, I belong to the religion of man's free self-expression. Yes, I don't bother about the thousand restrictions of science; I go straight to life and truth. Yes, I would give a thousand clever, middling works for one work, even bad, in which I believed I could detect a new and powerful accent.

Zola, "Mon Salon" in *L'Evénement*, Paris, 27 April-20 May 1866.

In 1863 Cézanne made the acquaintance of Renoir. One day the latter saw one of his friends, Bazille, come into his studio with two unknown men whom he presented to Renoir: "I'm bringing you two first-rate recruits!" They were Cézanne and Pissarro. About that same period Cézanne met Manet, to whom he was presented together with Zola, by Guillemet. Cézanne was struck at once by Manet's power of realization. "He spits out the colour!" exclaimed Cézanne. Then, thinking awhile, he added: "Yes, but what he lacks is harmony, and temperament as well."

Ambroise Vollard, *En écoutant Cézanne, Degas, Renoir*, Paris, 1938.

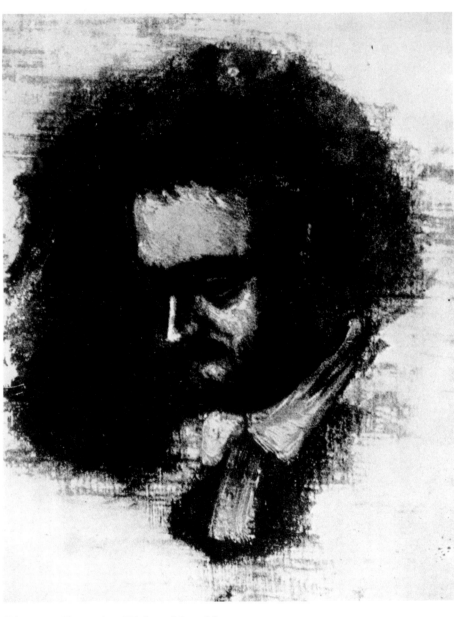

Cézanne: Portrait of Zola, 1861-1862.

Priest of a new religion

Zola
Cézanne
Pissarro

In April-May 1866 a series of seven articles by Emile Zola appeared in *L'Evénement* under the heading "My Salon." The first two questioned the make-up of the jury and its criteria of selection. In the third Zola set out his own aesthetics, which consisted in a single demand: that the artist should be himself, eschewing all schools, cliques or systems. The fourth article was devoted to Manet, whom Zola did not know. This was paradoxical in a series of reviews of the 1866 Salon, when the jury had rejected both Manet's submissions, the *Fifer* and the *Tragic Actor*. That his *Déjeuner sur l'Herbe* had caused a scandal at the Salon des Refusés in 1863 did not matter much; that whole exhibition had been a scandal. But in 1865 *Olympia* had caused another scandal at the Salon, and that was intolerable.

Pissarro is an unknown name, and no one will have anything to say about him... I, however, would like to shake his hand, before leaving. Thank you, sir, your landscape reposed me for a good half-hour during my journey through the great desert of the Salon. I know that you were only grudgingly admitted to the Salon, and I offer you my sincere congratulations. Moreover, you must know that you please no one, and that your picture is considered too bare, too dark. So why the devil are you such a duffer as to paint so soundly and study nature so frankly?

Come now, you choose a winter's day, and you have there no more than the end of a road, with a hill at the back, and empty fields up to the horizon. No treat for the eyes in this. Austere and earnest painting, with a pointed concern for truth and accuracy, and a strong and ruthless will. You are a great duffer, sir–you are an artist I like.

Zola, "Mon Salon" in *L'Evénement*, Paris, 27 April-20 May 1866.

Pissarro is not commonplace from inability to be picturesque. On the contrary, he employs his robust and exuberant talent to bring out the vulgar features of the contemporary world.

Jean Rousseau in *L'Univers Illustré*, Paris, 1866.

Pissarro: not finding his name in the previous Salon catalogues, I assume that he is a young newcomer. He seems to have a liking for Corot's manner. A good master, sir, but you must take care not to imitate him.

Jules Castagnary in *L'Artiste*, Paris, 1 September 1863.

Pissarro: On the Banks of the Marne, Winter, 1866.

The Salon must never again risk provoking such scenes. In his fifth article Zola hailed Monet's *Camille*, and in the next he expressed regret that Courbet, Millet and Théodore Rousseau should have toned down their peculiar asperity of expression. These uncompromising articles were not to the taste of readers of *L'Evénement*, and Zola was silenced. A final article acclaimed Corot, Daubigny and Pissarro. Zola's articles bracketed together, in 1866, painters whom he did not know or hardly knew and who did not know or hardly knew each other. What they had in common was that they had all been mocked or rejected for not painting in the way artists were supposed to paint, for daring to take the present as their model, and for daring, above all, to depict daylight and bright colours.

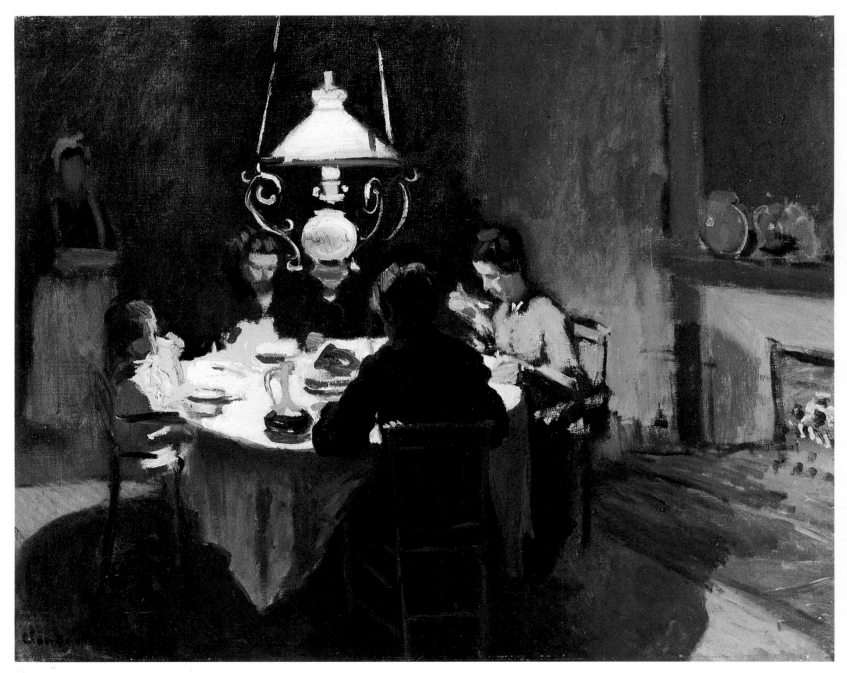

Monet: The Sisley Family at Dinner, c. 1869.

An uncommitted painter

Sisley
Monet

Sisley *père* did not oppose his son's becoming a painter. He was an exporter of artificial flowers, and the income these provided enabled Sisley to live without having to sell his paintings, like Bazille. He met Bazille, and Monet and Renoir as well, in Gleyre's studio. In 1863 they spent some time together at Chailly-en-Bière, in Fontainebleau Forest. Back in Paris, Sisley offered Renoir the hospitality of his Avenue de Neuilly studio, as Bazille was to take him in later. But Sisley did not paint much. Acceptance or rejection by the Salon in no way affected his lot and indeed left him indifferent. He seems to have had nothing to prove, not even to himself. When he signed a petition, it was one launched in 1863 to protest against a lowering of the age limit for the Prix de Rome from thirty to twenty-five.

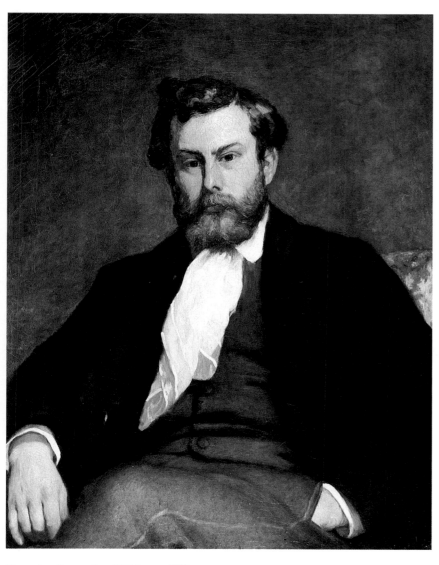

Renoir: Portrait of Sisley, 1868.

Renoir: At the Inn of Mother Anthony, 1866.

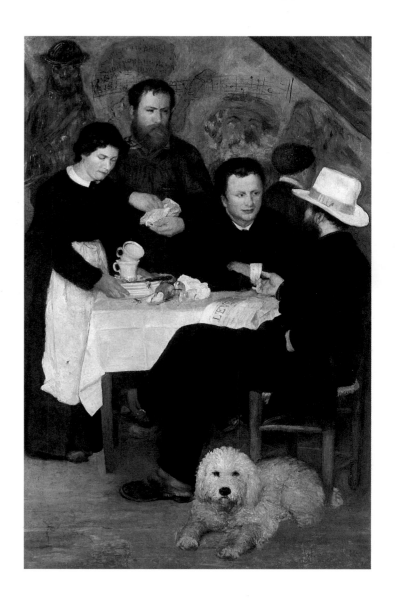

Nana is clearing the table. Mother Anthony herself is seen leaving the room. The back wall is covered with the doodles and caricatures left there by her art-student patrons. Renoir himself contributed a portrait of Henri Murger, author of *Scènes de la vie de bohème* (1848).

Lying on the white tablecloth is a copy of *L'Evénement*, the paper to which Zola contributed seven articles in April-May 1866 reviewing the Salon and praising Monet, Manet and Pissarro. This is what Sisley, wearing a hat and gesturing with his right hand, is talking about. Who is the man standing on the other side of the table, rolling a cigarette? Renoir himself? (In Bazille's portrait he is thinner in the face.) Monet, perhaps, who had come over to Marlotte from Chailly? (Carolus-Duran portrayed him less rough-looking.) Seated with his

Renoir:

The *Inn of Mother Anthony* is one of my pictures of which I have kept some pleasant memories. Not that I find this canvas particularly exciting, but it reminds me so much of the excellent Mother Anthony and her inn at Marlotte, the real village inn. I took as the subject of my study the main room, which also served as the dining room. The old woman with a kerchief tied over her head is Mother Anthony in person. The fine girl pouring out the drinks was the maidservant Nana. The white poodle is Toto, who had a wooden paw. I had a couple of my friends, Sisley and Le Cœur, pose for me around the table. As for the motifs making up the background of my picture, I took them over from the subjects actually painted on the wall, which had been done unpretentiously, but often quite successfully, by habitués of the place. I myself had drawn on it the figure of Murger, which I reproduced in my canvas, on the upper left.

<div align="right">

Ambroise Vollard, *En écoutant Cézanne,*
Degas, Renoir, Paris, 1938.

</div>

In 1866 Renoir painted at Marlotte one of the most important of his early works, the *Inn of Mother Anthony*, a public-house where artists used to meet.
Renoir had come to Fontainebleau Forest along with Claude Monet and Sisley, with whom he had become very friendly in Gleyre's studio.

<div align="right">

Théodore Duret, *Renoir*, Paris, 1924.

</div>

Bazille: Portrait of Sisley, 1867-1868.

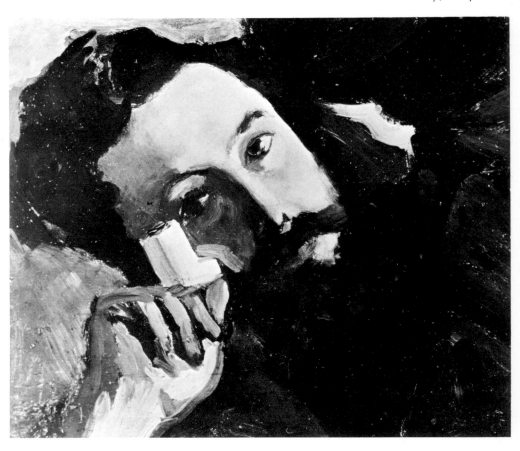

arms on the table is the painter Jules Le Cœur. The costumes—the standing man's smock, Sisley's spats—are those worn for thirty years past in the forest around Marlotte, so popular with painters. But the stir created by Zola's articles in *L'Evénement* shattered an atmosphere of scorn and insult and established a community that drew together the student generation and the artists whom Fantin-Latour had gathered round Delacroix two years earlier.

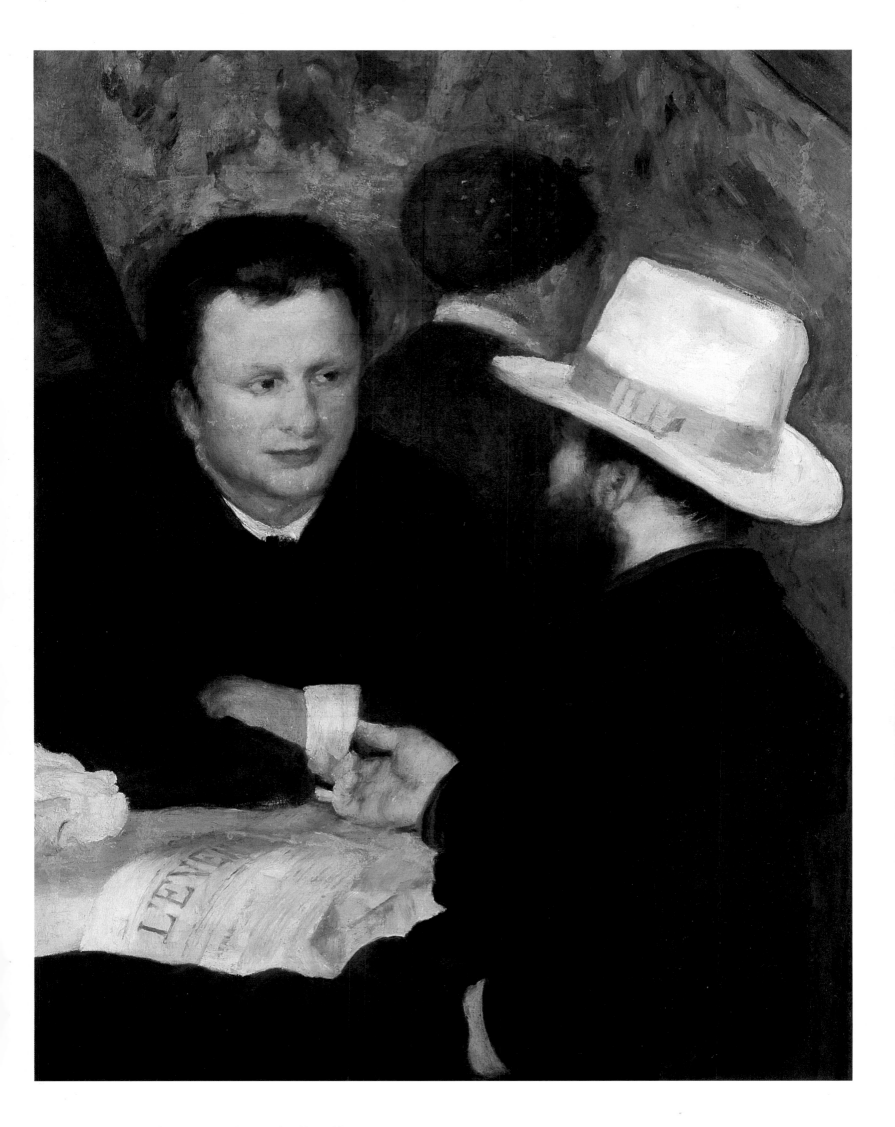

Renoir: At the Inn of Mother Anthony, detail, 1866.

Dallemagne: Portrait of Manet, c. 1865. Photograph.

The individual's one pair of eyes

A book often republished and well known to every artist and collector was Chompré's "Short Dictionary of Fable, for the understanding of poets, pictures and statues whose subjects are drawn from poetic story." It explained all allusions from A ("a letter regarded by the Greeks as ill-omened in their sacrifices") to Zymbraeus ("Thymbraeus or Tymbraes, an epithet of Apollo, originating from his cult at Thymbra, a town or rather a country district not far from the city of Troy"). Chompré in hand, the visitor saw the Salon as a library, and the canvases as representing pages, verses or stanzas. Not as pictures.

Count Nieuwerkerke, Superintendent of Fine Arts, watched over the Salon. Every year it drew large crowds. A high point of the Paris season, carefully chronicled and reviewed in the press for weeks, it was news and not to be missed. It alone ruled the art of painting. The jury kept out inadmissible pictures and set prices by the medals it awarded. When a painter was rejected, it meant that he was reduced to anonymity, to contempt, perhaps to poverty.

"Ladies and Gentlemen, we are going if you please to make a few visits together to this central market of painting, which is called, I don't know why, the Salon." The invitation was from Guy de Maupassant. The "central market of painting" was the Palace of Industry, a steel-and-glass structure at the lower end of the Champs-Elysées. Opened in 1857, it housed indifferently the Charolais cattle of an annual agricultural fair and the painted nymphs of the Salon. The nature of the architecture ruled out a fresh reconstruction of the Salon Carré in the Louvre, where the exhibition had been held until 1848, and from which it took its name. The vaulted steel roof of the Palace of Industry was ill-suited to the closing ceremony of the Salon, in which prizes, decorations and medals were awarded. There the ceremony seemed tawdry. So from 1864 it was held in the Louvre itself. Being awarded a medal or decoration there was like being recognized as worthy of the old masters permanently exhibited there. What more could a painter want? It was taken for granted that art was great only when governed by the principles of the Ecole des Beaux-Arts, and certified by a stay at the Académie de France in Rome, the Villa Medici, the ambition of every art student. (But how could the young painters know that Delacroix had written in his *Journal* on 4 June 1832: "Better to be sent as a cabin-boy to the Barbary Coast on the first ship that comes along than to go on wearing out this classical ground of Rome. Rome is no longer in Rome.") It was unthinkable to depart from the French tradition stretching back to David and Le Brun, the nobility of painting. The closing speeches at the Salon paraded that certitude and that fidelity. Nothing had changed; nothing must change.

In having a poem printed in the catalogue of the 1865 Salon, Manet was aping a ritual. Astruc's verses, however, failed to give sanction to *Olympia*. To the art lovers who passed through the Salon, she was too much of a contemporary, too much like a pornographic photograph of a recumbent prostitute. Verses or no verses, they could not see her as a Venus. At the Salon every painting had to be

capable of being recognized, narrated, named. She, in the strictest sense of the word, was unnamable; she was unspeakable, so by definition she was indecent. Two years earlier Manet's *Déjeuner sur l'Herbe* had been considered obscene. But it was not their "immorality" that made these two paintings intolerable, it was because they belonged to their own time. There was no subject but history. And history was conjugated in the past tense. Manet's *Déjeuner sur l'Herbe* was no more scandalous than Courbet's *Bathers* had been; the present was unacceptable. Realism, which painted in the present tense, was the first blow struck at Salon dogma, the first onslaught on the pre-eminence of the subject.

On what was then meant by "subject." Without a subject you could not have a painting. And the "grander" the subject the greater the painting, subjects being grand in proportion as they were old. The annals and epic poems of antiquity together with the Old and New Testaments headed the hierarchy of subjects. History, on the other hand, sometimes lacked the correct patina. Ingres was a purist: "Modern painters call themselves history painters. Their claim must be demolished. A history painter is one who presents heroic deeds, and such deeds are to be found exclusively in the history of the Greeks and Romans." But, *pace* the authoritative Ingres, the pretenders were eventually accommodated and history in the shape of the heroic and grandiose deeds of whatever period of the past became a fit subject for the history painter.

No one smiled at or scorned the periwigged figures painted by Meissonier. The nineteenth century, which invented Progress and the promise of a radiant future, needed the pledge of the past, of *all* the pasts, to justify its noble attitudes. Hence its inveterate eclecticism, borrowing from all periods and mixing them freely. Manet refused to cheat: "The truth is that we have no other duty but to extract from our own age what it offers us, without thereby ceasing to admire what previous ages have done. But to make a free-for-all, as the barkeepers say, is idiotic."

In the same way, landscape could not be a simple statement about nature. Jean-Baptiste Deperthes had laid down the rules in his *Théorie du Paysage*: the representation of nature must exclude everything that did not satisfy the criteria of a fine ideal, calculated to ennoble the soul. Although published in 1818, the Deperthes theory had yet to be discarded. Landscape was still very often "the traditional composite setting, the heroic parsley of the foliage, the monumental tree, either cedar or beech, three centuries old and inevitably sheltering some mythological felony or love affair" described by Jules and Edmond de Goncourt. The School of 1830 and the Barbizon painters began to alter its lighting, as Romanticism had altered its emotional content. "We are the sons of Rousseau, Chateaubriand, Lamartine and Musset," wrote Zola, noting that landscapists "have abandoned the classical landscape in order to invent a landscape as flowery as one could wish, almost as false as the other but suiting the new fashion and catering for our need for unspoilt nature. If they live out in the fields, if they sit down in front of a horizon to copy it, they contrive to spice their copies,

to titivate them, as it were, in order to launch them on the world to the best advantage."

Manet, Degas and Cézanne dropped the subjects that guaranteed medals at the Salon. Degas painted his *Spartan Boys and Girls Exercising* in 1860 and *Semiramis Building Babylon* in 1861. Of Manet's two Christs, the one with angels was done in 1864, the one being mocked by soldiers in 1865; after that, nothing more of this kind. Cézanne's *Judgment of Paris* of about 1883-1885 and the later *Leda and the Swan* (1890?) looked forward to the *Large Bathers* more than they looked back to mythology.

Year by year these painters rid themselves of any hierarchy of genres, as they had rid themselves of the subject. Manet painted a bunch of asparagus as he painted the *Execution of the Emperor Maximilian*. Their landscapes, still lifes and portraits were simply paintings: they did not need to meet the criteria of the codified genres of landscape, still life, and portraiture (which is not to say that they failed to do so). A flood by Sisley is a painting in the same way as a woman in the tub by Degas; the one is not a landscape, the other is not a genre scene.

Nothing of what they painted bore any relation to the sublime as tradition sought it and claimed to invoke it with time-honoured rituals. Their paintings did not look beyond themselves; they ceased to be icons of a particular morality, a particular civilization, and became pictorial realities. The Salon that thrust them aside offered illustrations, representations. They offered it paintings. Dialogue was impossible. The nudes the Salon was looking for must first and foremost be academy figures robed in morality. The nudes Manet exhibited (*Déjeuner sur l'Herbe*, which he referred to as "the foursome," and *Olympia*, a prostitute) were sensuality, sexuality. "When I've painted a buttock," Renoir said, "and I feel like smacking it, that means it's finished!" Sensuality was now something positive.

Cézanne made Vollard sit as still as an apple for hours on end, and he painted his portrait as he painted portraits of apples. Monet's series, the haystacks in 1890, Rouen Cathedral in 1892-1893, were neither haystacks nor a cathedral. The titles of the Rouen Cathedral series made this clear: "blue harmony," "morning effect, white harmony," "morning sun, blue harmony," "full sunlight, harmony of blue and gold." The colours were given *equal billing*. (When these men began to paint, painting had laid down a text—the subject. Straw and stone, haystacks and cathedrals, were objects, pretexts.)

Painting a subject meant painting a story, conjugating a tense. The Impressionists painted the moment, with the verb in the infinitive. Painting a subject meant painting an exceptional event. An exception does not allow of a series. Each moment of a series addresses the eye; a subject addresses the imagination. With the Impressionists, the record of the exceptional changes. The subject assigns it to a caste, that of culture. The art of the subject is the art of a society. Removal of the subject requires the individual, with one pair of eyes.

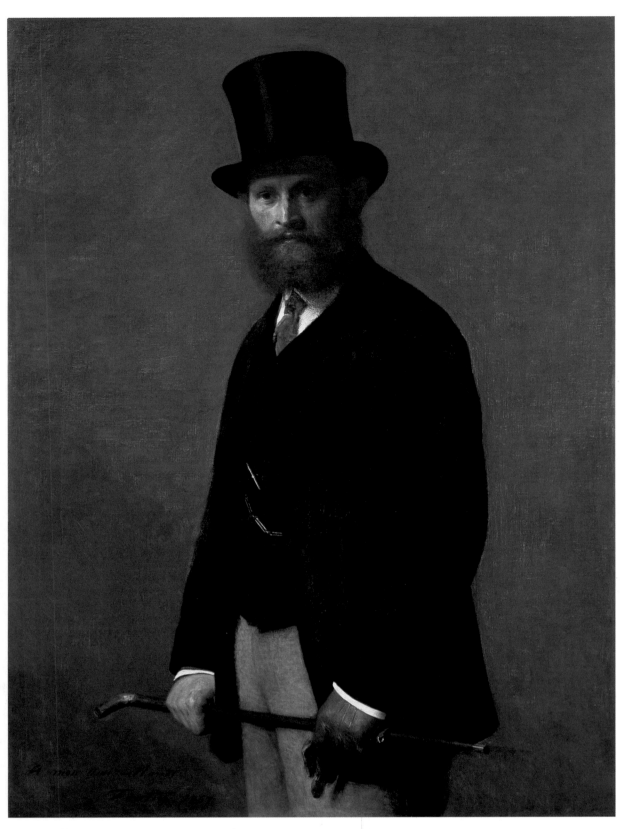

Fantin-Latour: Portrait of Manet, 1867.

The
excluded
master
Fantin-Latour
Manet
Degas

None who knew Manet can look at this picture without sorrow. It is more than a likeness, it is in the nature of an apparition.

George Moore, *Impressions and Opinions*, London, 1891.

Manet posed for *Homage to Delacroix*, shown at the 1864 Salon. It provoked controversy and sarcastic comment. By what right did the realists, who had turned their backs on their alleged master, see themselves as the heirs of Delacroix? A caricature by Gill changed the title to "Myself and Delacroix, surrounded by my friends." Was Fantin-Latour laying claim to the leadership of the modern school? In fact the scandals repeatedly provoked by Manet's pic-

Degas: Portrait of Manet and his Wife
(cut down by Manet), c. 1865.

– But, Monsieur Degas, wasn't it Manet himself who cut down the portrait you did of him and his wife?

The painter, sharply:

– By what right, sir, do you presume to judge Manet? Yes, it's true. And, after all, maybe he was right to do so. I was the fool in that business, for at the time I got angry and took down from my wall a small still life that Manet had given me: "Sir, I wrote to him, I send you back your *Plums*." Ah, what a pretty canvas that was! And I did a fine thing that day. For when I was reconciled with Manet I asked him to give me back "my" *Plums*, and well, do you know, he had sold them!

Ambroise Vollard, *Souvenirs d'un marchand de tableaux*, Paris, 1948.

tures made him pre-eminent. Insults, disparagements and calumnies placed Manet alone at the head of the modern school. In 1866 he was rejected by the Salon. In 1867 he was kept out of the World's Fair exhibition. He was like a pariah, but undaunted. Fantin, admiring his nerve and equanimity, offered to paint his portrait. Manet agreed to sit and the portrait was shown at the 1867 Salon. The dedication, "To my friend Manet," was pure defiance.

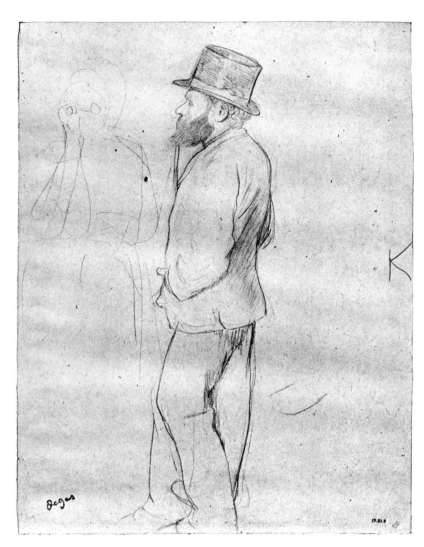

Degas: Study for the Portrait of Manet, c. 1864. Pencil.

An iconoclast

Degas
Manet

"Degas was painting Semiramis when I was painting Modern Paris," says Manet. "Manet is in despair because he cannot paint atrocious pictures like Carolus-Duran, and be fêted and decorated; he is an artist, not by inclination, but by force. He is as a galley slave chained to the oar," says Degas.

George Moore, *Confessions of a Young Man*, London, 1886.

No art is less spontaneous than mine. What I do is the result of thought and the study of the great masters: of inspiration, spontaneity, temperament, I know nothing.

Degas quoted by George Moore, *Impressions and Opinions*, London, 1891.

Renoir on Manet and Degas:
They were very close. They admired each other as artists and liked each other as chums. Manet assumed the manner of a jaunty frequenter of the boulevards, but behind it Degas found the principled man of breeding that he was himself. But, as in all great friendships, they were continually at loggerheads and continually making it up...
Degas found in Manet the middle-class Parisian that he was himself. But in Manet there was another element, by no means the least curious: a strain of prankishness, which impelled him to pull the wool over your eyes...
Degas had in common with Manet this love of practical joking. I have seen him get endless fun, like a schoolboy, from blowing up some artist's reputation, which of course a week later was completely deflated.

Ambroise Vollard, *En écoutant Cézanne, Degas, Renoir*, Paris, 1938.

A Manet cannot be read. Neither *Déjeuner sur l'Herbe* nor *Olympia* tells a story. What visitors to the Salon des Refusés in 1863 and to the Salon in 1865 thought they could decipher was obscene. So it had to be hushed up. What is indecipherable and hushed up belongs to silence. Manet's silence was unacceptable. The Salon, trying to be no different from a museum, required pictures that told a story. A painting was a subject, which it then "rendered." Manet *rendered* nothing. Doing away with the subject meant doing away with lifelikeness, for a painting that told no story had no need to simulate. For some years now photography had been providing lifelikeness. Painters were aware of this, and afraid of it. At a time when photographs were aping painting, recycling the painter's studio props and putting models in the "heroic" poses of academic art, Manet dismissed such references, iconoclastically sweeping aside a kind of painting that was concerned with images.

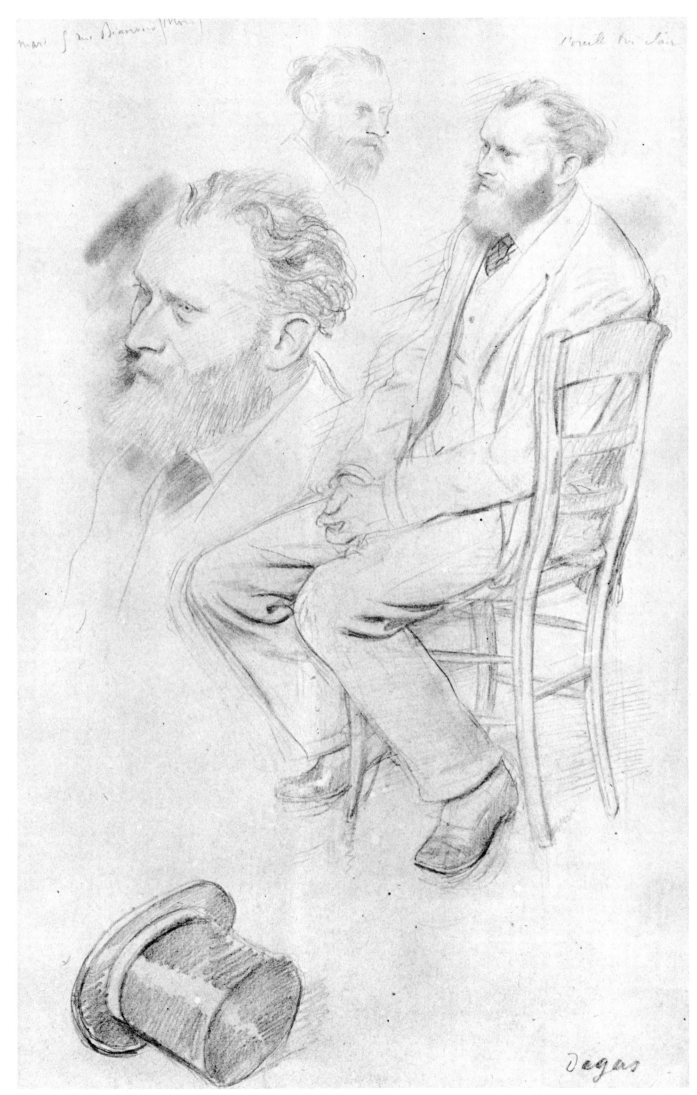

Degas: Portrait of Manet, 1864-1865. Pencil.

One of my friends asked me yesterday if I would speak about this picture, which is my portrait. "Why not?" I said. "I'd like to have ten columns in the paper to say out loud what I thought to myself, during the sittings, when I saw Edouard Manet fighting step by step with nature. Do you think my pride so shallow as to take any pleasure in talking to people about my face? Well, yes, I will speak about this picture, and the wags who may find something to make fun of here will simply prove themselves fools."

I remember the long hours of sitting. In the numbness that comes over one's motionless limbs, and the eyestrain of looking into bright light, the same thoughts kept floating up within me, with a soft, deep plash. The foolishness that runs through the streets, the lies of some and platitudes of others, all that human noise which flows on pointlessly like dirty water was far away. I seemed to be outside the world, in an air of truth and justice, full of scornful pity for the poor devils floundering about down here.

Now and then, in the somnolence of the pose, I looked at the artist standing before his canvas, his face tense, his eye bright, intent on his work. He had forgotten about me, he no longer knew I was there, he was copying me as he would have copied any human beast, with an attention, an artistic awareness that I have never seen elsewhere. And then I thought of the dishevelled dauber of legend, of the fanciful Manet of the caricaturists, who set him painting cats by way of a joke. The wit of man, it must be confessed, is often exceedingly stupid. I thought for hours of this destiny of individual artists, which makes them live apart, in the solitude of their talent. Around me, on the studio walls, hung those powerful and distinctive canvases which the public failed to understand. It is enough to be different from others, to think in your own way, for you to become a monster. You are accused of mistreating your art and flouting common sense, precisely because the skill of your eye and urgings of your temperament lead you to unusual results. As soon as you fail to keep to the broad current of mediocrity, the fools hurl abuse at you and accuse you of madness or pride.

While turning over these ideas I saw the canvas fill up. What surprised me most was the extreme scrupulousness of the artist. Often, when he was dealing with a secondary detail, I

A meeting of minds
Zola
Manet

wanted to quit the pose and injudiciously advised him to invent.

"No," he answered. "I can do nothing without nature. I don't know how to invent. So long as I tried to paint from set lessons, I produced nothing of any value. If I am worth anything today, I owe it to exact interpretation and faithful analysis."

Therein lies his whole talent. Before all else he is a naturalist. His eye sees and renders objects with an elegant simplicity. I know that I can't make blind people like his painting. But true artists will understand me when I speak of the faintly acrid charm of his works.

The portrait he has exhibited this year is one of his best canvases. The colouring is very intense and has a powerful harmony. Yet this is the work of a man accused of not knowing how to paint or draw. I defy any other portraitist to set a figure in an interior, with equal energy, without allowing the surrounding still lifes to detract from the head.

This portrait is an aggregate of difficulties overcome. From the frames in the background and the charming Japanese screen on the left, down to the least details of the figure, everything holds together in a skilful, clear and brilliant colour scheme, so real that the eye overlooks the crowding of objects and simply sees a harmonious whole.

I do not speak of the still lifes, the accessories and books lying on the table: here Edouard Manet is a past master. But I particularly recommend the hand placed on the figure's knee: it is a marvel of execution. Here, finally, is skin, true skin, without any ridiculous trompe-l'œil. If the entire portrait could have been brought to the point where this hand stands, the crowd itself would have hailed it as a masterpiece.

Zola, "Mon Salon" in *L'Evénement Illustré*, Paris, 2 May-16 June 1868.

After getting acquainted at the Café de Bade in May 1866, Manet and Zola saw a lot of each other, either at Manet's studio or at the Café Guerbois, the new meeting place of the modern school. Manet offered to illustrate Zola's stories *Contes à Ninon*, but Lacroix, the publisher, vetoed the project. On 1 January 1867 Zola's second article on Manet appeared in the *Revue du XIX^e Siècle*. Manet thanked him next day and told him of his decision: debarred from the World's Fair due to open in the spring, he would hold a one-man show on his own. Comprising forty canvases, it opened on 24 May 1867 in a shed set up on the corner of Avenue de l'Alma and Avenue Montaigne. Zola revised his article and

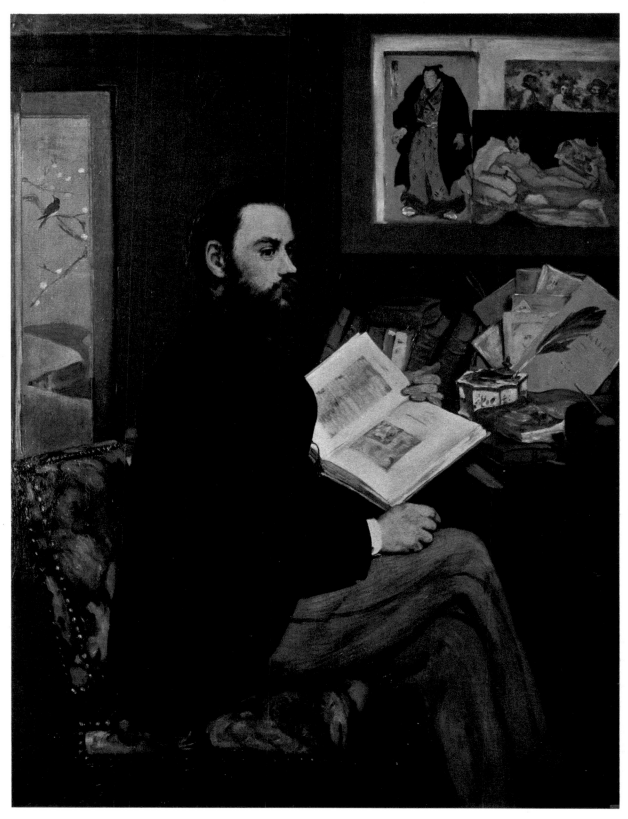

Manet: Portrait of Zola, 1868.

published it in booklet form as "Edouard Manet, A Biographical and Critical Study." Its blue cover can be seen behind the inkstand and quill in Manet's *Portrait of Zola*, done in February 1868, its title serving as signature. Above it is a reproduction of *Olympia*: photograph or engraving? The coloured print is Japanese, as is the screen behind Zola. For a decade or more Japan had been a point of reference for every modern-minded artist. Manet's friend Bracquemond had been an apostle of Japanese art ever since discovering a volume of Hokusai prints in 1856. The books and pictures with which Manet has surrounded Zola form a portrait of a meeting of minds and a sharing of interests.

Berthe Morisot, before 1869. Photograph.

Later, rejoining Manet, I blamed him for his conduct. He replied that I might expect every devotion from him, but that he would never take the risk of playing the part of nursemaid.

Berthe Morisot, letter to her sister Edma, Paris, 2 May 1869.

Poor Manet is out of sorts. As always, his exhibition is not much liked by the public, but for him this is always fresh matter for surprise. Yet he told me that I brought him good luck and that he had a purchaser inquiring about *The Balcony*. May it be so for his sake, but I fear that his hopes are going to be dashed once more.

Berthe Morisot, letter to her sister Edma, Paris, 23 May 1869.

Ah, when you need to relax your nerves, how delightful it is to contemplate his *Balcony* with its beaming family of blue-grey or rather slate-grey dolls, lolling there like Angora cats of pure Parisian blood! After a good hearty laugh, any honest man endowed with common sense asks himself this question: What had the selection committee been eating when they permitted the wall to be decorated with such a thing as this? They must have been eating hashish, and hashish of the first quality which makes you see even more than stars at noonday.

Baron de Viel-Castel in *Le Pays*, Paris, 25 May 1869.

You can understand that one of my first concerns was to go to Room M. There I found Manet, shading his head with a hat, with a bewildered look. He begged me to go and see his painting because he dared not approach it. Never have I seen such expressive features. He was laughing, and yet anxious, assuring me both that his picture was very bad and that it would be a great success. His is decidedly a charming nature, one that I like very much. His paintings as always produce the effect of a wild or slightly unripe fruit. They are far from displeasing me, but what I like best is the portrait of Zola... In *The Balcony* I look strange rather than ugly. Some of the onlookers are said to have applied to it the term *femme fatale*...

Whenever I pass in front of *The Balcony with Green Shutters*, my face brightens up and I become hilarious.

Louis Leroy in *Le Charivari*, Paris, 6 May 1869.

I have not the honour of knowing Monsieur Manet. He is said to be a charming man, and what is more, a wit. Add to this natural gift an undeniable painter's temperament, and then ask yourself how, with all that, an artist arrives at this uncouth art, one in which, in the green shutters of *The Balcony*, he debases himself to the level of a house painter. It is really exasperating!

Albert Wolff in *Le Figaro*, Paris, 20 May 1869.

Antoine Guillemet, seen smoking a cigarette, had also been rejected by the Salon, in 1866 and 1867. He was the first to show Manet a painting by Cézanne, whom he had met at the Académie Suisse and with whom he painted at Aix in the autumn of 1866, as he painted with Bazille at Honfleur in 1867. Berthe Morisot, leaning on the railing, had been introduced to Manet by Fantin-Latour at the Louvre, where she was copying Rubens. Standing beside her is Fanny Claus, a violinist who played duets with Suzanne Manet, a pianist. Her fiancé, Pierre Prins, frequented a fencing school with Manet and painted with Sisley. The long sittings that Manet demanded of his models used to exhaust

The balcony
Manet
Berthe Morisot

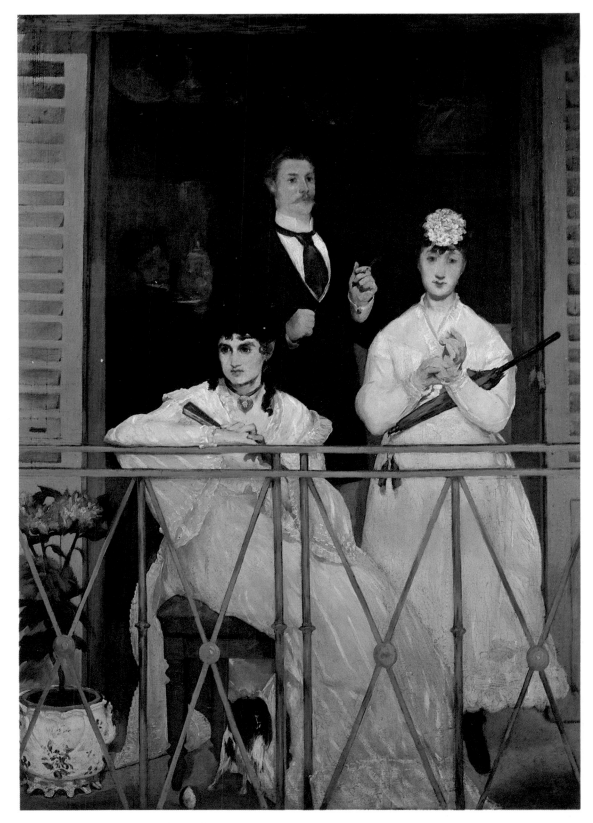

Manet: The Balcony, 1868-1869.

them. The three figures appear indifferent to one another's presence. They are not even looking in the same direction. Neither the potted plant on the balcony nor the dog with its ball nor the young man carrying a jug through the dark room beyond constitutes a story. There is an allusion to Goya. But Goya's *Women on a Balcony* are quietly commenting on what they see; here there is only the balcony. Because it could not be "read," either as a genre scene or an allegory or even an anecdote, *The Balcony* confused and exasperated people. It broke all the rules. It had no subject. It was a painting and nothing else, and as such it was unacceptable.

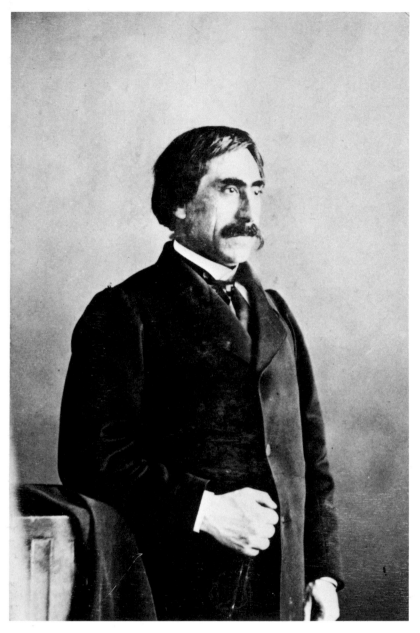

Nadar: Portrait of Théophile Silvestre, 1865. Photograph.

In this same studio in the Rue Guyot, he also painted my portrait in 1868. I thus had an opportunity of seeing in action the propensities and habits that guided him in his work. The small portrait was to represent the original standing, his left hand in his waistcoat pocket, his right leaning on a cane. The grey suit stands against a grey background. The whole picture, then, was in the greys. But when he had painted what I considered to be a well-finished picture, I saw that Manet was not satisfied with it. He was intent on adding something to it. One day when I came in, he made me take the pose as before, and beside me placed a stool which he set to painting; it was covered with a garnet-red material. Then he had the idea of taking a paperbound volume which he threw on the stool and painted in its light green colour. Again, on top of the stool, he placed a lacquered tray, with a decanter, glass and knife. All these objects added up to a still life of varied tones in one corner of the picture, which he had by no means intended at first and which I had never reckoned on. But afterwards he added a still more unexpected object, a lemon on the glass of the little tray.

I had watched him with surprise making these successive additions when, wondering what might be the reason behind them, I understood that I had in action, before me, his instinctive and as it were organic manner of seeing and feeling. Evidently the picture all in grey monochrome was not to his liking. It lacked the colours that might content his eye, and not having put them in at first, he added them afterwards, in the form of a still life.

Théodore Duret, *Histoire d'Edouard Manet et de son Œuvre*, Paris, 1902.

Exceptions

Rare were the journalists and critics who, like Astruc, Silvestre or Duret, sided with these painters who confused, annoyed and astonished people. What distinguished them concerned something more than painting. They were heretics, mutineers, undermining a code that extended beyond the Salon. The Salon was first of all a museum, and the museum was a temple and an order. It was not what they owed to the School of 1830 or the Barbizon masters or the Realists that people held against them, for those men had done little but alter the subject of their painting. The crucial difference was that these young painters were doing away with painting's subordination to genres. In painting a portrait like a landscape or a still life they were breaking with their traditional repertoire, subordinating every object to painting in the same way. They were standing every principle on its head. The only people who accepted them, the only people who *could* accept them, were those over whom readers had no right of inspection —the ritual kind of inspection that simply verifies its own certainties.

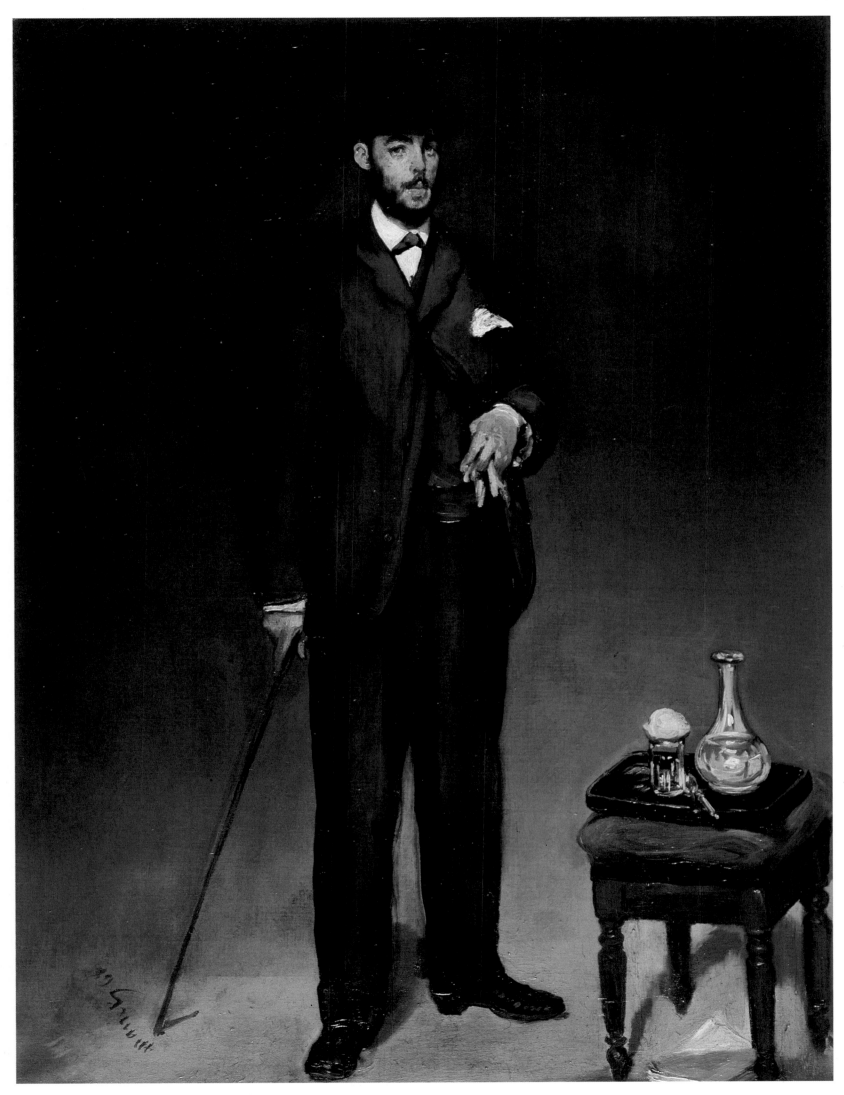

Manet: Portrait of Théodore Duret, 1868.

Monet is one of the few painters who know how to paint water, without silly transparency, without deceptive reflections. With him, water is alive and deep. It is true water. It laps around the boats with little greenish billows, slashed with white gleams. It spreads out in greenish pools, which a breath of air sets rippling. It lengthens the masts which it reflects by breaking their image. It has dull and lurid tints, lit up by sharp brightnesses. It is not the artificial water, crystalline and pure, of seascape painters who work at home.

Zola, "Mon Salon" in *L'Evénement Illustré*, Paris, 2 May-16 June 1868.

It's harder than you think, and I'll bet that you would not split much wood. No, you see, advice is very difficult to give, and I don't think it would serve any purpose, if I may say so without offence. All the same, I have probably not reached the end of my troubles. Here is winter at hand, a season not

In the floating café, there was a bustling, shouting throng of people. The wooden tables, where the overflowing drinks ran in thin sticky streams, were strewn with half-empty glasses and surrounded by half-tipsy people. The whole crowd was calling out, singing, brawling. The men, with hats thrust back and red faces, with the glowing eyes of drunkards, were moving about restlessly and yelling out, from a natural need of brute beasts to make noise. The women, seeking a prey for the evening, were scrounging drinks in the meanwhile. And in the free space between the tables, there were the ordinary frequenters of the place, a battalion of rowdy canoers with their girl friends in short flannel skirts.

The place reeks of stupidity, vulgarity and shabby flirting. Males and females are on a par. Over it floats an odour of love-making, and these people flare up and fight for a trifle, to keep up their worm-eaten reputations which sword thrusts and pistol bullets only bring down lower.

A common theme

Monet
Renoir

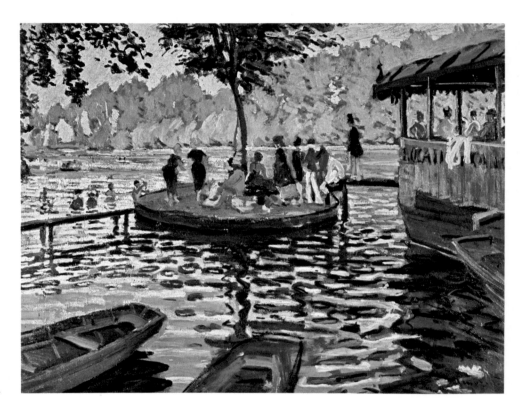

Monet: La Grenouillère, 1869.

very pleasant for the wretched. Then comes the Salon. Alas! I still won't be in it, for I shall have done nothing. I do have a dream, a picture of the bathing spot at the Grenouillère, for which I've made a few poor sketches, but it is a dream. Renoir, who has just spent two months here, also wants to do this picture.

Monet, letter to Bazille, 25 September 1869.

The island is nipped off right at the Grenouillère, and on the other side of it, where a ferry runs, continually bringing in people from Croissy, the rapid arm of the river, full of swirls, eddies and foam, rolls along like a torrent. A detachment of pontoneers, in the uniform of artillerymen, is camped on that bank, and the soldiers, sitting in a row on a long rafter, were watching the water flow by.

Some people who live in the neighbourhood drop in on Sunday, out of curiosity. A few young fellows, very young and callow, appear there every year, to learn the ropes. Trippers and strollers show up. A few simpletons wander in.

The place is aptly called the Grenouillère, the frog pond.

Guy de Maupassant, "La Femme de Paul" in *La Maison Tellier*, Paris, 1881.

The day was enjoyed, along with the fatigue, the speed, the free and vibrant open air, the reflection of the water, the sun beating on one's head, the mirroring flame of all that dazes and dazzles in these outings on the water, that almost animal intoxication of being alive produced by a great steaming river, blinded by light and fine weather.

A laziness, at times, came over the canoe which surrendered to the flow of the current. And slowly, like those screens in

which pictures turn round under children's fingers, the two banks went by, the greenery hollowed out by shadows, the little woods edged with a strip of grass trodden down by Sunday strollers; the boats with vivid colours drowned in trembling water, the shimmering made by moored yawls, the glittering river-banks, the water's edge animated by laundry women's boats, by loads of sand, by carts with white horses. Over the hillsides the fine day dropped soft veils of velvety blue in the hollow of shadows and the green of trees. The Mont-Valérien was lost in a haze of sunlight, and a noonday glow seemed to give something of Sorrento to Bas-Meudon. Little islands with green-shuttered red houses rolled out their orchards full of gleaming laundry. White villas shone on the heights and the long ascending garden of Bellevue.

In the tavern arbours on the towing-path, daylight played over the tablecloths, the glasses, the gaiety of summer frocks. Painted signposts, pointing the way to the cold baths, glowed with light on little strips of sand. And in the water smiling and shivering children moved about, small, frail, graceful bodies, casting before them on the rippling water a flesh-coloured reflection.

Often in little grassy creeks, cool places under the willows, in the thick waterside meadow, the crew relaxed. The troop of them scattered, to escape the sultry heat in one of those unbuttoned siestas, stretched out on the grass, at full length under the shading branches, showing no more of human fellowship now than one side of a straw hat, a patch of a red jersey, or the frill of a petticoat, just what might float up from a shipwreck on the Seine. Then came the awakening, the hour when in the paling sky the gilt and distant white of Paris houses began to shine in a rising glow of light. And then came dinner time, the great canoers' dinner.

Edmond and Jules de Goncourt, *Manette Salomon*, Paris, 1867.

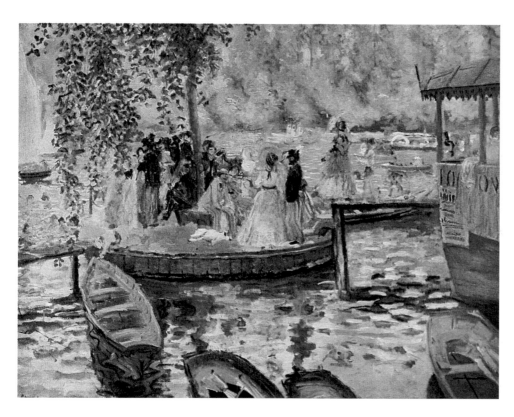

Renoir: La Grenouillère, 1869.

The Grenouillère ("frog pond"), an island in the Seine just west of Paris, was the fashionable place to go. There a very mixed bag of artists, aristocrats and demimondaines mingled with boating parties and middle-class pleasure-seekers on a day out from their summer residences in nearby Croissy or Bougival or Chatou. A visit by Napoleon III and Empress Eugénie in July 1869 sealed the island's reputation, and Maupassant wrote about it. When Monet and Renoir began to paint the Grenouillère they were in the same plight: they were not doing much painting for the simple reason that they could not afford colours and canvas. Yet, in spite of poverty, debt and a diet of stale bread, they did paint, easels placed side by side on the riverbank. They had to: painting came first.

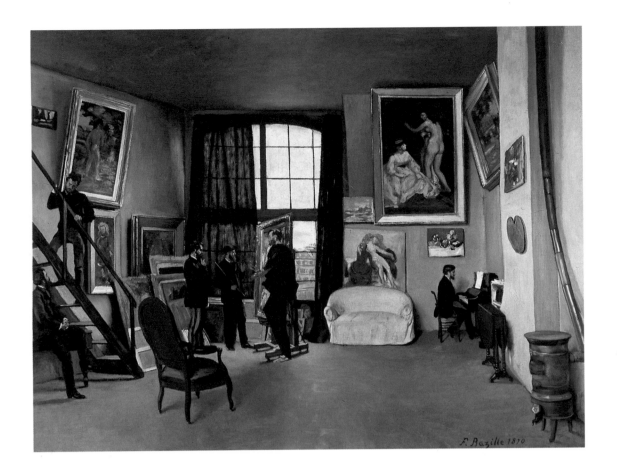

Bazille: Studio in the Rue de la
Condamine, entire and detail, 1870.

I've been amusing myself up to now by painting a picture of my studio with my friends in it. My own figure has been painted in by Manet... This picture has retarded the one that I mean to do for the Salon, *La Toilette*, but I'm tackling it now and it won't take long to do.

> Frédéric Bazille, letter to his parents, Paris, c. 1870.

It was a theory of his that young open-air painters should rent the studios unwanted by academic painters, those studios that the sun visited with the living flame of its rays.

> Zola, *L'Œuvre*, Paris, 1886.

It may well be that the pictures of Courbet, Manet, Monet and their like contain beauties which escape the notice of such old romantic heads as ours, already streaked with silver threads.

> Théophile Gautier in *Le Moniteur Universel*, Paris, 11 May 1868.

He dreamed of a studio. He aspired to it with the yearnings of a schoolboy and the appetites of his nature. What he saw in it were those horizons of Bohemia which delighted him from a distance: the romance of hardship, the casting off of ties and rules, freedom and indiscipline, the unbuttoned side of life, chance, adventure, unexpectedness every day, escape from the tidy, regulated home, headlong flight from family and Sunday boredom, all the voluptuous mystery of the female model, the work that gave no trouble, the right to wear fancy dress all year round, a sort of never-ending carnival. Those were the images and temptations suggested to him by the stern and exacting career of art.

> Edmond and Jules de Goncourt, *Manette Salomon*,
> Paris, 1867.

Edmond Maître is playing the piano. Zola on the stairs is talking with Renoir. Another conversation is going on in front of the canvas that Bazille is showing to Manet (with the maulstick) and Monet. In this studio at 9 Rue de la Condamine, where Manet painted Bazille's portrait, everything was shared. Bazille's hospitality was the saving of both Monet and Renoir. The paintings hung on the walls or stacked against them are by one or another of them. Beside the tall window is a big Renoir canvas, rejected by the 1866 Salon because it was indecent in the way that Courbet's *Bathers*, shown at the 1853 Salon, were indecent. "Quoting" a rejected Renoir was tantamount to cocking a snook at the jury's verdict. And to make the painting in which he did so, Bazille re-used the rough sketch of another Renoir, a *Diana the Huntress* that, the subject and title notwithstanding, the jury also rejected in 1867. On top of a sketch by Renoir, Bazille painted the studio where Manet painted his portrait.

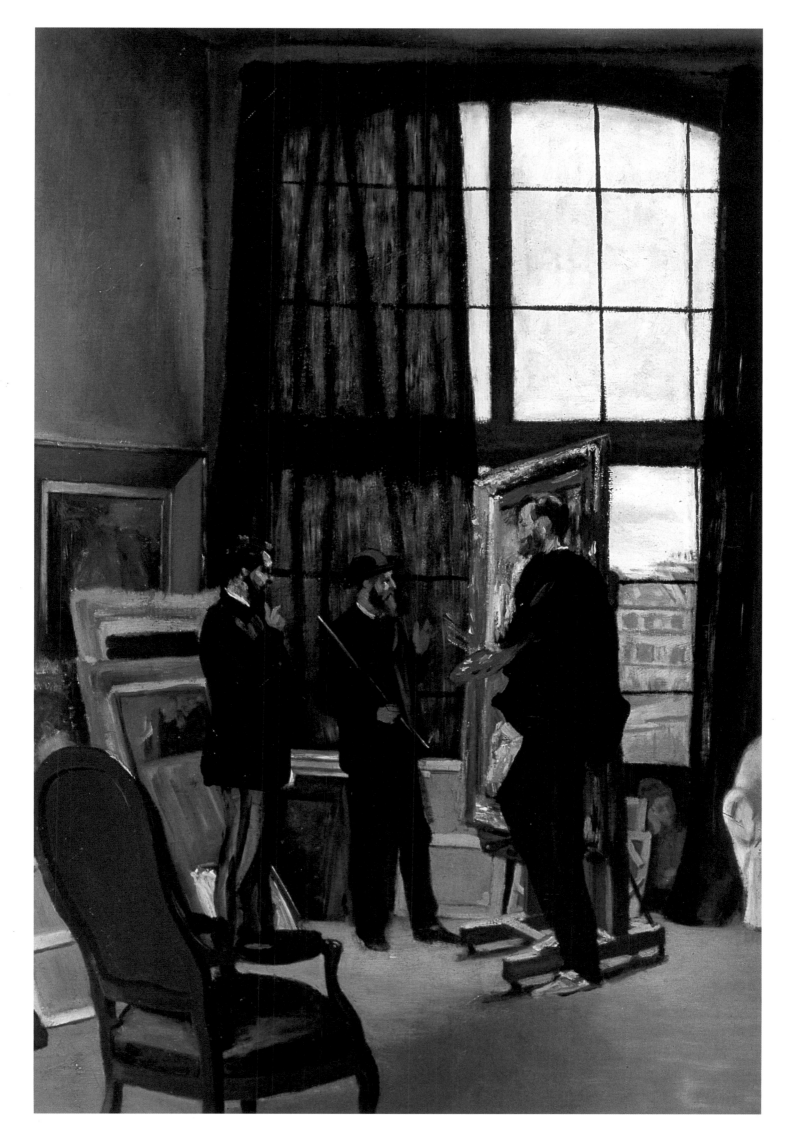

The Salon of 1870 included a large picture exhibited by Fantin-Latour under the title *A Batignolles Studio*. It was one of those arrangements, such as he had already painted, like his *Homage to Delacroix*, bringing together men linked by common tastes. His *Batignolles Studio*, then, represented Manet sitting at an easel, painting, and grouped around him, the artists and writers who had felt his influence or had become his defenders. They were: Emile Zola, Claude Monet, Renoir, Bazille, Zacharie Astruc, Maître and Scholderer. The picture attracted particular attention. It was painted in a prevailing grey note and in that strain of realism which, arising then as something new, would have sufficed to make it noticed. Further, he brought before the public the image of those rebels who intrigued it, and the public was pleased to meet them at last. It was vaguely known, from statements in the press, that in a certain café in the Batignolles quarter of Paris a group of men had gathered round Manet. The public fancied that at such gatherings strange things indeed were being said and prepared. And to Parisians of the lower town Batignolles seemed a place well suited to such a club, for to live in or visit that part of Paris struck them as an outlandish idea and matter for joking. Fantin's picture coming just then, and showing Manet and his group in a Batignolles studio, provided public

and journalists with the qualifying term they had been waiting for, one that answered exactly to their ideas. So it was that at that time and for some years to come Manet and his friends were designated as the Batignolles School.

There never was a Batignolles School...

It would also be a mistake to conclude from Fantin's picture that Manet's friends were in the habit of foregathering in his studio, in the manner represented. This was an artistic licence, simply a means of showing them all together: such a grouping never existed except on canvas. Manet did have his studio in the Batignolles quarter, but it was not a meeting place. It was located in a rather run-down house in the Rue Guyot, a side street behind the Parc Monceau. The house, which no longer stands, was surrounded by building sites and warehouses of all kinds, with courtyards and large empty spaces. This part of Paris, then thinly populated, has since changed entirely.

The studio consisted of one large room, almost ramshackle. Only finished pictures were to be seen there, stacked up against the wall, with or without frames. As Manet had not yet sold more than one or two canvases, his entire output was there accumulated.

Théodore Duret, *Histoire d'Edouard Manet et de son Œuvre*, Paris, 1902.

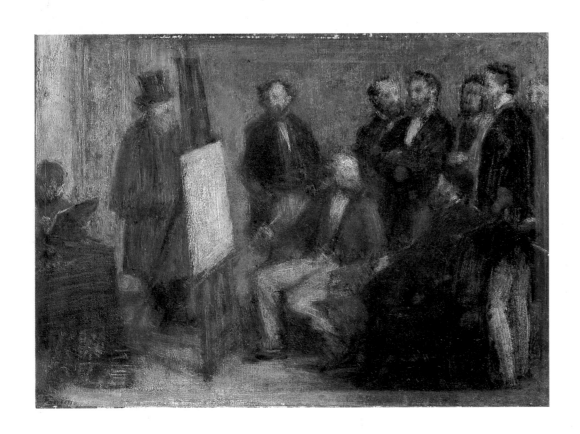

Fantin-Latour:
◁ Study for A Studio in the Batignolles Quarter, 1869.
▷ A Studio in the Batignolles Quarter, 1870.

Six of the models from Bazille's Rue de la Condamine studio are here too: Monet on the extreme right, Bazille himself, hands clasped behind his back, Maître, Zola, Renoir, wearing a hat, and Manet, seated at the easel. Behind Manet, a little apart from the others, is the painter Otto Scholderer, an admirer of Courbet whom Fantin-Latour had introduced to Manet two years before this. The last figure is Zacharie Astruc, book in hand, sitting for his portrait as he had sat in 1862 for *Concert in the Tuileries*. Fantin's group portrait was accepted for the 1870 Salon. Fantin did not paint his own portrait in the *Studio in the Batignolles*

The individual and the group

Fantin-Latour
Manet
Zola
Bazille...

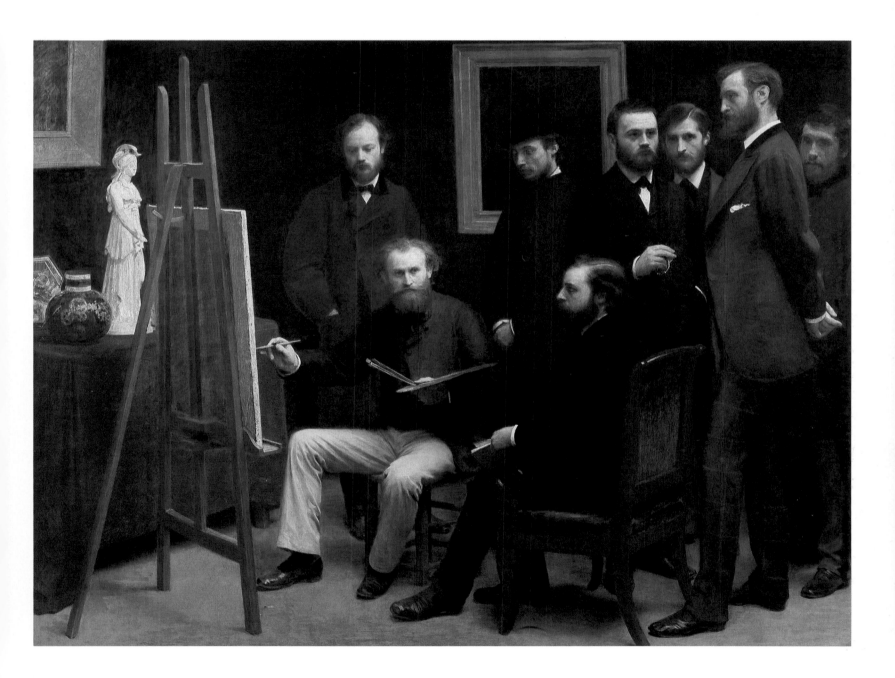

Quarter, but he did include, standing on the red tablecloth, a glazed vase and a plaster statuette. Neither was a mere prop; they both made a deliberate statement, one about the painter, the other about the painted. The decoration on the vase alluded to the Japanese prints that were a source of fascination to all those present here. The plaster figure of Minerva concerned Fantin alone and stood for the ideal of Greek truth and purity that he held in reverence. Minerva was the personification of reason, a reason that curbed, restrained and put aside temptation and excess. That was Fantin's base.

Manet: Portrait of Berthe Morisot, 1874. Watercolour.

Manet reads me a lecture and sets up that everlasting Miss Gonzalès before me as a model: she has a good manner, she is persevering, she knows how to carry a thing through, whereas I am simply capable of nothing. Meanwhile he is starting anew on her portrait for the twenty-fifth time. She sits every day and evening, and her head is washed with soft soap. Such is the encouragement he gives to people to sit for him.

Berthe Morisot, letter to her sister Edma,
13 August 1869.

We spent Thursday evening together at Manet's. He was bubbling over with high spirits and said a lot of foolish things, each funnier than the other. For now, all his admiration is concentrated on Miss Gonzalès but he still can't get on with his portrait of her. He tells me he has reached the fortieth sitting and the head has been painted out again. He is the first to laugh over it...

The Manets came to see us on Tuesday evening and we visited my studio. To my great surprise and pleasure, I came in for the greatest praise. My work now is said to be decidedly better than Eva Gonzalès. Manet is too frank for there to be any mistake about it, and I'm sure he did like it very much. Only I remember what Fantin says: "Manet always takes to the painting of people he likes." Then he tells me to finish and I confess that I don't understand what more I can do... How excessive he is in everything! After saying so many disagreeable things to me, he now foretells a success for me at the next exhibition.

Berthe Morisot, letter to her sister Edma, 1869.

I cannot say that Manet has spoiled his picture, for I saw them in his studio just before the exhibition and I was delighted with them. I don't know why it is, but the portrait of Miss Gonzalès has a faded effect. The presence of the painting next to it, though a wretched one, makes it lose enormously. There are some finenesses of tone and delicacies which had charmed me in the studio and which disappear in broad daylight. The head still remains feeble and not at all pretty.

Berthe Morisot, letter to her sister Edma, 1870.

Of the two pictures exhibited annually by Manet, there was always one that more especially attracted the eye, one in front of which the crowd gathered, and this year it was the *Portrait of Mlle E.V.* (Eva Gonzalès). In Miss Gonzalès Manet has painted the only pupil he ever really had and more or less completely trained...

Manet depicted Eva Gonzalès lifesize, sitting in front of an easel, painting a bouquet of flowers and wearing a white dress. The background was in light grey, and on the floor lay a sky-blue rug. The picture was thus executed in full light, and the various colours in it were, as always, juxtaposed without transition and with no attenuation of half-tones. It was this arrangement that offended; visitors declared it to be brutal and shrill. Accustomed for many years to the opaque shadows which painters extended over their canvases, the public had really had to acquire the eyes of a night bird to dislike this portrait of Eva Gonzalès.

Théodore Duret, *Histoire d'Edouard Manet et de son Œuvre*, Paris, 1902.

Those female saints in the desert or delivered up to the executioner were not more courageous than the young lady who allowed Monsieur Manet to portray her in full length with so dingy a dress. And far from expressing her horror, she laughs at the torture; she smiles in the midst of her squalor as if at the centre of an apotheosis.

Laurent Pichat in *Le Réveil*, Paris, 1870.

A flat and abominable caricature in oils.

Albert Wolff in *Le Figaro*, Paris, 13 May 1870.

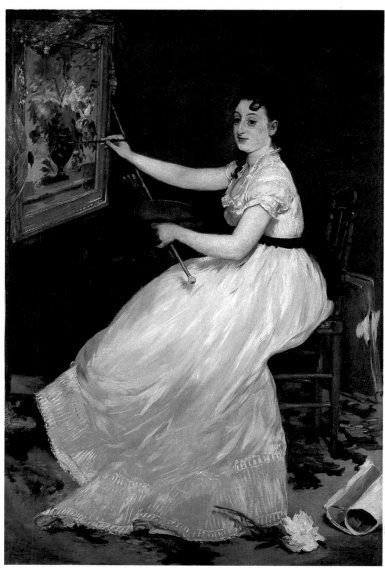

Manet: Portrait of Eva Gonzalès, 1870.

To be a painter under thirty, to reject the stifling do's and don't's of academicism, and to seek to paint moments of light was to invite certain contempt. To be under thirty, a painter and, with the same non-conformist aspiration, a woman was to be doubly exposed to scornful condescension. (The only creative activity to which women could aspire was having children. That, and nothing else, was their duty. The men's suits worn by George Sand and Rosa Bonheur were seen as proof of their depravity.) Berthe Morisot, twenty-eight, and Eva Gonzalès, twenty, two beautiful young women, sat as models for Manet. Such was a woman's place, a woman's role. But they also, as Manet's pupils, themselves aspired to be painters. To win acceptance they had to beat the double handicap of the way in which they had chosen to paint and the fact that they were women; initially their pictures were commented on in the same terms as needlework, with much talk of their "daintiness" and "charm."

Interference

Berthe Morisot
Manet

I agree with you: the Morisot girls are charming. What a nuisance it is that they aren't men. However, even as women, they might serve the cause of painting by each marrying an academician and sowing discord in the camp of those old fogeys. But that is asking of them a great deal of self-sacrifice. Meanwhile, present my compliments to them.

Manet, letter to Fantin-Latour,
Boulogne-sur-Mer, 26 August 1868.

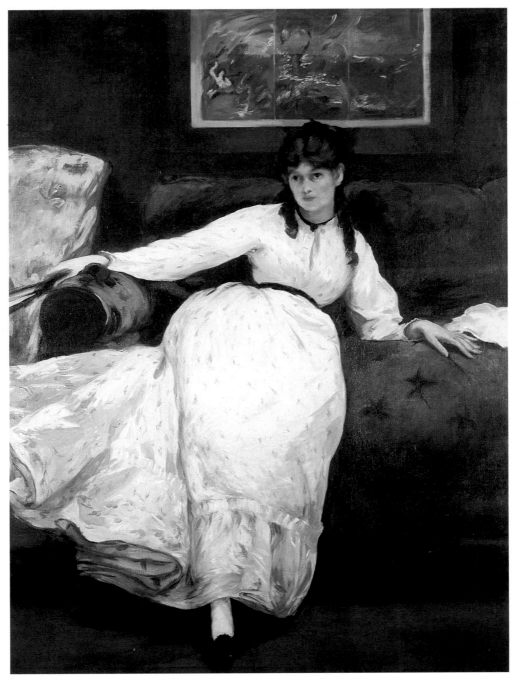

Manet: Repose (Portrait of Berthe Morisot), 1870.

In Bazille's picture of his Rue de la Condamine studio, Manet is painting the portrait of Bazille. Degas painted a portrait of Manet sitting on a couch behind his wife at the piano. Not liking the portrait of her, Manet cut it off. A matter of hours before the deadline for delivering her picture to the Palace of Industry, for the Salon, Berthe Morisot showed Manet the double portrait of her mother and sister that she intended to submit for the Salon. He proceeded to add accents to one of the dresses, then reworked the whole painting. (Berthe Morisot was

Manet asked me how I was getting on, and seeing me hesitate he said with spirit: "I'll drop in tomorrow and have a look at your picture... I'll tell you what needs to be done."

The next day, which was yesterday, he comes in about one o'clock and finds it very good, except for the lower part of the dress. He takes the brushes and adds a few accents which look very nice; mother is in raptures. And that is the beginning of my troubles. Once in train, nothing can stop him. He goes from the petticoat to the bodice, from the bodice to the head, from the head to the background. He keeps on cracking jokes, laughs like a mad child, hands me the palette and takes it back again. By five o'clock we had produced the prettiest caricature that ever was seen... Mother finds the adventure funny; I find it a sorry business.

Berthe Morisot, letter to her sister Edma, winter, 1869-1870.

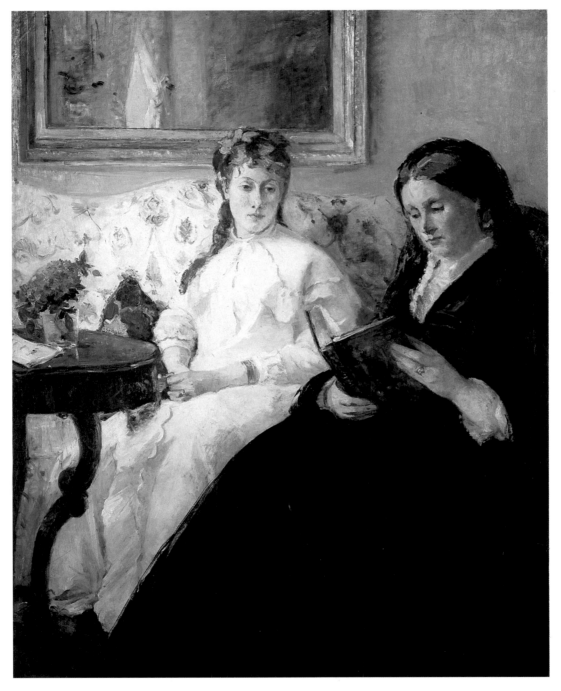

Berthe Morisot: Portrait of the Artist's Mother and her Sister Edma, 1869-1870.

shattered. Degas, furious, retrieved his amputated canvas. Bazille kept the *Studio* in which Manet had emphasized his unusual height.)

Manet treated other painters' pictures like his own, reworking them, touching them up or truncating them. These instances of radical interference: are they pointers to what probably went on in the studios of these painters who, individually and collectively, were looking for a different kind of painting? The work of one was in a sense the work of all.

On a par
Berthe Morisot

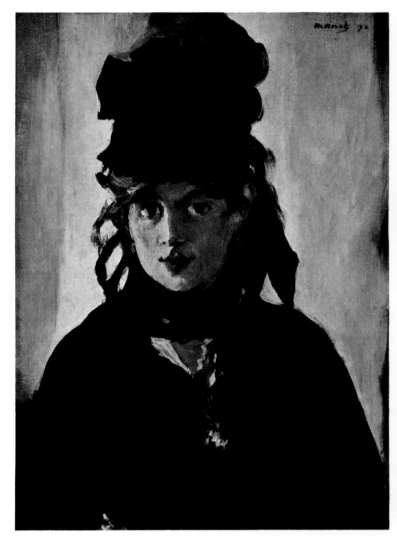

Manet: Berthe Morisot with a Bunch of Violets, 1872.

I did not go to Manet's on Thursday evening... The previous Thursday he was so kind to me, so good as to find me once again not so ugly after all and he would like to have me back to sit for him. Out of boredom I shall end up by proposing it to him myself.

Berthe Morisot, letter to her sister Edma, 1871.

Renoir:
As regards Madame Morisot herself, what a curious thing is destiny! Such a painter, with so pronounced a temperament, was born into the most austerely "bourgeois" circle that ever existed and at a time when a child who wanted to become a painter was not far from being regarded as the dishonour of the family! And what an anomaly it is too, to see such a painter appear in our age of realism, a painter so steeped in the grace and finesse of the eighteenth century; in a word, the last elegant and "feminine" artist that we have had since Fragonard, not to mention that "virginal" quality which Madame Morisot had in so high a degree in all her painting.

Ambroise Vollard, *En écoutant Cézanne, Degas, Renoir*, Paris, 1938.

Renoir:
One day when Mallarmé was reading one of his poems to her, Berthe Morisot said:
– Look here, Mallarmé, what about writing just once as if it were for your cook?
– But, he answered, I would write no differently for my cook!

Ambroise Vollard, *Auguste Renoir*, Paris, 1920.

Berthe Morisot was more than just Manet's model and pupil. During the years when they worked side by side it was she who initiated Manet into a new brightness of colour and the shorter, comma-like brushstroke used by Monet and Renoir. And as the only woman among the painters of the new school she neither was nor wished to be anyone's rival and would not let any of her paintings resemble those of Manet. It was around her—as Madame Eugène Manet, for on 2 December 1874 she married Edouard's younger brother—and her alone that in after years, beyond all the estrangements, misunderstandings and rivalries, Renoir, Degas, Monet, Mallarmé and the rest were reunited.

Manet: Bunch of Violets and Fan, 1872.

Stéphane Mallarmé, Méry Laurent and Manet (sitting), 1872. Photograph.

My dear fellow, my one friend. I have just now received your letter. You are crazy, out of your mind, and I embrace you with my whole heart. May God watch over you and my poor brother! Yours ever, Ed. Maître.

P.S. Why not consult a friend? You have no right to enlist like that. Renoir has just come in and I hand the pen to him. Ed. Go to blazes, you dear damned fool! Renoir.

P.P.S. Love to Cassagnac (Paul de).

<div style="text-align: right">Edmond Maître, letter to Bazille, 1870.</div>

What terrible events and how are we going to get to the end of them? Everyone puts the blame on his neighbour and, in short, we have all been accomplices in what has happened.

<div style="text-align: right">Manet, letter to Berthe Morisot,
Paris, 10 June 1871.</div>

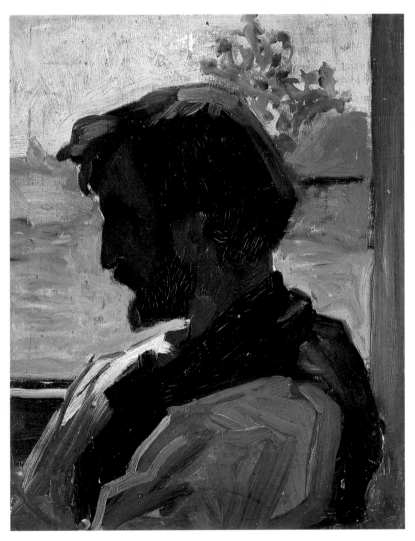

Bazille: Self-Portrait at Saint-Sauveur, 1868.

Berthe Morisot to her sister Edma:

The Prussian cruelties rack my nerves and I have a great desire to keep calm.

I am dazed by the silence... Paris is much changed since you left. I think back to that day on the 4th of September, and it no longer seems to me the same city.

<div style="text-align: right">Sunday, 18 September 1870.</div>

Would you believe that I'm getting used to the noise of the cannon? I seem now to be absolutely hardened and able to bear anything.

<div style="text-align: right">Sunday, 25 September 1870.</div>

If you knew how sad this poor Paris is! and how sad everything is.

I have come out of this siege absolutely disgusted with my fellow humans, even with my greatest friends. Selfishness, indifference, narrow-mindedness, that is what you meet with from almost everyone.

<div style="text-align: right">Thursday, 9 February 1871.</div>

You are quite right, my dear Edma, to suppose that we shall be spared nothing. The Prussians are to enter the city on Wednesday and our neighbourhood in particular has been designated as due to be occupied by them.

You know that all our acquaintances have come out of this war without a scratch, except for poor Bazille, killed at Orléans, I believe. The brilliant painter Regnault was killed at Buzenval.

The others have made a great to-do about very little. Manet spent the time of the siege changing his uniform.

<div style="text-align: right">Monday, 27 February 1871.</div>

Now and then one meets people who have come from Paris. Their accounts are very contradictory: now the population is starving to death, now the city is perfectly quiet. What is certain is that everyone is fleeing, which goes to show that life there is not pleasant.

<div style="text-align: right">Late March 1871.</div>

On 8 May 1870 a plebiscite confirmed the Empire. Maurice Richard, Minister of Fine Arts in the liberal Emile Ollivier cabinet, awarded Courbet the Legion of Honour. In a stinging reply dated 23 June 1870 Courbet denied the state any competence in matters of art and declined the supposed "honour"; fifty years old and a free man determined to live out his life in freedom, he brushed aside a title that in his eyes was a mere adjunct of the monarchical order. On 19 July the Empire declared war on Germany. On 2 September Napoleon III and his army surrendered at Sedan. On 4 September the Republic was proclaimed at

Manet: Portrait of Courbet, 1878. Pen and ink.

Renoir:
I saw a lot of Courbet. He was one of the most astonishing fellows I ever came across. I remember in particular one detail about his exhibition in 1867. He had had a sort of closet built from which he could keep an eye on his exhibition. When the first visitors arrived, he was getting dressed. To miss nothing of the enthusiasm which the public was bound to feel, he went down in a flannel waistcoat, without pausing to slip on the shirt which he was still holding in his hand. And Courbet himself, gazing at his own pictures: "How fine they are! They look magnificent! So fine that it's really stupid!"
And he kept repeating: "Yes, it's really stupid!"
It was he again who said, at an exhibition where his work had been hung near the door: "How foolish, nobody will want to go any further!"
His admiration was of course reserved for his own painting. One day he wanted to pay a compliment to his friend Claude Monet: "Oh, it's pretty bad, what you're sending into the Salon. But just think how it will annoy them!"

Ambroise Vollard, *En écoutant Cézanne, Degas, Renoir*, Paris, 1938.

History

Bazille
Courbet
Manet

Manet: Civil War, 1871-1873. Lithograph.

the Hôtel de Ville in Paris. On 19 September Paris was besieged. On 27 October Metz fell. On 28 November Bazille was killed in action. On 28 January 1871 the armistice was signed. On 12 February the National Assembly met in Bordeaux. On 17 February Thiers became head of the government. On 18 March Paris proclaimed the Commune. On 21 May began *"la semaine sanglante"* during which it was bloodily suppressed.
War, exile and civil war notwithstanding, Manet, Monet, Pissarro and Renoir went on painting.

Manet: The Barricade, 1871. Lithograph.

The Franco-Prussian War and the Commune

Less than seven weeks into the Franco-Prussian War the Second Empire fell and the Republic was proclaimed. "Let's hope it lasts," sighed Bazille. It was a hope shared by all these painters. Meanwhile the war went on, a pattern of defeat, retreat and flight. In the besieged city of Paris Courbet headed the committee of artists set up on 6 September 1870 by the Government of National Defence. The committee asked for permission to dismantle the "Colonne de la Grande Armée," the great monument to Napoleon I in the Place Vendôme. The board of munitions of the sixth *arrondissement* then suggested that the bronze of the column be used to cast much-needed cannon. The great symbol of the Bonapartes, who had twice stifled national independence and political freedoms, should now, they said, serve France. Courbet's committee rejected the suggestion; the dismantled column was to be placed in the main courtyard of the Hôtel des Invalides. A violent controversy flared in the press, with the result that no one touched the column during the siege of Paris.

Bazille, though under no constraint to do so (his parents having paid for a substitute for him), joined the Zouaves. His regiment left Besançon as part of General Bourbaki's attempt to break the Prussian stranglehold on Paris. On 28 November, at the battle of Beaune-la-Rolande, Bazille fell. In December Manet, whose family had taken refuge in the Pyrenees, joined the general staff in Paris. He was a National Guard lieutenant, with Meissonier as his colonel. (Degas was a gunner in the same National Guard.) Like Tissot, Manet drew the defences of Paris from a captive balloon. He made an engraving of the balloon flight in which Gambetta left Paris, and he painted the *Railway Station at Sceaux* and *Petit Montrouge*. Meanwhile Renoir, who had been called up into the Chasseurs after refusing a posting to General Trochu's staff, was recovering from dysentery in Bordeaux. Cézanne was in hiding. He too, like Bazille and Monet, had had a substitute bought for him by his parents under the Empire, but the Republic had called up all those with exemptions. Cézanne, who was in love, deserted, as did Monet, who reached London in December 1870. There he joined Pissarro, who had recently arrived with his family. Driven out of Louveciennes by the advancing German army, he had initially sought refuge with his friend Piette. Pissarro's large family and Danish nationality ruled out his fighting for the Republic. Sisley, a British subject, stayed in Louveciennes at first with his sick father. At the armistice Manet rejoined his family. Berthe Morisot remained in Paris, as did Fantin-Latour, who was ill.

Hunger and cold racked the besieged Parisians. "Paris is anything but quiet... Paris does not want the Republic stolen from it, and it wants a proper one, a Republic of wealth-sharing and social upheaval," wrote Berthe Morisot. Under the Commune Courbet continued the struggle, having told the Germans: "Here we're eating anything: horses unfit for service, donkeys, and I don't know what else. We'll end up eating our rats, cats and mice. But we'll hold out, even if it means turning cannibal. Go away, please go away, you who are so fond of boots and who now, I'm sure, have no shoes. Go away! And God bless you!" On 30 April 1871 Courbet wrote to his parents: "Here I am, thanks to the people of Paris, thrown into politics up to my neck. President of the Federation of Artists, a member of the Commune, a municipal-authority delegate, a Public Education delegate: the four most important jobs in Paris... Paris is a real paradise: no police, no nonsense, no exactions of any kind, no disputes. Paris is running itself, like clockwork. That's the way it should be allowed to stay." Adolphe Thiers disagreed. So did Renoir, who had returned to Paris to paint. "I hated that whole clique," he wrote (referring to the Commune). "But when I got a close look at the Versaillais [the official government forces] I could not help thinking they were as stupid as the others." One day Renoir, who found he could not paint where he wished to without being harassed, recognized a face among the portraits of the principal figures of the Commune displayed in a window in the Odéon district. It was that of Raoul Rigault. Two years before, under the Empire, Rigault had been on the run from the police and Renoir had saved him by passing him off as a painter in Mother Anthony's inn at Marlotte. Now Rigault was himself prefect of police. "The very next day I called at police headquarters and asked for Mr. Rigault, sure that when they heard my name they'd start dancing attendance on me. Imagine my stupefaction when I was told they did not know what I was talking about. When I insisted, someone butted in with: 'What is this "Mister" business? We only know a Citizen Rigault!' The word 'citizen' might have replaced 'mister,' but the administrative formalities were unchanged: no one could be seen who had not asked for an appointment. I wrote a simple message on a scrap of paper: 'Do you remember Marlotte?' Moments later 'Citizen' Rigault was striding towards me with both arms outstretched, and the first thing he said was: 'Let's hear the *Marseillaise* in honour of Citizen Renoir.' I explained to the prefect of police that I was keen

to complete my study of the Feuillants terrace and also to be allowed to go where I wished in Paris and the suburbs. It goes without saying that I came away with a fully authorized pass... I was thus left in peace for as long as the Commune lasted." Did he see the Vendôme Column come down on 16 May? "Suddenly, around 5 o'clock, a creaking sound was heard. The giant wavered, bent, broke in three, and collapsed in a whirling cloud of white dust, while the statue of the Imperator came crashing down on the rubble of the barricade and the head rolled into the gutter. Immediately the bands struck up as red flags flew above the pedestal." On 21 May 1871 the "week of blood" began. On 7 June Courbet was arrested.

Pissarro returned to France. "A certain amount of my stuff has been saved; it doesn't look like much, judging by my paintings; ... forty or so, and I had between twelve and fifteen hundred, paintings, studies, sketches, the work of twenty years of my life. I think that if one kind of property is sacred, it's the kind that is the product of our own minds, made with our own hands, yet I believe the Versailles people have no intention of doing anything for those who have suffered losses of this sort. I have only one bed left, which is broken, no mattress, no bolster, no crockery, kitchen utensils, etc., nor any of those little things that go to make up a household, my scrapbooks, my books, the tools of the painter's trade. In short, I can see three or four big pieces of furniture in various states of disrepair that have been salvaged, which is sad."

Order was restored. The painting recommenced. But without Courbet, who in 1872 was condemned and imprisoned, a broken man. (Years later, in 1887, Pissarro wrote: "The *Figaro* has just published two letters by the great Millet that throw a most peculiar light on that great artist and reveal a very petty side to that man of talent. It's disheartening. I haven't yet read the letters, but Signac has given me the gist of them. They convey the great Millet's indignant protest against the [men of the] Commune, whom he refers to as savages and vandals, ending with a mighty swipe at the excellent Courbet, who to my mind comes out of it a greater man.")

Realism was dead. But the Republic went in dread of anarchy and would tolerate nothing that smacked of it. Perhaps soon, despite everything, there might be some sales? Monet and Pissarro had met a fellow refugee in London, the dealer Durand-Ruel.

Some twenty years later:
The curious thing about this Cézanne exhibition at Vollard's is the kinship one finds in some of his Auvers and Pontoise landscapes with my own. After all, we were always together. But what is certain is that each of us kept the one thing that matters, his own "sensation." That would be easy to demonstrate.

Pissarro, letter to his son Lucien,
Paris, 22 November 1895.

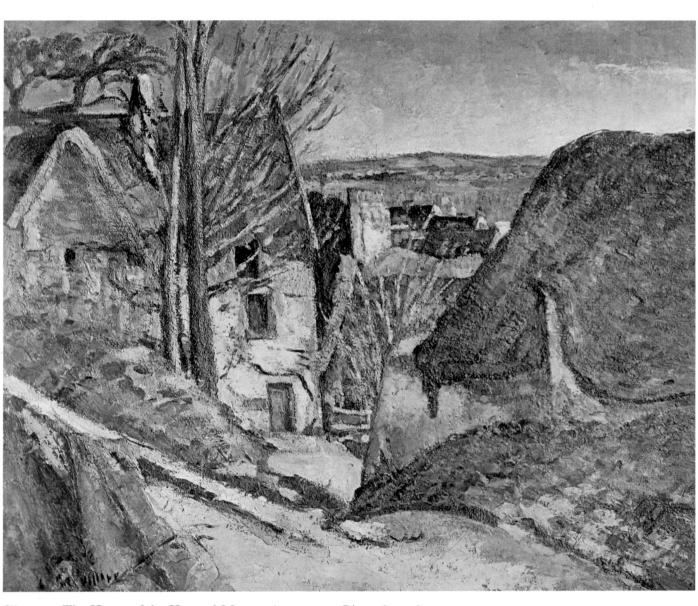

Cézanne: The House of the Hanged Man at Auvers-sur-Oise, 1872-1873.

Pissarro painted with Cézanne, who came to stay with him after the war, as he had painted with Monet in London and as Monet and Renoir had painted the Grenouillère side by side. Cézanne and Pissarro had respected each other ever since their first meeting at the Académie Suisse ten years earlier. They shared the same uncompromising rigour, the same stern determination. The exchange between them took place at various levels. In London, with its washed-out light of mists and fogs, Pissarro had seen and studied Constable and Turner. But Turner's shadows were still holes. In his native Provence, where the light falls vertically, Cézanne had never painted outdoors; nor had he done so during the years spent in Paris. Pissarro took him out and sat him in front of the "motif."

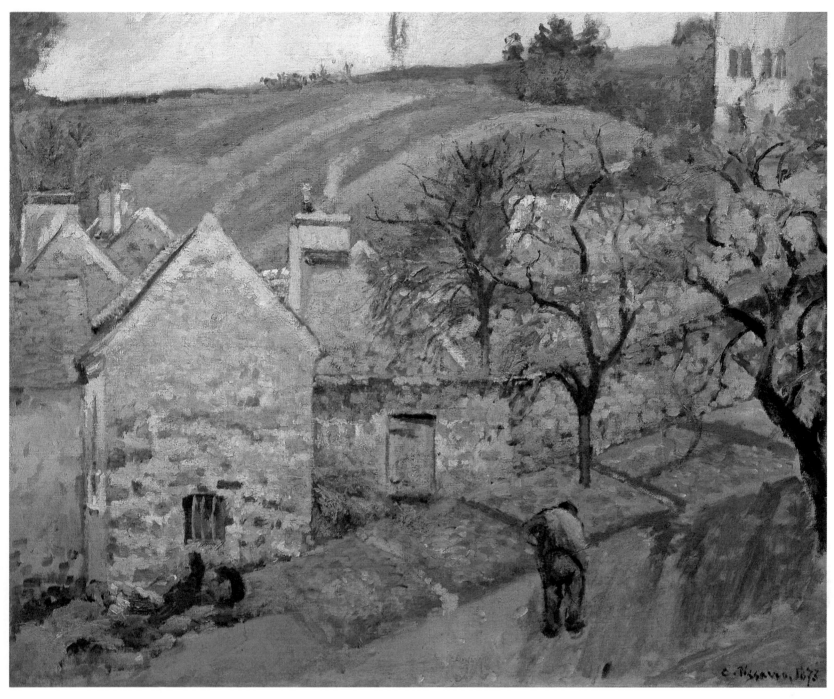

Pissarro: Hillside at L'Hermitage, Pontoise, 1873.

The encounter with nature was decisive. Complex, diverse and implacable, it became Cézanne's sole criterion. His painting of shapes, colours and light had to be as intense as the sensation inspired by nature. Those two poles, nature and sensation, were the only points of reference for painting as far as both Cézanne and Pissarro were concerned. The views of Auvers and Pontoise that they painted were not landscapes but canvases. (Nature as painted by Pissarro and Cézanne could no longer be termed bucolic, for their rusticity had nothing pastoral about it.) The lines of roads and riverbanks or of gables, trees and branches define variations in light, not the space hollowed out by conventional perspective. Their landscapes are not dramatic in any theatrical sense; they are pictorial.

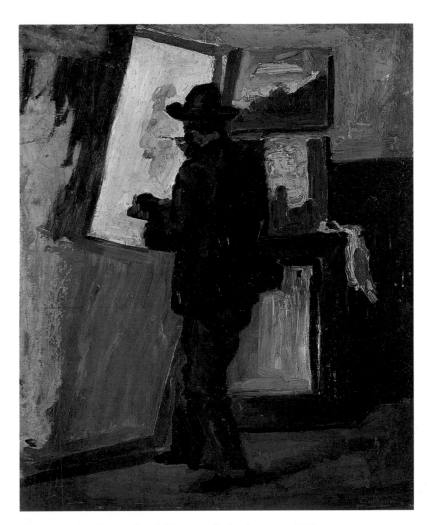

Guillaumin: Portrait of Pissarro Painting, c. 1868.

Cézanne:
Portrait of Guillaumin with
the Hanged Man, 1873.
Etching.

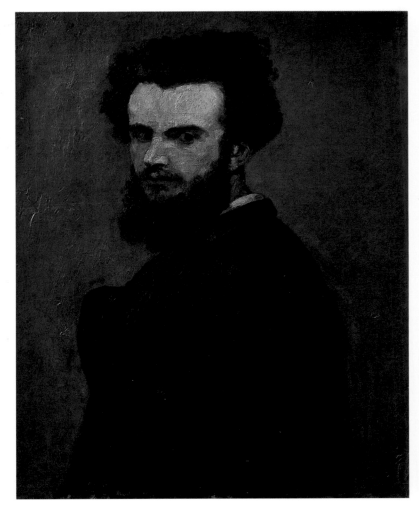

Guillaumin: Self-Portrait, c. 1875.

I sometimes have a horrible fear of turning up a canvas of mine. I'm always afraid of finding a monster in place of the precious jewels that I thought I had put there!... So it does not surprise me, oh not at all, that in London the critics assign me to the bottom rank. Alas! I'm afraid it may be all too true. Yet there are moments when I really feel a great relief in finding certain very foursquare and very good things in my character. Enough of that. Painting, and art in general, delights me. It is my life. What does the rest matter? When you do a thing with your whole soul and everything that is noble within you, you always find your counterpart, a man who understands you; no need for them to be legion. Isn't that all the artist should desire?

Pissarro, letter to his son Lucien, Rouen, 20 November 1883.

For years Ludovic Piette—a pupil of Couture, in whose studio he met Manet—and Pissarro painted the same motifs together, at Montfoucault in Brittany (where Piette welcomed Pissarro and his family as they fled from the Prussian troops) and at Pontoise (where Pissarro lived for twelve years). Guillaumin also joined Pissarro at Pontoise as often as his job in the Paris highways department permitted.

It was on a press belonging to Dr. Gachet, at Auvers-sur-Oise, that Cézanne printed the etching of his *Portrait of Guillaumin with the Hanged Man*. This no doubt alluded to the *House of the Hanged Man*, painted at Auvers. Possibly, too, it was an allusion to Manet, who had had a young model commit suicide in his Rue

The hanged man and the outdoor models

Pissarro Cézanne
Guillaumin Piette

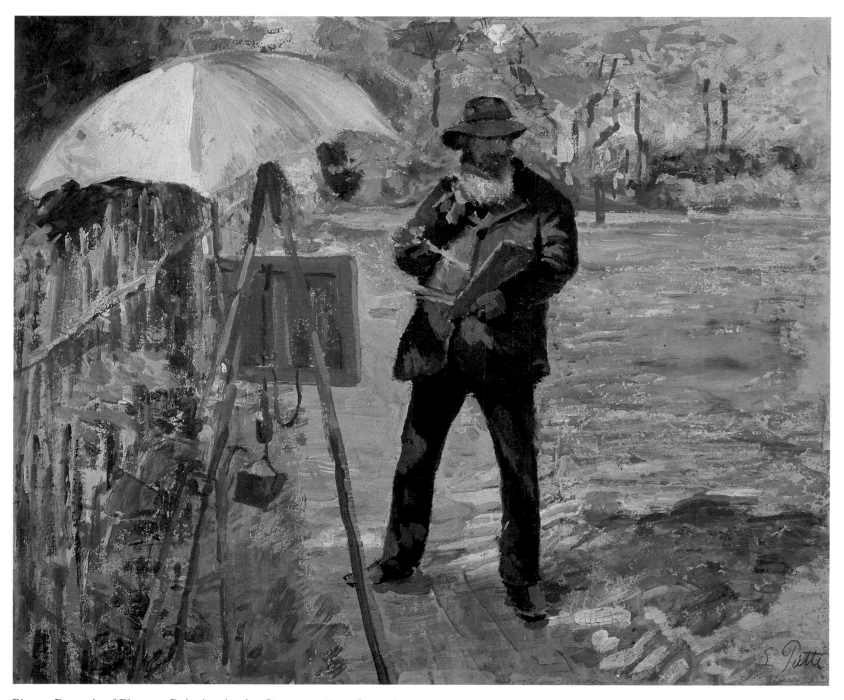

Piette: Portrait of Pissarro Painting in the Open, c. 1870. Gouache.

Lavoisier studio. The hanged men of Auvers and the Rue Lavoisier were emblems, in a way, of the "school" forming round the twin poles of Manet and Pissarro, the urban man-of-the-world and the retiring ascetic, the city and the outdoors.

Like Manet's *Déjeuner sur l'Herbe*, shown at the 1863 Salon des Refusés (where Cézanne and Guillaumin were also represented, though their names did not appear in the catalogue), the landscapes that Renoir and Monet painted outdoors were still genre scenes peopled by holiday-makers. In the landscapes of Pissarro and his circle the figures—where there were any—were those of working people.

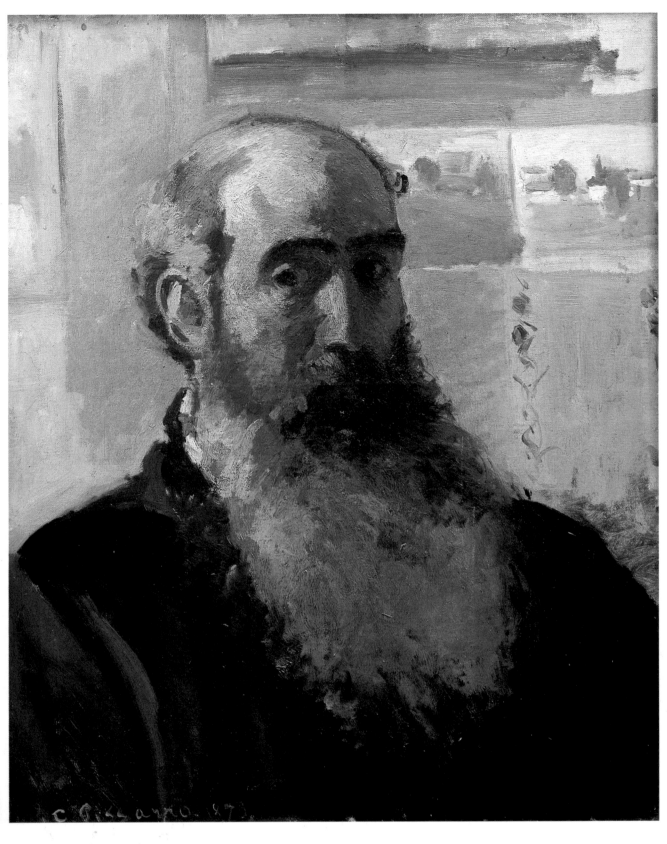

Pissarro:
Self-Portrait, 1873.

The landscapes that Cézanne and Pissarro painted at Auvers and Pontoise were not settings for narrative, anecdote or genre scenes. They were simply nature; they did not set out to be anything else. Nature was still one of the most abstract concepts in painting. At the Salon it had always been a utility that painters represented as they knew it to be rather than as they saw it. (The kind of nature that years of watercolours and wash drawings in holiday sketchbooks had taken as their model was essentially a memory haunted by ruins, whether of temples or castles made no real difference.) The nature that these painters sought to capture was as ordinary and everyday (Pissarro) as it was immutable (Cézanne). Being both of the moment and eternal, it lay outside time. The sacred dimension in their paintings was timelessness. Their landscapes were icons, but of this world.

The motif

Pissarro
Cézanne

Many years later Cézanne looked back:
Study modifies our vision so much that the humble and colossal Pissarro finds himself justified in his anarchistic theories.

Letter to Emile Bernard, Aix, 1905.

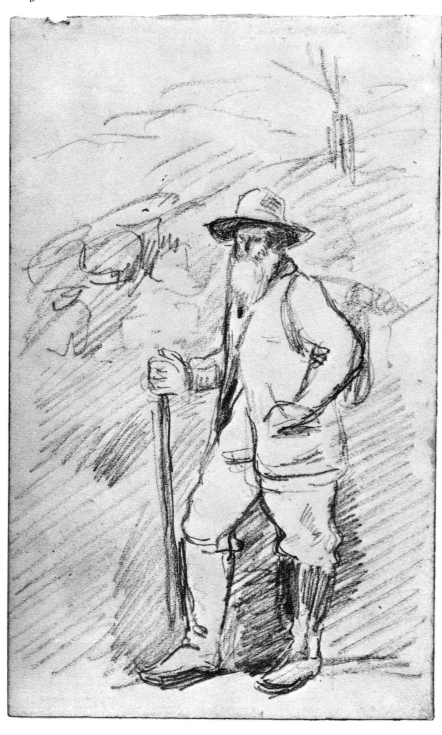

Cézanne: Portrait of Pissarro Going out to Paint, 1872-1876. Pencil.

Pissarro: Portrait of Cézanne, c. 1874. Pencil.

I shall next mention Paul Cézanne, who is surely the greatest colourist of the group. There are by him, at the exhibition, some landscapes of Provence of the finest character. The so able and experienced canvases of this painter may make the bourgeois smile. They nevertheless contain the makings of a very great painter. The day when Paul Cézanne shall be in full possession of his means, he will produce some quite superior work.

Zola, "Une exposition:
Les peintres impressionnistes" in
Le Sémaphore de Marseille, 19 April 1877.

Cézanne: The Biting
(Cézanne Etching beside Dr. Gachet),
1873. Pencil.

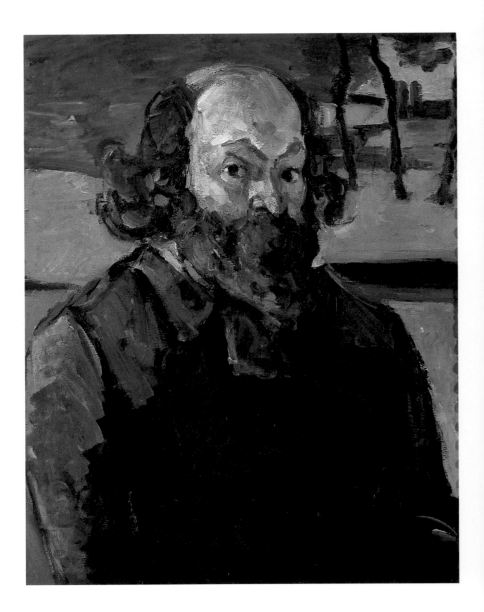

Cézanne: Self-Portrait, c. 1873-1876.

Cézanne regarded *Olympia* as simply *une belle tache*, a great blob. Manet thought Cézanne's painting was "dingy." Cézanne's humorous bid to outdo the older man in terms of scandal—*A Modern Olympia* committed the double indecency of depicting a brothel scene with slashing brushstrokes—became part of the collection of Dr. Gachet at Auvers-sur-Oise. The doctor's house in Auvers was a meeting place for artists and the motif of many of their canvases. Daumier, Daubigny, Pissarro, Cézanne and Guillaumin were all guests of his. They were also his patients, and he purchased their paintings. His engraving workshop was at the disposal of them all. He did etchings and drypoints himself, signing them with the pseudonym Van Ryssel—adding "of Lille," his native town, in Flemish. In Paris, where he practised medicine and taught anatomy, Dr. Gachet frequented the same cafés as his artist friends, Forain, Desboutin, Manet, Renoir and the rest.

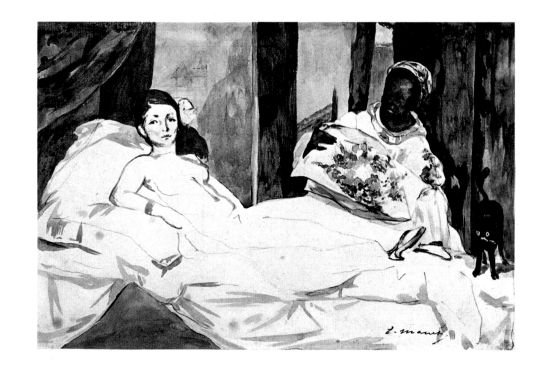

▷ Manet: Olympia, 1863. Watercolour and pencil.

▽ Cézanne: A Modern Olympia, c. 1873.

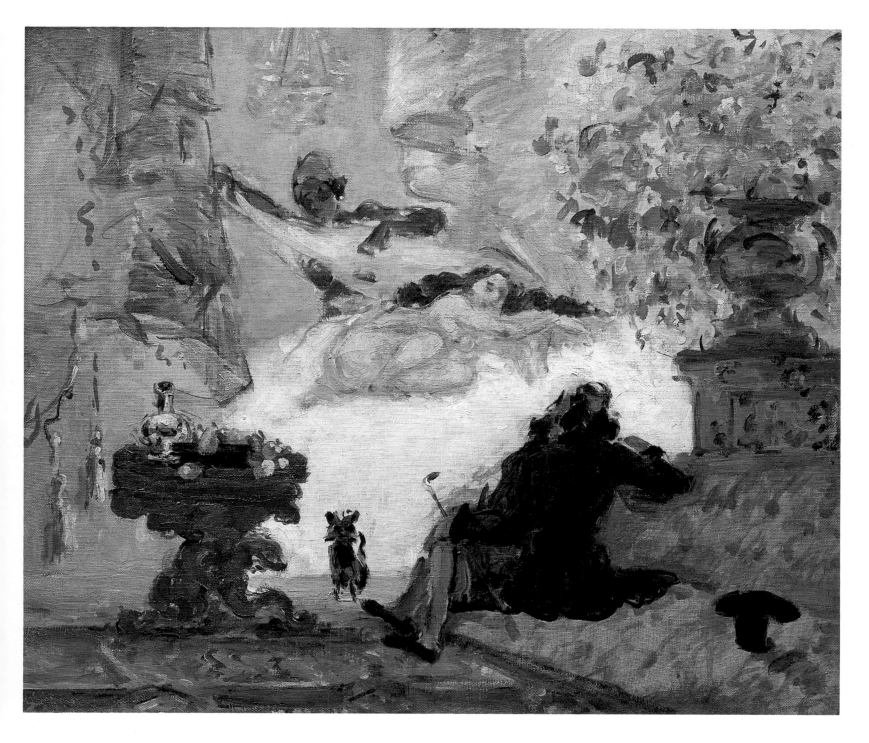

Pissarro and Cézanne, c. 1872. Photograph.

Pissarro... has a good opinion of me, who have a good opinion of myself. I begin to find myself stronger than all those around me, and you know that the good opinion I have of myself is based on sound knowledge. I have to keep working, not to arrive at finish, which arouses the admiration of fools. And this thing that the vulgar appreciate so much is only the outcome of craftsmanship, and makes any work resulting from it inartistic and common. I must seek completion only for the pleasure of being truer and more knowing. Believe me when I say that there always comes a time of recognition, and one gets admirers who are much more fervent and convinced than those who are only flattered by vain appearances.

Cézanne, letter to his mother, Paris,
26 September 1874.

Cézanne: Portrait of Pissarro, c. 1873. Pencil.

Pissarro's portrait of Cézanne is not so much a representation as a portrait of shared convictions. The heavy jacket with the rounded lapels, the scarf and the cap are those Cézanne wore every day when out painting. They are tokens of both the sitter's and the painter's purpose. Behind Cézanne's left shoulder is Pissarro's painting of *Father Galien's House in the Gisors Road, Pontoise*. Cézanne "quoted" the same painting in his *Still Life with a Soup Tureen*. Above is the caricature of Courbet published by Léonce Petit in *Le Hanneton* on 13 June 1867. Here it is a salute to the great Realist, the Master of Ornans. Cézanne is shown with his back to Adolphe Thiers, as caricatured by Gill in *L'Eclipse* on 4 August 1872.

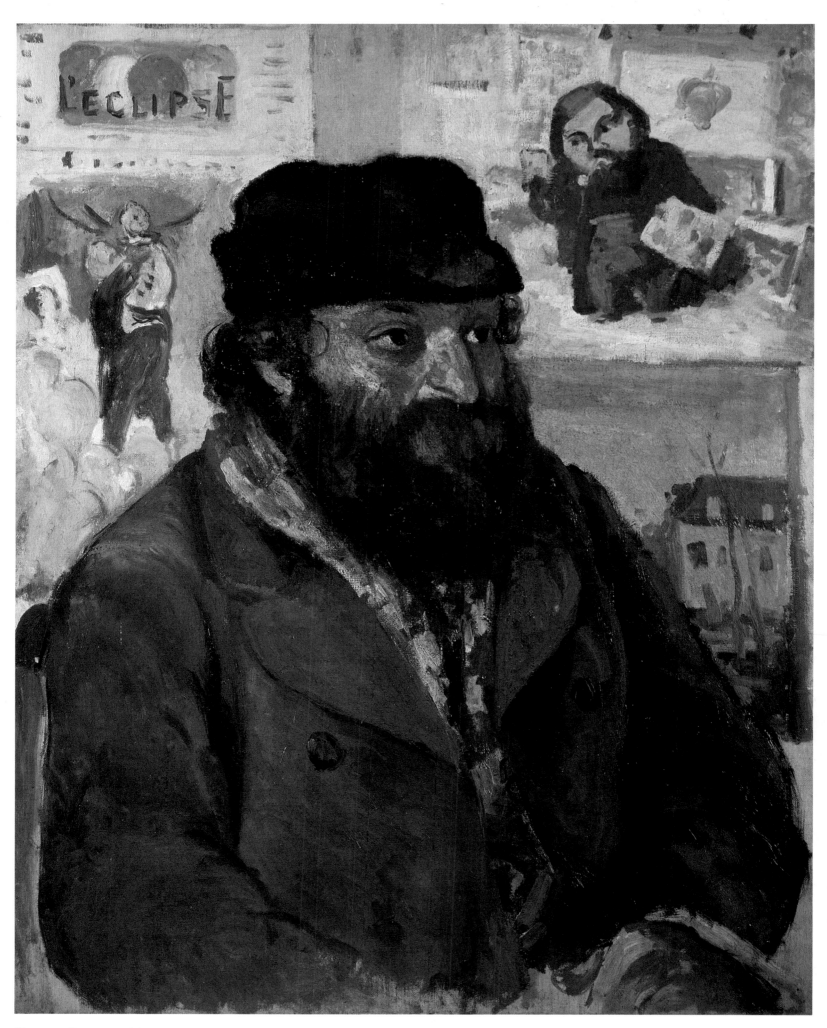

Pissarro: Portrait of Cézanne, 1874.

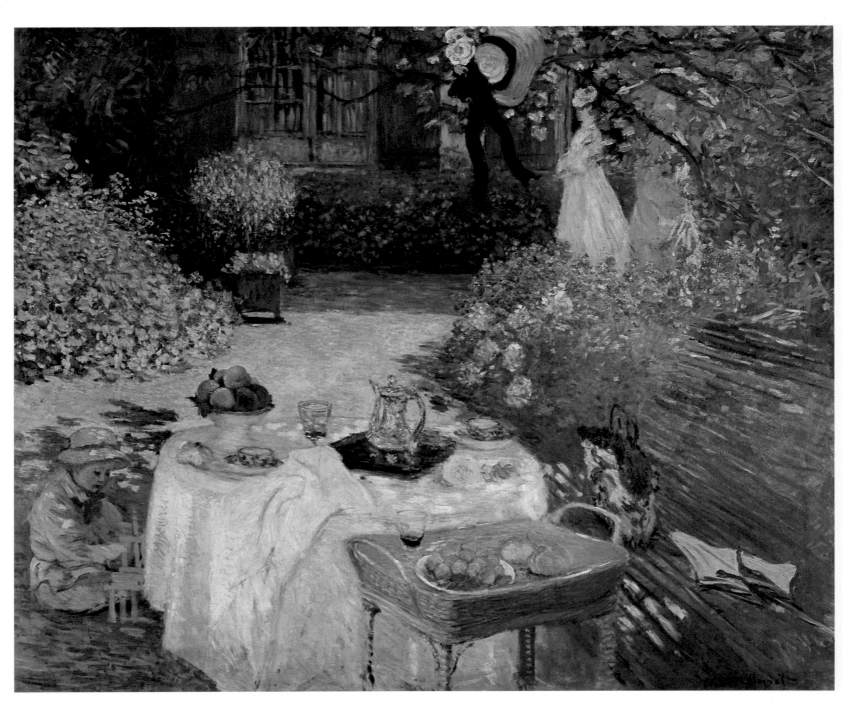

Monet: In the Garden (The Luncheon), c. 1873-1874.

Open air

When the Impressionists set up their easel in the open air, their subject was not landscape, but light. Landscape painting was in a class apart, with a tradition behind it. It was not as highly regarded as subjects deemed great. If a great subject needed a landscape, it was only an adjunct. Landscape was only the setting for a story. Fields were fields of battle, and woods were the haunt of nymphs or the venue for a hunt. (There was no difference when it came to realism. Courbet proves it in *The Painter's Studio*, where he is seen painting a landscape indoors.) Neither Millet's *Angelus* nor Courbet's *Siesta at Haymaking Time* is a landscape. They are genre scenes representing prayer and rest. Nature is the setting. It is no longer the same in canvases like Corot's *Gust of Wind* or Courbet's *Wave*. In this case, the foam is romantic, like the foam of Paul Huet's waves. The elements let loose show nature embodying forces, monsters and demons. Romantic storms are epics, not land or seascapes. The landscape paintings of Ruisdael, Van de Velde, Van Goyen, Hobbema and Koninck are landscapes and nothing more. They tell no story. They had a more decisive influence on Monet—by way of Boudin and Jongkind—than the Barbizon School. In Fontainebleau Forest, at Chailly-en-Bière and Marlotte, like Théodore Rousseau or Diaz, the youthful Impressionists at first did nothing but sketches for use later in the studio, where the light is no longer the same. Monet did not give up the idea of submitting his *Luncheon on the Grass* for the Salon because he had not finished it, but because he *could* not finish it in the studio. The light there failed him.

Boudin to Monet: "Anything painted directly, on the spot, always has a strength, a power, a lively touch that is lost in the studio. Your first impression is the right one. Stick to it and refuse to budge."

So as not to lose anything of this impression, in the spring of 1866, when he was going to paint *Women in the Garden*, Monet dug a trench and fitted up a system of pulleys so that he could raise and lower the canvas, which he wanted to finish without having to go back to the studio. *Women in the Garden* is not a landscape,

it was a discovery. Nature must only be painted out of doors. Monet, Renoir and Bazille made the open air a rule, as it was already for Pissarro. Manet, in 1866, saw no need for it. "Look at this young man [Monet], trying his hand at open air painting! The Old Masters must be turning in their grave!"

The open air sweeps the canvas clean, and the eye too. At Monet's Argenteuil home, Manet began to paint in the open air in 1874. Degas's comment: "Poor Manet! After painting *Maximilian* and *Christ with Angels*, all he has done since 1875 is abandon regal magnificence for laundering!" Degas despised open-air painting. He wrote (2 March 1877): "We can love nature but we can never be sure that our love is returned, so what is the good of showing our feelings more clearly?"

Looking at Monet's canvases, Degas said: "I'm leaving. All these reflections on the water hurt my eyes!" And later: "It seemed to me that the place was full of drafts, I felt like turning up my collar." He told Vollard: "You know what I think about artists who paint on the highway. If I were the government, I would have the police keep an eye on people who do landscapes from nature. Not that I wish anyone harm, I would even let the police use small shot to begin with."

The open air is uncomfortable, bad weather spoils work. From Pourville Monet wrote to Durand-Ruel (18 September 1882): "After a few days' fine weather, it's raining again; the studies I had begun have to be put aside. It's driving me mad, and unfortunately I take it out on my poor canvases. I have destroyed a big flower picture I had just painted, as well as three or four canvases not only scored but torn to shreds. It's stupid, I know, but as the time to leave approaches and I see nature changed so completely, I lose heart thinking how much money I have spent to no good purpose."

Six years later he wrote to Berthe Morisot from the Chateau de la Pinède near Antibes: "I am working tremendously hard. I take a lot of trouble, but I cannot

say I'm satisfied yet, for another spell of bad weather would spoil everything I have begun, and then it is so difficult, so fragile and delicate, and I tend to be so brutal. Anyhow, I am really making a big effort."

She replied (14 March 1888): "I envy you your sun, and many other things besides, even your brutality! You are hard to satisfy, but I can see you are in form and making delightful pictures."

There were other open-air constraints. Berthe Morisot again: "One doesn't know where to go. I tried a field. I had no sooner sat down than I had more than fifty boys and girls around me, shouting and gesticulating. It ended in a pitched battle. The owner of the field came and told me quite crossly that we ought to ask permission to work, when we are there we attract the local youngsters who do a lot of damage.

"In a boat, the troubles are different. It rocks, there's the infernal lapping of the waves, you have sun and wind, the boats change place every minute, etc. From my window, it's very pretty to look at, but very ugly to paint; views from above are nearly always incomprehensible. The upshot is that I'm not doing much, and the little I do seems horrible."

Cézanne wrote to Zola (19 December 1878): "I began to see nature a little late. This does not, however, make it any less interesting." About Cézanne, Vollard wrote: "He did not like people to watch him when he was painting. Renoir told me just how touchy he was. During a stay at Jas de Bouffan, Renoir accompanied Cézanne to his motif. An old woman was in the habit of sitting down with her knitting a few yards away. She only had to be near to put Cézanne beside himself. As soon as he noticed her—and with his keen, penetrating eyes, he caught sight of her from afar—he cried out 'The old bitch is coming!' and despite all Renoir's efforts to stop him, he packed up his things in a rage and away he went."

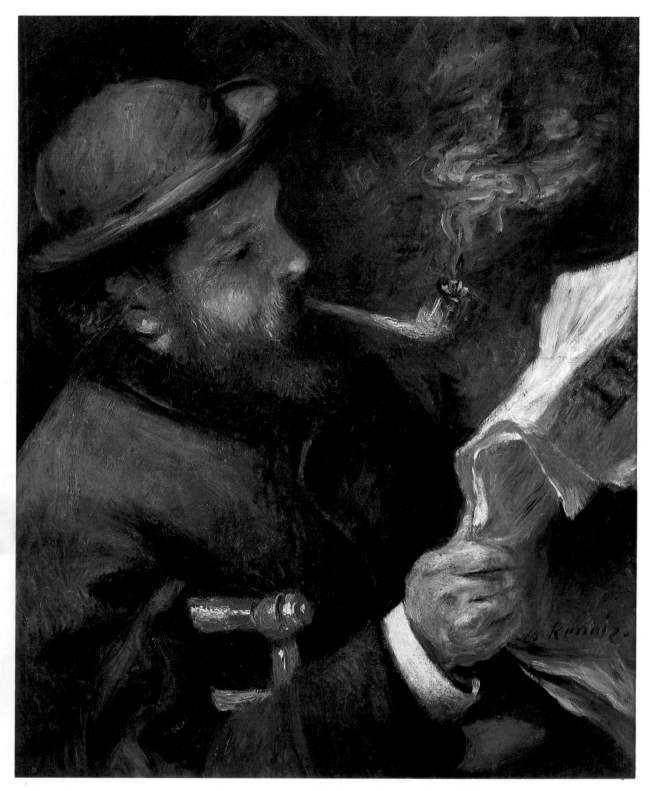

Renoir: Portrait of Monet, 1872.

The portrait of Camille Monet makes a pair with that of Claude Monet reading a newspaper. The T at the end of the title, all that is legible, may stand for *L'Evénement*, seen lying on the table some years before in the *Inn of Mother Anthony*, a token of loyalty. Monet posed for Renoir, as Renoir posed for Monet. These painters had no official status. In France under the Third Republic, painters had no more of a position or function than under the Empire, which had just collapsed. David was the last painter to have a function, one of the last to receive commissions based on a contract. Bonnat was not, under the Republic, what David had been under the Empire, any more than Couture, Cabanel or Winterhalter had been the David of Napoleon III. Without an official function—the substitute, academic conformity, is a counterfeit—the painter stands alone with his painting.

Renoir on Monet:
He was a born gentleman. People were amazed not only by
his virtuosity, but by his manners.

> Ambroise Vollard, *En écoutant Cézanne,*
> *Degas, Renoir*, Paris, 1938.

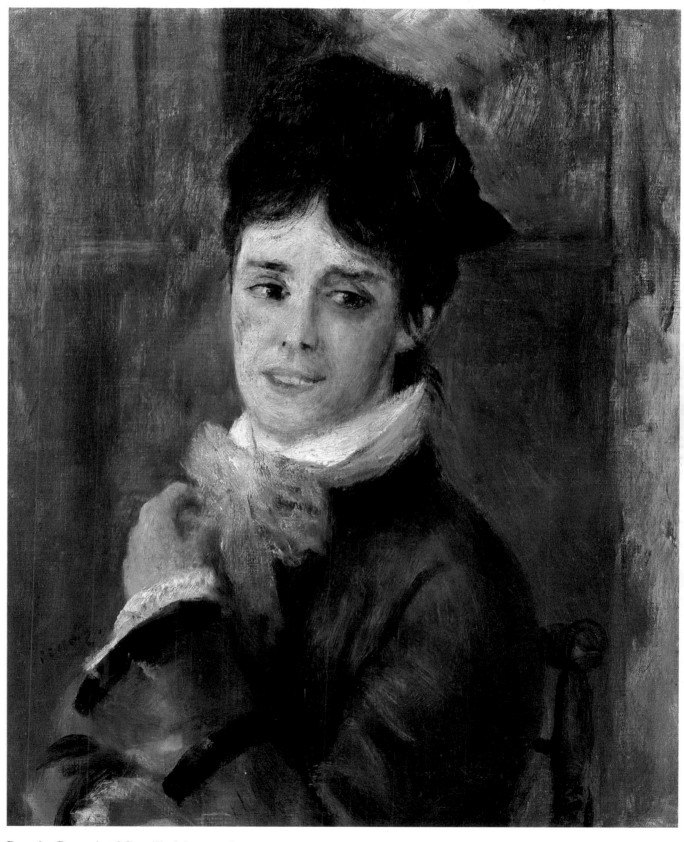

Renoir: Portrait of Camille Monet, 1872.

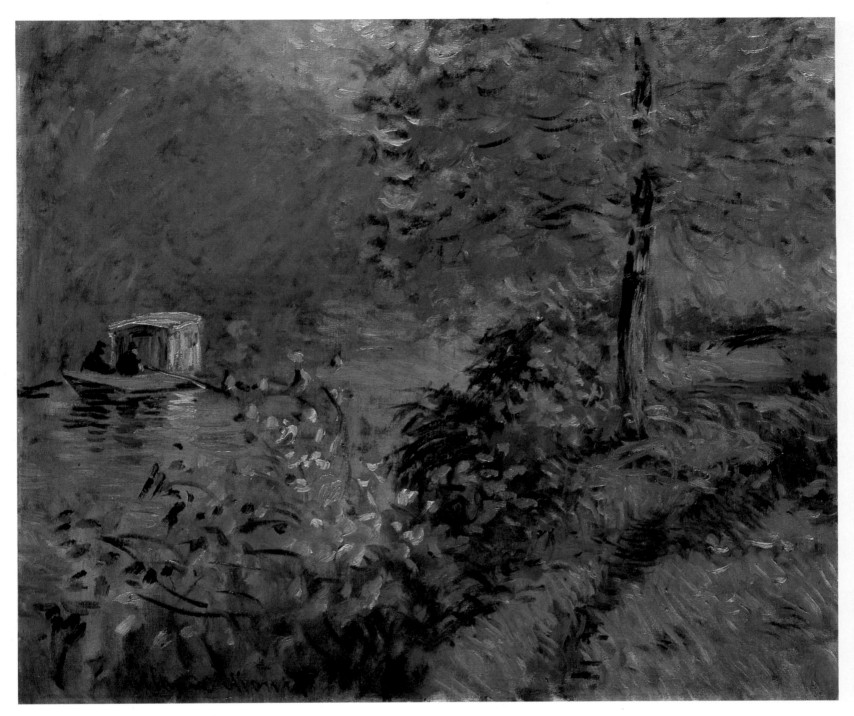

Monet: The Studio Boat, c: 1876.

Renoir:

So it was in 1873, with the feeling of having at last "arrived," that I rented a studio in the Rue Saint-Georges. I may say that I really liked it there. That same year I did a good many studies at Argenteuil, where I was working with Monet, and one picture in particular was *Monet Painting Dahlias.*

<div align="right">Ambroise Vollard, Auguste Renoir, Paris, 1920.</div>

It was in my London gallery, at the beginning of 1871, that I made the acquaintance of Monet, whose pictures I had noticed at the Salons of recent years, but whom I had had no opportunity of seeing, for he was seldom in Paris. He was brought to me now by Daubigny, who rated his talent very high. I purchased from him at once the pictures he had just painted in London. Monet in turn introduced me to Pissarro, who was also in London and had just painted some most interesting canvases there. Monet's paintings cost me 300 francs, Pissarro's 200 francs. For years that was the price I continued to pay for them. No one else would have been so generous, for they were forced to sell them for 100 francs, then for 50 francs and even less, when it proved impossible for me to continue my purchases.

On my return to Paris I saw more of Monet and Pissarro, and I made the acquaintance of Renoir, Sisley and some of their friends. One day when I called on Alfred Stevens I also found two pictures by Manet. As this great artist received no visits in his studio, he had asked his friend Stevens to sell them for him by exhibiting them in his own studio... From Manet, then and there, I bought everything he had ready in his studio, that is 23 pictures, for 35,000 francs, accepting the prices he asked for them.

<div align="right">Paul Durand-Ruel, Memoirs.</div>

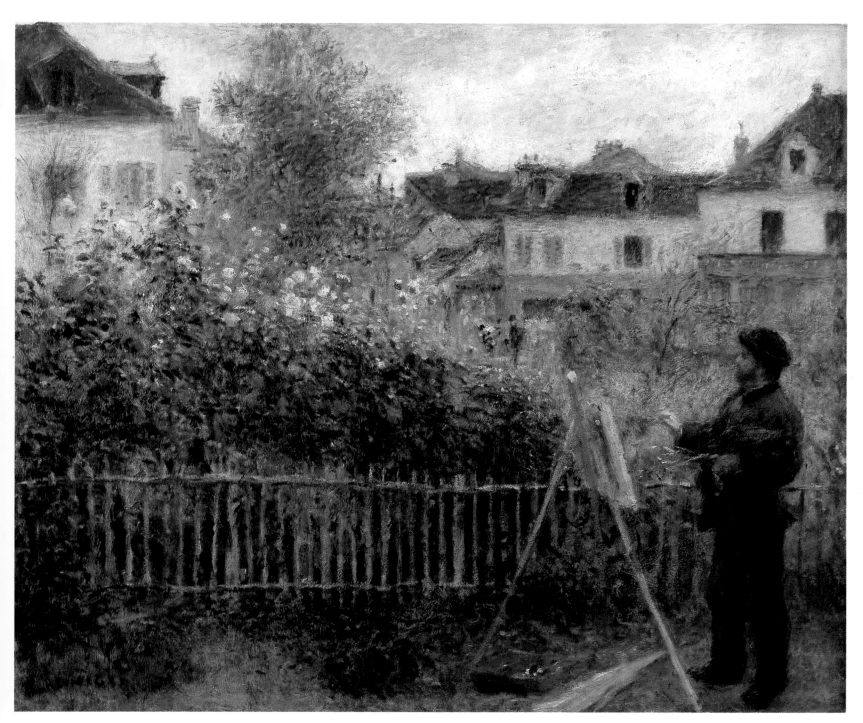

Renoir: Portrait of Monet Painting in his Garden at Argenteuil, 1873.

Light, air and water

Monet
Renoir

It cost one franc twenty centimes by boat and one franc fifty by train to go from Paris to Argenteuil, where Monet rented a house from the mayor, a friend of Manet's, near the Porte Saint-Denis workhouse. Monet often had Renoir to stay with him, and Sisley, Caillebotte and Manet would drop in. The two latter had houses further up the Seine at Gennevilliers; Sisley was living at Voisins-Louveciennes. Together, they painted the hillsides, the footbridge replacing a bridge destroyed during the Franco-Prussian war, the boats, canoes and regattas on the Seine, and even Monet's garden. In all the scenes, landscapes and portraits they painted, they paid no more heed to the old rules of the art than to the principles which the pontiffs of the Salon observed so rigidly. Light, air and water were their only models.

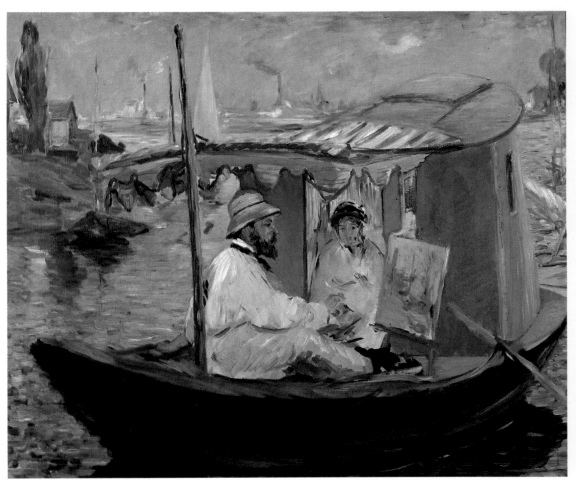

Manet: Portrait of Monet in his Studio Boat, 1874.

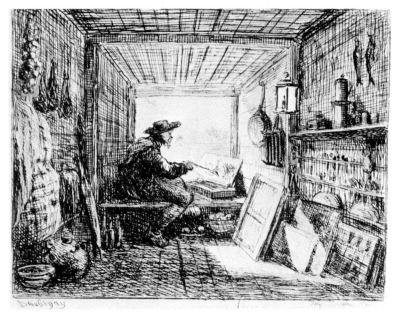

Daubigny: The Studio Boat, 1861. Etching.

Manet had this to say of Monet: "There is not one painter in the whole School of 1830 who can plant a landscape as he can. And then his water! He is the Raphael of water."

Antonin Proust, *Edouard Manet, Souvenirs*, Paris, 1913.

When, on Sundays, one called on Manet in the Rue de Saint-Pétersbourg studio, his one thought was to sing the praises of all the painters who, improperly as it happens, have come to be known as the School of Batignolles. He would set their canvases in a good light, so anxious to find purchasers for them that he forgot all about his own works. During these showings, he would express the most passionate admiration for Claude Monet, whose portrait he had painted in a boat, a canvas which he particularly liked and called *Monet in his Studio*.

Antonin Proust, *Edouard Manet, Souvenirs*, Paris, 1913.

Daubigny was one of the few members of the Salon jury who would sooner have admitted the bold innovations of young painters than the sombre orthodoxy of conformist artists. Colours, said Daubigny, could never be bright enough, and he painted landscapes that were brushed freely and quickly, recording his impressions of nature. Count Nieuwerkerke dubbed him a mere liberal, a free-thinker, worse still, perhaps a materialist. In 1857 Daubigny built a studio boat. The washerwomen and laundresses on the river banks who saw him pass on the Seine, Yonne, Epte or Oise, from his home at Auvers-sur-Oise, nicknamed his boat the *Bottin*, the little box. Monet painted in a similar boat.

I went to see Monet yesterday. I found him in a sorry state, very much on his beam ends. He asked me to find someone who would take any ten to twenty of his pictures, and pay 100 francs apiece for them. What about it? Would you be willing to join me and we would each give him 500 francs? Of course we would have to conceal from him the fact that we are the actual purchaser. I had thought of applying to a dealer or some art-lover; but I foresee the possibility of a refusal.

Unfortunately one has got to be a good judge of painting like ourselves in order to make this excellent purchase, however reluctant one may be, and at the same time render this service to a man of talent. Do answer me as soon as possible and let me know when we can meet.

Manet, letter to Théodore Duret, 1875.

Manet: Portrait of Monet, c. 1874. Indian ink wash.

A floating studio

Manet
Monet
Daubigny

Monet: The Studio Boat, c. 1874.

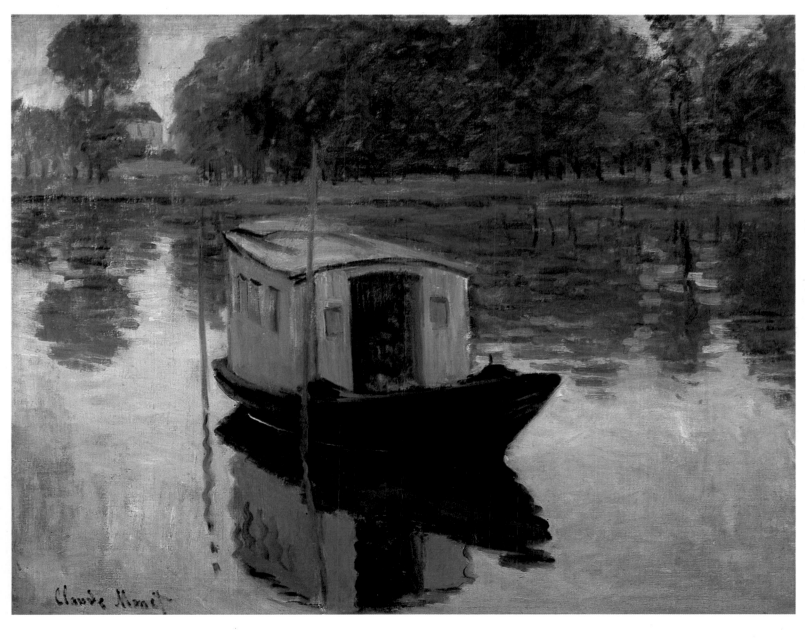

Nadar: Front of his photographic studios at 35 Boulevard des Capucines, Paris,
where the first impressionist exhibition took place in 1874.

Optical illusion and art market

A painter lived on his income or his sales. If he had no private means and could not sell his pictures, he soon found himself in debt. If the Salon refused his work, he could expect neither honours nor a market. For Manet, Bazille or Sisley, refusal was only a matter of honour. For Renoir, Monet, even Cézanne, whose father only gave him an allowance of a hundred francs a month, and for Pissarro, it amounted to being sent to the pawnbroker's provided, of course, they had something to hock. Dealers only sold what sold in the Salon, and the Salon alone decided the price.

Dealers were few, and fewer still those who would look at and buy a painting not endorsed by the Salon. Père Martin was one of these. "He never lost his way among second-rate daubers. He went by instinct straight to artists with personality, who were still controversial but destined—the flair of his drunkard's flaming nose told him from afar—for a great future. Furthermore, he was a great haggler; he had the cunning of a savage when it came to getting the picture he wanted cheap." He was the model for Père Malgras, thus described in Zola's novel *L'Œuvre*. He bought Pissarro's paintings for twenty to forty francs apiece, Cézanne's for fifty, Monet's for a hundred. Although Père Martin bought the pictures, he did not show them in his gallery at 52 Rue Laffitte. On the other hand, Louis Martinet, who housed the Société Nationale des Beaux-Arts at 26 Boulevard des Italiens, exhibited Manet's works there and defended him in his review *Le Courrier Artistique*, but he neither sold nor bought them. After the Franco-Prussian war, the Georges Petit Gallery was still only interested in the masters of 1830 and the Barbizon school. The dealer Adolphe Goupil salvaged in 1872 the pictures Thiers had excluded from the Salon. They were battle scenes. The feelings of the German Empire still had to be considered. In these exceptional circumstances Goupil opened his Place de l'Opéra gallery to works, history paintings, which could not be admitted to the Salon where they should have had their place. It was useless, however, to give him the name of painters unless they were medallists. Louis Latouche, in his small shop at the corner of Rue Laffitte and Rue Lafayette, welcomed Pissarro, Monet, Bazille, Sisley and Renoir. It was there, in 1867, after his *Diana the Huntress* had just been rejected at the Salon, that Renoir's petition for a new Salon des Refusés was opened for signature. Latouche was not only a colourman, framer and picture dealer, he was also a painter. He bought Manet's canvases, as did Bazille, but he did not create a market for them. No more did Père Tanguy. Arrested in 1871 as a member of the Paris Commune, and released through the good offices of a town councillor, Père Tanguy had been and remained an anarchist. He reopened his colour shop at 14 Rue Clauzel, where he gave credit and bartered painting materials for pictures, which he sometimes sold to customers like Dr Gachet. At Père Tanguy's, painters could at least be sure of getting what they needed for their work. To sell, you had to exhibit, so if the Salon refused pictures, they had

to be shown without the Salon. For Renoir, Monet, Pissarro and many others it was out of the question to build a private pavilion like the one Manet put up in the Place de l'Alma, in 1867, where he exhibited fifty pictures during the Paris World's Fair. The pavilion cost him 18,305 francs. That one-man show made him known, but did not help him to sell. That same year Cézanne, Monet and Pissarro were rejected by the Salon.

In 1872 the Salon jury was stern. Jongkind, Pissarro, Fantin-Latour, Monet, Cézanne and Renoir were among the signatories, in June, of a fresh petition to Charles Blanc, Minister of Education and Public Worship, requesting the opening of a Salon des Refusés, where the rejected painters could exhibit.

In May 1873, ten years after the one allowed by Napoleon III, a new Salon des Refusés was held.

Renoir exhibited in it. The artists urgently needed to show their works and sell them. Money matters were beginning to spoil relations within the group. When Théodore Duret bought a Monet, there was a fuss over the price. Duret wrote to Pissarro (17 September 1873): "A difficulty has arisen between Mr Claude Monet and myself. Since it was you who introduced me to him, I shall be glad if you will kindly act as intermediary and convey to him the reply given in this letter. This is what happened: I bought a picture from him on 24 May, he says for twelve hundred francs, I say for a thousand. I remember it quite distinctly. At such prices, I said nothing; I thought them too high. A moment later he told me: 'For you, I will let them go at twelve hundred *and a thousand francs.*' After this reduction I made a deal, taking the smallest for a thousand francs."

At the end of October, Pissarro replied: "The last time I saw Monet, he wanted me to ask you to be kind enough to let him have the 200 francs still due. He is short at the moment, and it would be a help to him to have them. At the same time, the sooner you are quit of this trifling matter the better. I profoundly regret the split in our group brought about by this affair. I think very highly of young Monet and am very upset, as a friend of both, not to be able to bring the two of you together and make you forget a moment of bad temper. I esteem you also too highly to think for a moment that you could be biassed in any way. What we ought to do is forget all this sort of thing and think only about Art."

To be able to think only about Art, other things must not always come in the way. Other things included the fact that Durand-Ruel could not go on buying their pictures as he had been doing since the end of the war. If their only patron failed them...

Pissarro suggested to Monet that they should make their group a joint-stock company, along the lines of the workers co-operative guilds. Meetings were held, and Renoir proposed that the company should be called the Société Anonyme des Artistes Peintres, Sculpteurs et Graveurs.

The photographer Nadar offered to lend the group his old studios at 35 Boulevard des Capucines. Degas suggested the group should call itself after the boulevard, *La Capucine* (nasturtium), with that flower as emblem. The name had associations with the wartime song "*Vive le son du canon!*". The sound of the guns during the war and the Commune was still in the air. The exhibition opened. On 25 April, *Charivari* printed an article by Louis Leroy under the headline "The Impressionist School":

"What a strenuous day it was when I ventured to visit the first exhibition in the Boulevard des Capucines together with Mr Joseph Vincent, landscape painter, pupil of Bertin, medallist and decorated by several governments...

"What does that canvas depict? Look at the catalogue.

"*Impression, Sunrise.*

"Impression, I knew it. I said to myself that since I was impressed, there must be something impressive about it. And what freedom, what ease in the execution! Half-made wallpaper is more finished than that so-called seascape!...

"Père Vincent started a war dance in front of the gaping attendant, shouting the while in a half-choking voice:

"Ha, Ha! I'm a walking impression, the avenging palette knife, Monet's *Boulevard des Capucines*, Cézanne's *House of the Hanged Man* and the *Modern Olympia*! Ha! Ha! Ha!"

Leroy's article gave Impressionism its name. The word thrown out as a mockery became a title to glory. Renoir said: "In 1877, when I exhibited again with some of the same group, I insisted on keeping the name Impressionism, since it had caught on. It was a way of telling the public, as everyone understood: 'The pictures shown here are the kind you don't like. If you come to see them, so much the worse for you. You won't get your money back!'" At the time of this exhibition, in 1877, Berthe Morisot wrote to one of her aunts: "If you read some of the Paris papers, the *Figaro* for example, patronized by the best circles, you will know that I am one of a group of artists holding a special exhibition, and you will also have seen what these gentlemen think of us. On the other hand, we have nothing but praise in the radical press; but you don't read it! In short, we are in the public eye, and we think so much of ourselves that it makes us all very happy. My brother-in-law [Manet] is not with us. By way of success, he has just been turned down by the Salon. He takes his rebuff with the utmost good humour."

On the same day that the word "impressionism" was coined by Leroy (25 April 1874), *La République Française* printed an unsigned article (by Burty) ending as follows: "Here then is a young battalion that will make its mark. It has already conquered—and this is the point—those who love painting for its own sake."

In *Le Siècle* (29 April) Castagnary wrote: "In a few years' time, the artists grouped today in the Boulevard des Capucines will be divided."

How it came about matters little, the mark was made and the group divided. Scorn had united the painters; recognition dispersed them. What they had in common was that they paid no heed to the principles and rules laid down by the Salon. "What shocked people more than anything else was that nothing in our works recalled the things they were used to seeing in museums."

Impressionism was an optical illusion. In reality it was only a mutual aid society, born of solidarity. The group exhibition made a breach in the monopoly of the market for works of art dominated by the Salon. Durand-Ruel saw what was happening; as early as 1875, he was the valuer at the first auction of the group's works and he made the arrangements for their second exhibition in 1876. Impressionism was indeed a school, but it was not a matter of aesthetics; it was a new market for art. The Salon, created under the monarchy, no longer suited the needs of the Third Republic.

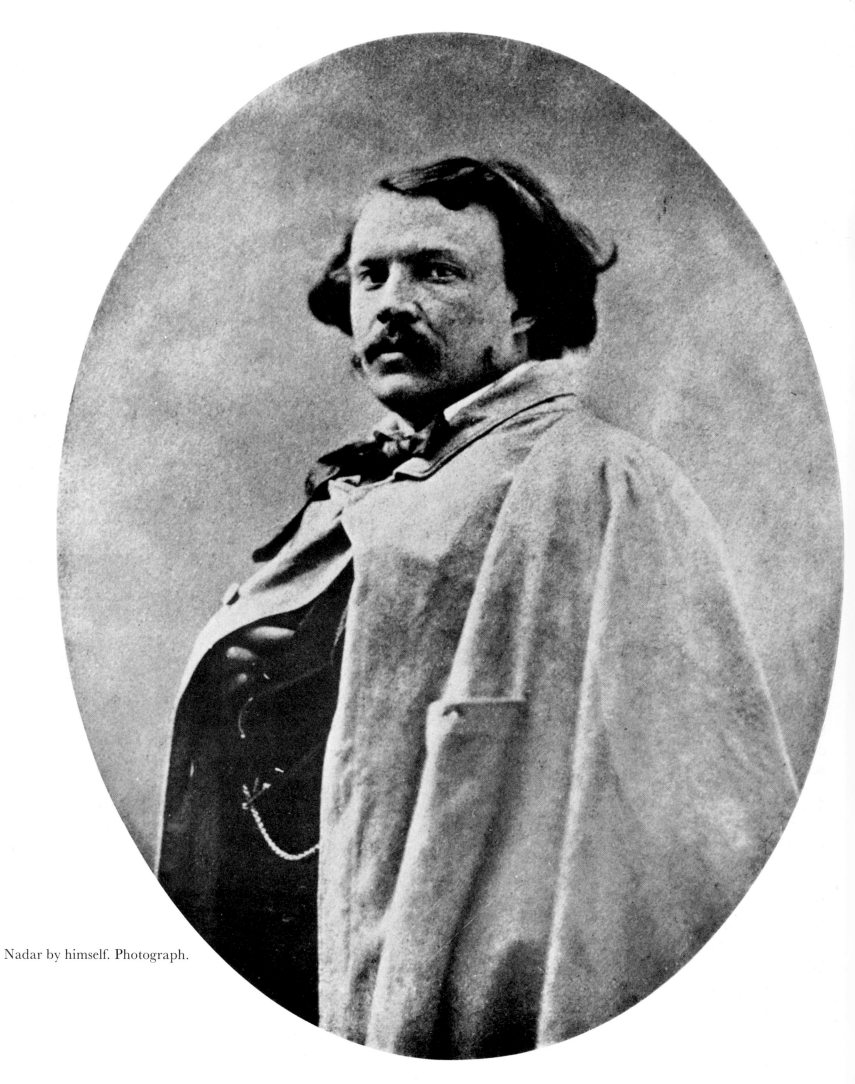

Nadar by himself. Photograph.

Degas to Nadar: "Come now, you bogus painter, you bogus artist, you photographer!"

First, we open on the 15th. So there is no time to lose. We've got to hand our things in by the 6th or 7th or even a bit later, but soon enough for the catalogue to be ready on opening day. There's plenty of room there *(Nadar's old studio in the Boulevard des Capucines)* and a unique location, etc., etc., etc.

Degas, letter to Félix Bracquemond, Tuesday [1874].

Their first exhibition opened in April 1874, at 54 Boulevard des Capucines, in the premises occupied by the photographer Nadar. It was there, in front of a picture by Claude Monet called *Impression, Sunrise*, that the term Impressionism was coined, applied to the exhibitors and printed for the first time, in the heading of an article by Louis Leroy in *Le Charivari*.

Théodore Duret, *Renoir*, Paris, 1924.

They were swept with a general enthusiasm. Yes, they must take the field together. They all joined in, thronging together, the better to rub shoulders and press forward in a body and go into action. Not one at that moment had any thought for his own glory, for nothing yet divided them, neither their profound dissimilarities which they were unaware of, nor the rivalries which would one day make them clash. Was not the success of one the success of all the others? Their youth was seething within them, they were running over with dedicated fervour, they were beginning anew the eternal dream of joining together for the conquest of the earth, each one contributing his effort, each one impelling another, and arriving in a compact group, in closed ranks.

Zola, *L'Œuvre*, Paris, 1886.

Société Anonyme des Artistes Peintres, Sculpteurs et Graveurs: Joint Stock Company of Painters, Sculptors and Engravers
Renoir:
Such was the name of our group. It gives no clue to the tendencies of the exhibitors. But I was the one who refused to accept any name with a precise signification. I was afraid that if we were called merely *Some* or *Certain Artists* or even *The Thirty-Nine*, critics would immediately begin talking about a "new school," whereas all we wanted was, so far as possible, to show painters that it was time to return to the ranks; other-

wise it looked as if painting would go under for good. And returning to the ranks meant, of course, relearning a craft that no one was any longer familiar with.

Ambroise Vollard, *Auguste Renoir*, Paris, 1920.

This exhibition is an interesting sight. On show are a couple of hundred pictures, and most of them would make a cab horse rear up. Till you see it, you can have no idea of the outrageous colours, the daring subjects, the queer procedures of execution. The impression felt by these *impressionists* in painting these extraordinary things is beyond guessing, but the visitor's impression is clear enough: he is simply bewildered.

Georges Maillard in *Le Pays*, Paris, 4 April 1875.

Manet is one of those who claim that in painting one can and should be satisfied with the *impression*. Of these *impressionalists* we saw an exhibition not long ago at Nadar's in the Boulevard des Capucines. It was quite simply disconcerting. Messrs Monet (a more intransigent Manet) and Pissarro, Miss Morisot, etc., seem to have declared war on beauty. The *impression* of some of these landscapists had turned into fog and soot.

Jules Claretie in *L'Indépendant*, Paris, 13 June 1874.

Most of these men are embittered egotists and blasé sceptics for whom pretentiousness and pigheadedness take the place of talent and hard work.

Duvergier de Hauranne in the *Revue des Deux Mondes*, Paris, June 1874.

Seriously, these lunatics must be pitied. Benevolent nature endowed some of them with superior abilities which could have produced artists. But in the mutual admiration of their common frenzy the members of this group of vain and blustering mediocrities have raised the negation of all that constitutes art to the height of a principle. They have attached an old paint rag to a broomstick and made a flag of it.

Albert Wolff in *Le Figaro*, Paris, 3 April 1875.

In rooms lent by Nadar at 35 Boulevard des Capucines, the Joint Stock Company of Painters, Sculptors and Engravers held an exhibition from 15 April to 15 May 1874. It was these artists whom the journalist Louis Leroy dubbed Impressionists. Manet did not take part. Bracquemond, however, showed an engraving, *The Divan*, a copy of a Manet portrait painted in 1862 and dedicated "To my friend Nadar." The choice of a photographer's studios for the exhibition was not significant of any complex relations with photography. Only, like photography, Impressionism did not qualify as Art. Indeed, in 1862, several members of the Institut de France, including Ingres, had signed a proclamation opposing any attempt to associate photography with Art, despite the fact that photography had been admitted to the Salon since 1859.

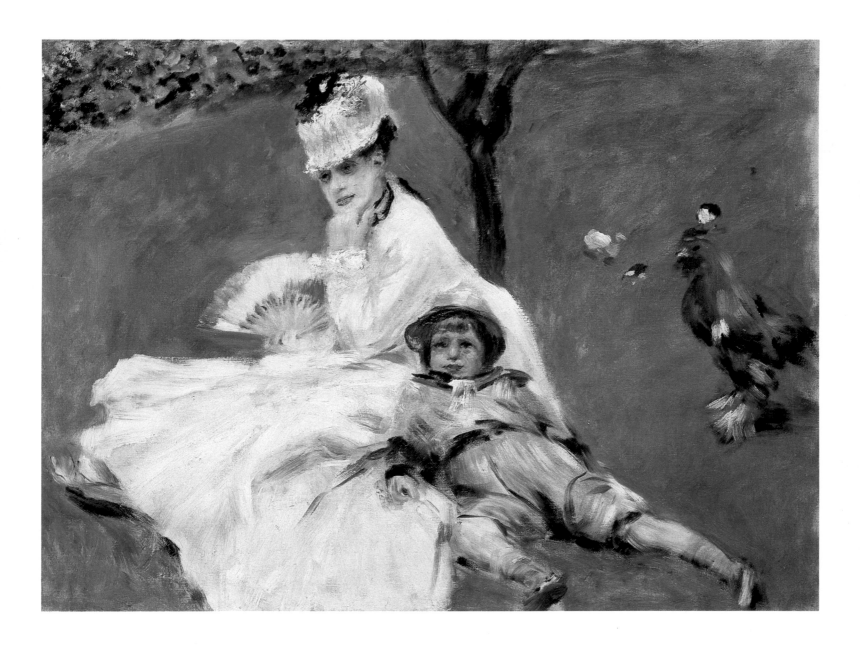

Renoir:
But to come back to the Rue Saint-Georges, among the pictures I painted in that studio I also recall a *Circus* showing some little girls playing with oranges, and also *Monet's Wife and Children* in Monet's garden at Argenteuil. When I arrived at Monet's, I found Manet there, who was about to paint the same subject, and as you can imagine I was not going to lose so good an opportunity of having the models all ready in front of me. Afterwards, when I had gone, Manet said to Claude Monet: "You are a friend of Renoir's. You should advise him to give up painting. You can see for yourself that he's not very good at it!"

Ambroise Vollard, *Auguste Renoir*, Paris, 1920.

Renoir and Monet both quite often repeated Manet's quip, confirmed or denied by others. In 1874 Manet had known Renoir for ten years. Renoir, Manet and Monet appear together in Bazille's *Studio in the Rue de la Condamine*. Renoir is standing behind Manet, who is painting a portrait of Astruc in Fantin's *Batignolles Studio*. Manet owned Renoir's *Portrait of Bazille at his Easel*, which Renoir considered one of his best works. Manet, however, was not in the habit of painting after anyone else's interpretation of his theme. Renoir, arriving unexpectedly one day and sketching beside him the portrait of Camille Monet and her son, was in Manet's eyes an intruder, and what was worse, a rival. Discomfited at seeing Renoir paint with masterly hand the same theme as himself, Manet cracked an absurd joke and gave a nonsensical piece of advice, provoking general hilarity. The tricks Manet and Degas got up to were all in the same vein, designed to prevent at all costs their taking themselves seriously. They left that to the academic painters.

The intruder

Renoir
Monet
Manet

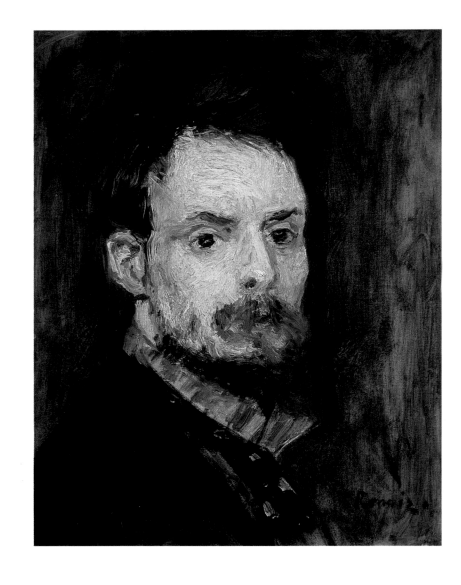

◁ Renoir: Camille Monet and her Son Jean
in the Garden at Argenteuil, 1874.

▷ Renoir: Self-Portrait, c. 1875.

Manet: The Monet Family in their Garden at Argenteuil, 1874.

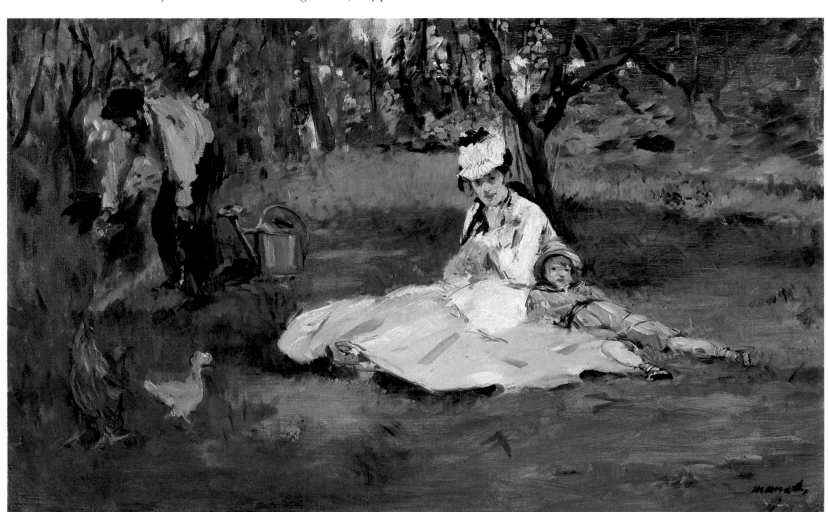

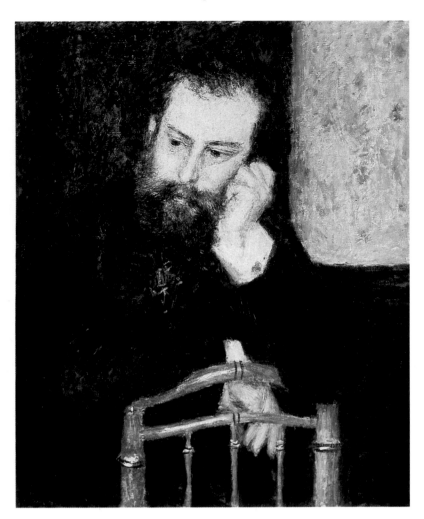

Renoir is a painter who specializes in human figures. His work is dominated by a scale of bright tonalities, with transitional passages of a wonderful harmony. It is like a Rubens lit up by the glowing sunlight of Velazquez. The portrait of Monet which he has exhibited is very fine.

Emile Zola, "Deux expositions d'art au mois de mai" (Salon of 1876 and Second Impressionist Exhibition), in *Le Messager de l'Europe*, St Petersburg, June 1876.

Renoir: Portrait of Sisley, c. 1875-1876.

Marie Bracquemond: Under the Lamp (Sisley and his Wife at Sèvres), 1877.

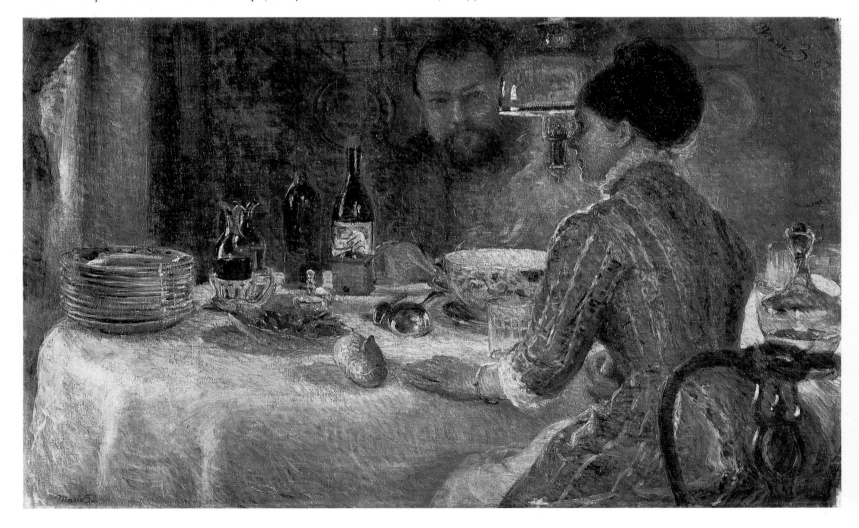

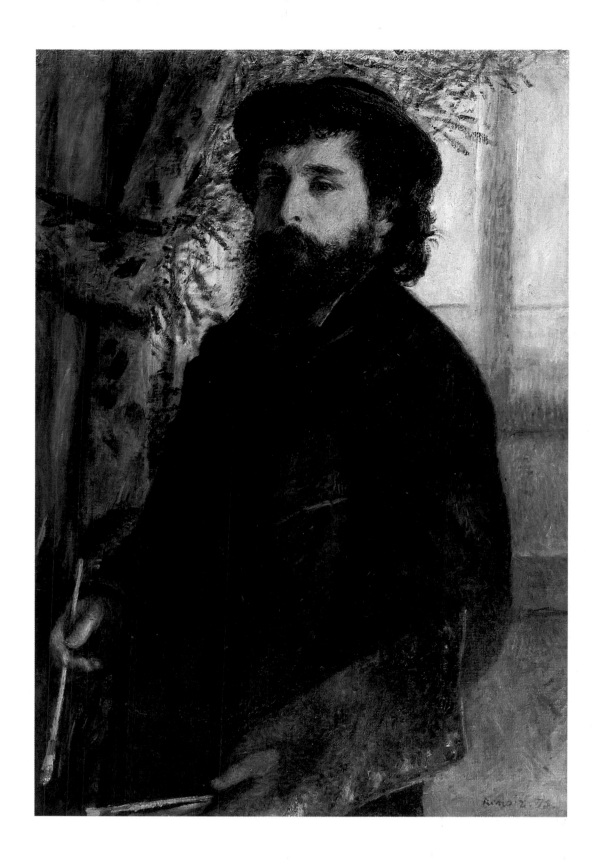

Renoir: Portrait of Monet, 1875.

The same year that Impressionism was founded—unwittingly—at an exhibition, Marie Bracquemond was hung for the first time in the Salon, although her work belonged to the impressionist school. Renoir's double portrait of Alfred Sisley and his wife Eugénie was probably painted at the Villa Brancas at Sèvres where the Bracquemonds lived; back-lit by a lamp, it was not a chiaroscuro, nor was it a heresy. The open air was neither a constraint, nor a hard and fast rule. When his father died, ruined by the war, Sisley had to find buyers for his paintings. His landscapes fetched quite good prices. The critics, so vicious in their attacks on the Impressionists in general, made an exception for Sisley, granting him distinction and charm. His subjects were the same as those of Monet and Renoir; he painted at Louveciennes, Poissy, Bougival and Saint-Cloud as well as Argenteuil. It was at Argenteuil, at the Monet home, that Renoir painted Sisley's portrait.

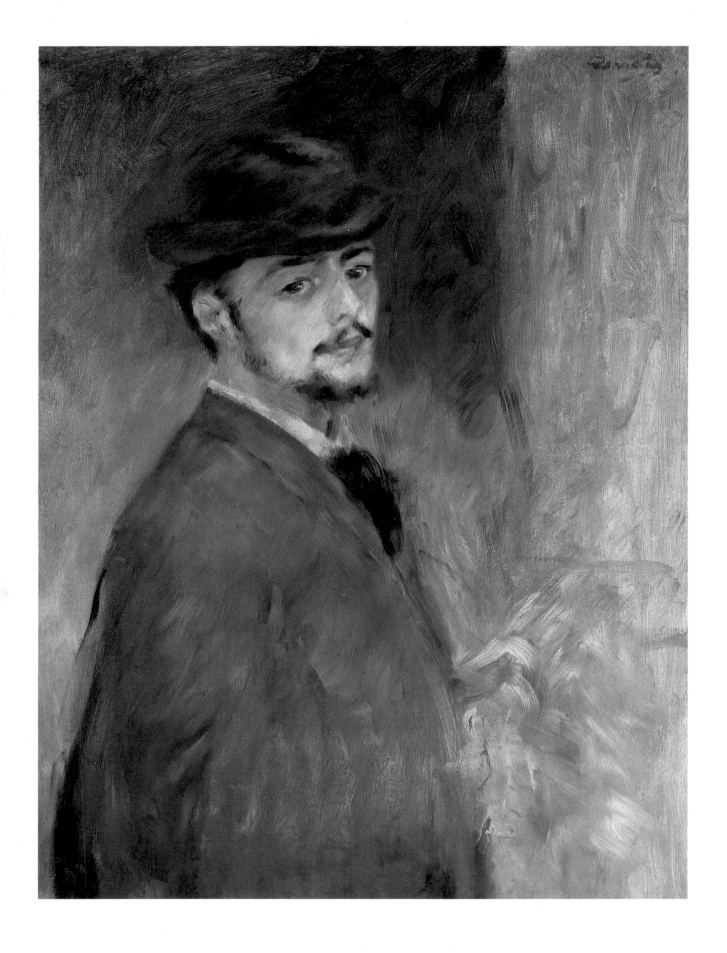

Renoir:
Self-Portrait, c. 1876.

Studying art with Bonnat, it was probably through him that Caillebotte met Degas, and through Degas, the group. His friends could not sell their pictures, so Caillebotte began buying them. Manet's and Monet's railway stations, Pissarro's peasants, Renoir's open air cafés, the *Ball at the Moulin de la Galette*, bought by Caillebotte (who inherited a fortune and became a generous patron of his friends) were all "subjects" that were taboo. For Caillebotte the painter, the subject of this ball was the light; he would probably not have been a patron of the arts if he had not been a painter. Floor scrapers are only fit to be models.

Painter and patron of painters

Caillebotte
Renoir

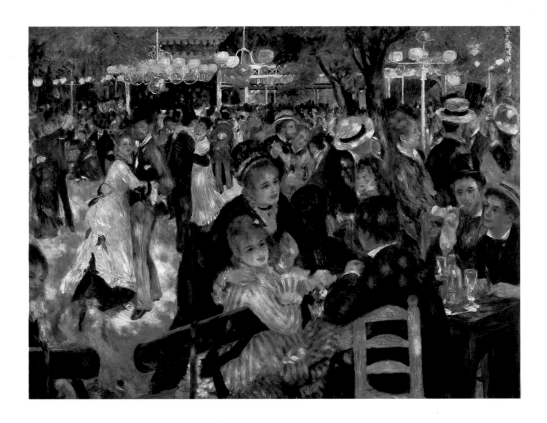

Renoir: Ball at the Moulin de la Galette, 1876.

Caillebotte: The Floor Scrapers, 1875.

Caillebotte is exhibiting *The Floor Scrapers* and *Young Man at a Window*, with an astonishing relief effect. The trouble is that this kind of painting is anti-artistic; it is bright as glass and bourgeois, because of overemphasis on exactitude. It is a photograph of reality, and when this is not enhanced by the original imprint of an artistic talent, it is a pitiful thing.

> Emile Zola, "Deux expositions d'art au mois de mai" (Salon of 1876 and Second Impressionist Exhibition), in *Le Messager de l'Europe*, St Petersburg, June 1876.

Renoir:
At Argenteuil I also met the painter Caillebotte, the first "patron" of the Impressionists. There was no idea of speculation in the purchases he made from us. All he wanted was to do a service to his friends. He went about it very simply: he only bought the pictures that were considered unsaleable.

> Ambroise Vollard, *Auguste Renoir*, Paris, 1920.

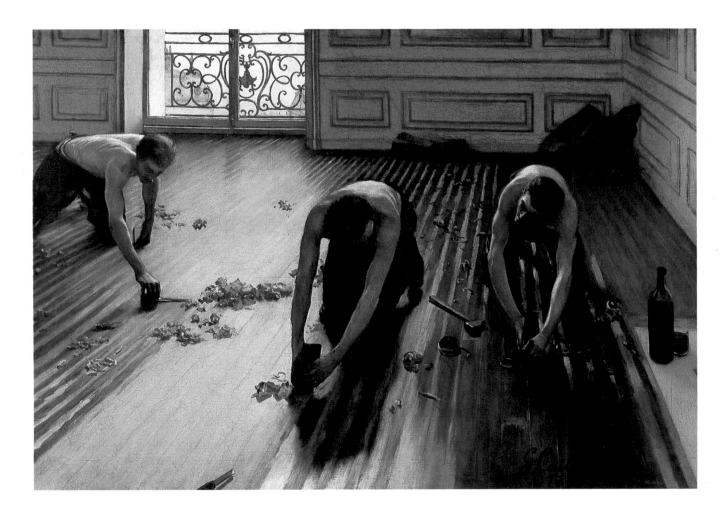

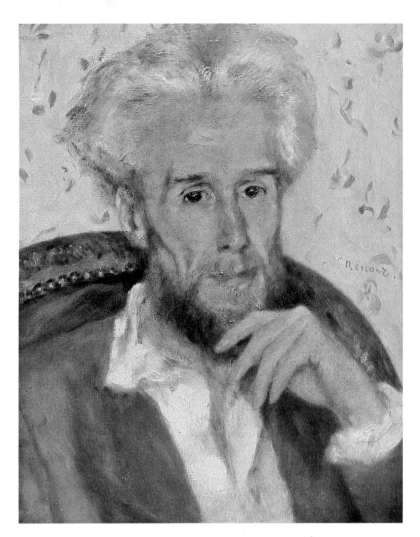

Renoir: Portrait of Victor Chocquet, 1876.

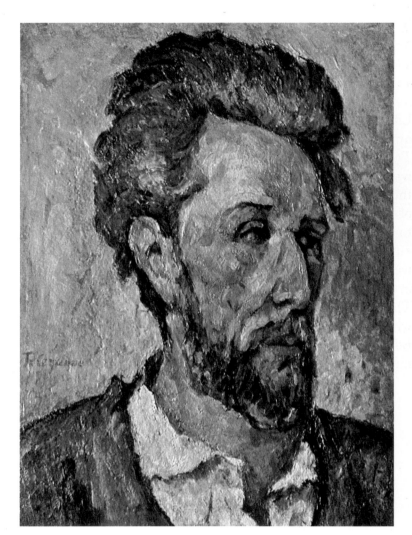

Cézanne: Portrait of Victor Chocquet, 1876-1877.

It was not enough to stand up to intolerance; pictures had to be sold. In 1875 Renoir convinced Monet, Berthe Morisot and Sisley that they would have to hold a public auction at Drouot's. Durand-Ruel was the valuer; Charles Pillet, the auctioneer. The sale was a free-for-all, a mêlée of jeers and insults. In the course of the sale, Georges Charpentier—publisher of Flaubert, Daudet, Maupassant and Zola, as his father before him had been of Hugo, Musset and Sand—bought three Renoirs: a *Head of a Woman*, knocked down at 65 francs, *The Angler* at 180 francs and *Garden with Dahlias* at 120 francs. Victor Chocquet, chief draftsman at the Customs Department, chanced to look in at the sale rooms. The canvases offered for sale by the auctioneers were a revelation to this art-loving civil servant. The next day, he wrote to Renoir and asked him to paint his wife's portrait.

From the time of this sale, Renoir and his friends could count on the missionary zeal of Chocquet and the backing of the Charpentiers by their purchases and commissions. The 1875 sale was the beginning of a new era in the life of the Impressionists. From then on, they had to be taken into account. Chocquet contributed the guarantee of a private collection, his own, which already included works by Corot and Delacroix, and Charpentier and his wife opened their hospitable home to them, where they made useful contacts and were helped to gain access to the Salon.

Madame Charpentier's drawing room was the rendezvous of all the celebrities in Paris in the world of politics, literature and the arts. The regular frequenters of the house were such men as Daudet, Zola, Spuller, the two Coquelins, Flaubert, Edmond de Goncourt... The latter's portrait by Bracquemond is striking. Very cold, pretentious, embittered...

To come back to Madame Charpentier, she was not content with merely inviting artists to her evening parties. To defend the cause of impressionist art, she gave her husband the idea of creating *La Vie Moderne*, to which we contributed. We were to be paid out of future profits; in other words, we never got a penny. But the worst of all was that, for our drawings, we were expected to use such paper! We had to apply a scraper in order to render the whites; I could never get used to this. The editor in chief of *La Vie Moderne* was Bergerat. Later, when Charpentier dropped the journal, my younger brother Edmond took over the editorship. But the journal was running out of steam and soon folded up.

<div align="right">

Ambroise Vollard, *Auguste Renoir*, Paris, 1920.

</div>

Renoir was the first to understand that he would get no orders for pictures this way. And so, as he needed to live, he began submitting again to the official Salon. For this he was treated as a renegade. I'm all for independence in everything; and yet I confess that Renoir's conduct struck me as being perfectly reasonable. You have to realize what an admirable source of publicity the official Salon is for young artists. Our customs being what they are, it is there and there alone that they can seriously triumph. Certainly, let the artist stay independent in his works, let him lose nothing of his temperament, but let him then fight it out in broad daylight, in the conditions most favourable for victory. It is a simple matter of opportunism, as our politicians would say.

<div align="right">

Zola, "Le naturalisme au Salon" in
Le Voltaire, Paris, 18-22 June 1880.

</div>

Renoir: Madame Charpentier and her Children, 1878.

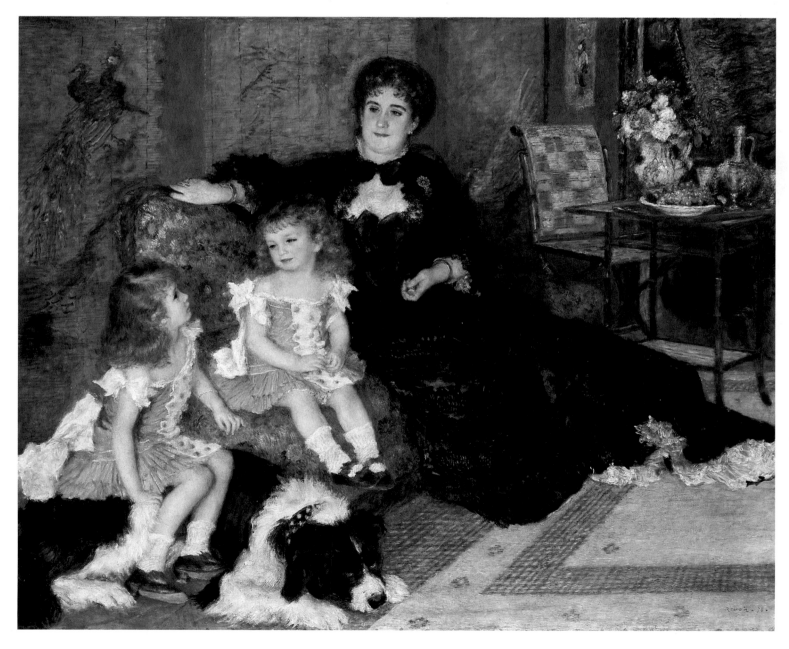

So many enchanting things, so many remarkable works and even masterpieces accumulated in [Durand-Ruel's] exhibition rooms in the Rue Le Peletier. Nowhere and at no time has such an exhibition been offered to the public.

<div align="right">Georges Rivière in L'Impressionniste, Paris,
6-27 April 1877.</div>

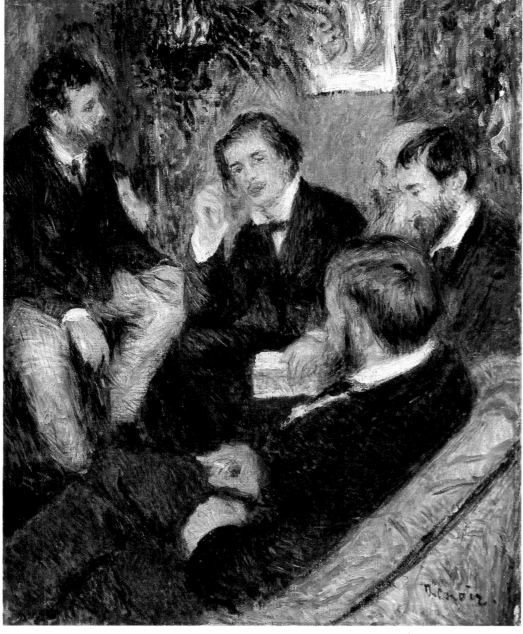

Renoir: The Artist's Studio, Rue Saint-Georges, 1876.

In the studio he rented from October 1876 in the Rue Saint-Georges, Renoir received his faithful friends and fellow non-conformists, Pissarro, Franc-Lamy, Cabaner, Lestringuez and Rivière. Franc-Lamy was illustrating Cabaner's songs. Cabaner set to music the poems of Baudelaire, Mallarmé and Charles Cros. A notorious bohemian, the friend of Verlaine and also of Rimbaud, whom he had put up in Paris in 1871, Cabaner only accepted the company of persons he considered "outsiders." Renoir was one. Lestringuez and Rivière, both civil servants, the former at the Ministry of the Interior, the latter at the Treasury, were others but in a different way. During the third impressionist exhibition in 1877, Rivière published a review called *L'Impressionniste*. The four numbers he brought out were no recommendation for promotion in a Ministry, the more so since a hostile public and press scorned both the impressionist school and the review as "a platform for self-seekers and malcontents."

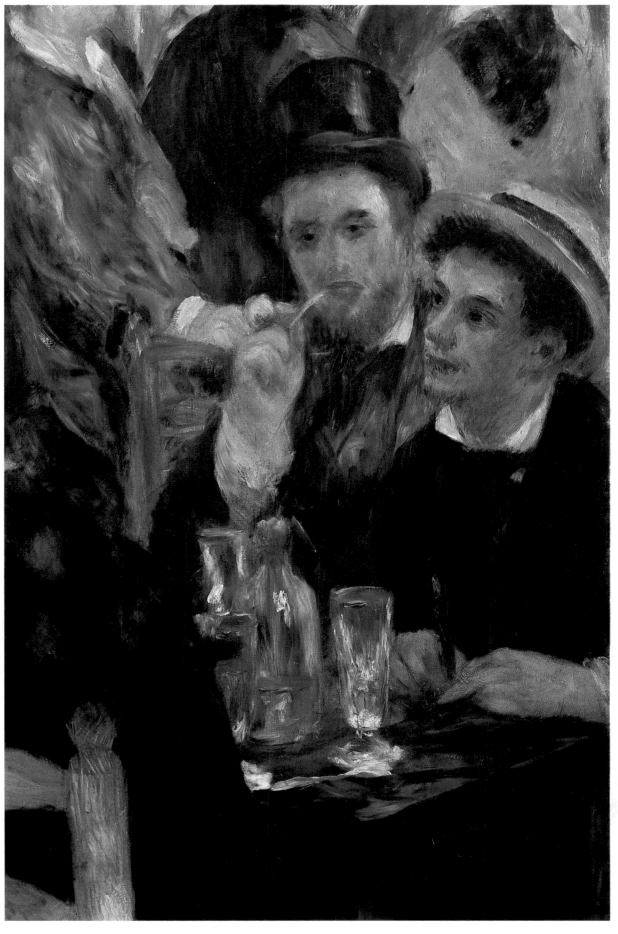

Renoir: Ball at the Moulin de la Galette, detail, 1876.

Seen as a whole, the exhibition of the Impressionists looks like a collection of freshly painted canvases smeared with floods of cream flavoured with pistachio, vanilla and gooseberries.

Baron Grimm in *Le Figaro*, Paris, 5 April 1877.

Since the famous *Salon des Refusés* of jovial memory, nothing like it has been seen. It is sheer madness, a deliberate romp into the horrible and abominable.

Georges Maillard in *Le Pays*, Paris, 9 April 1877.

"Bal des Canotiers" (Boaters' Dance-Hall) at Bougival. Period photograph.

Valuable counsels

The advice and help the Impressionists gave each other were of many different kinds. Caillebotte did not know how to paint a fan. Degas wrote to him:
"My dear Caillebotte,
"I've painted fans on silk and cambric. I recommend raw cambric. Go to Toupillier, the fan-maker, 2 Boulevard de Strasbourg, and ask him for prepared cambric. He has very good, even grained material. I've bought it from him several times.
"You can stretch it, or not, on cardboard or Bristol board. The easiest way is to stick it straight on to Bristol board. When you want to mount it, you just pull it off. I used watercolours and gouache white. I've experimented with gold and silver powder or the coloured powders you can get from dealers in trimmings for flowers; they hold with gum-water."
Another call for help, this time from Monet to Caillebotte:
"Giverny, 14 September 1891
"Dear Friend,
"Your boat would be a big help to me just now. I'm painting a lot of pictures on the river Epte and am very uncomfortable in my Norwegian rowing boat. If you really don't need it, send it to me either by steamer to Vernon or Port-Villé lock, or by rail. Rail would be the most practical, I think.
"Drop me a line anyway.
"Best wishes, Claude Monet.
"If the boat is stable and big enough, it will be most useful to me."
Monet was hard up. Manet wrote to Duret:
"I went to see Monet yesterday. He was gloomy, altogether in the dumps. He asked me to find him someone who would take any ten or twenty of his pictures, for a 100 francs apiece. Would you like us to do it between us, say 500 francs each?
"Of course, no one, Monet above all, must know that we are the purchasers. I thought of asking a dealer, or a collector, but am afraid they might refuse.
"Unfortunately, only someone like us, who knows their value, would be prepared, despite any reluctance he might feel, to make this excellent purchase of pictures and at the same time render a service to a talented artist. Reply as soon as possible, or let me know where we can meet."
Caillebotte made himself Monet's dealer. He wrote to him (1 May 1879):

"My dear Friend,

"I've just received your two canvases, both are torn. Was it by you? I'm having them mended. Tomorrow they will be at the Exhibition. One of them, the larger, is almost sold to Miss Cassatt. She has told me to ask you the price. I said I supposed you would let it go for about 350 francs. Both are very fine, especially the *Grey Weather*. You won't get anything better on the Avenue de l'Opéra."

The main help they gave each other was, however, through their mutual study and criticism of each other's works. The views they exchanged were their strength, because they confirmed the justice of their cause and identified the features that made them unique. Antonin Proust recalled how Manet "after standing for a long time one day, at Théodore Duret's, admiring a snow effect by Monet, said simply 'I won't try to paint anything similar. I couldn't'." In 1873 Pissarro convinced Duret: "Don't be afraid of making a mistake about Monet's talent. In my view it is very considerable and very pure, judged by other standards than yours. His art is carefully thought out, based on observation and quite a new kind of sensibility; it is poetry composed through the harmonizing of pure colours. Monet worships at the shrine of Nature." Some months later, Pissarro wrote to Duret again: "If you are looking for something out of the ordinary, I think Cézanne might be the man for you. He has some very strange studies, seen in a unique way of his own."

Berthe Morisot gave her opinion of Renoir: "A master of line. All his preliminary studies for a picture should be shown to the public, who generally imagine that the Impressionists work with dashing recklessness. I don't think anyone could surpass him in the rendering of form." Renoir gave his of Degas: "When one paints a brothel, it is often pornographic, but always desperately sad. Only Degas can give such subjects a joyful air together with the austerity of an Egyptian bas-relief. It is this near-religious and so chaste aspect of his work that makes it so great, and it is even more marked when he paints a prostitute." Renoir recalled how "A Degas nude, a charcoal drawing, impressed itself on my eyes. It was the only thing you could see in the room. It was like a piece of the Parthenon." "After Chartres," he added, "I know only one sculptor, Degas." Pissarro had the same high praise for him: "This confounded Degas, he has the answer every time, even with landscapes."

In 1895 Vollard opened the first Cézanne exhibition. Pissarro visiting it discovered "still-life studies with an amazing finish and unfinished pictures truly extraordinary for their untamed, rugged character. I don't think they will be much understood." A week later, Pissarro was there again: "Curiously enough,

while I was admiring this odd, disconcerting aspect of Cézanne's work, which has impressed me for many years, Renoir came in. My enthusiasm was only that of a St John heralding Renoir's fervour. Degas himself was won by the charm of this element of refined savagery in Cézanne; Monet as well, indeed all of us. As Renoir said to me very rightly, there is an undefinable resemblance to the crude yet marvellous remains of Pompeii."

Pissarro and Cézanne were looking at Monet's cathedrals. Pissarro: "Extraordinary mastery. Cézanne, when I met him yesterday at Durand's, agreed with me that they are the work of a determined, well-balanced artist seeking to suggest inexpressible subtle shades and effects, and succeeding better than any other painter I know."

In January 1899, hearing that Sisley was ill, Pissarro wrote: "I consider him the equal of the greatest masters. I have seen works by him of rare scope and beauty, among others a *Flood*, a real masterpiece." Had he forgotten what he said twelve years before? "Sisley is as always very skilful, quite sensitive, but wholly false." This criticism was made when Pissarro alone of all the Impressionists had opted for the theories of Seurat, with the result that just as, in his eyes, Sisley was "false," so Monet seemed to him "to give the impression of lacking light" and Renoir was "incoherent, because he could not draw and had lost the attractive tones he had sensed instinctively before."

The long history of the Impressionists is made up of praise and quarrels, rancour and admiration, anger and respect. Berthe Morisot wrote to Monet in 1889: "My dear Monet, may I have your permission to drop the Dear Sir and address you as a friend?" That same year Duret replied to Caillebotte: "What you wrote to me about the quarrel between Monet and Renoir made sorry reading. It is sad to see people who have gone through hard times together as friends separate as soon as success comes to them in different measure!" And Pissarro sighed:

"Are we going to be jealous of each other? Frankly, it's enough to make you sit tight in your corner and throw in your hand.

"Good-bye, my dear Monet.

"Very sincerely, C. Pissarro."

The portraits they painted of each other show how close their relations were. All the pictures in which they appear together were painted *before* 1880. They had been painted before the portrait of *Madame Charpentier and her Children* forced open the doors of the Salon and won them praise on account of the model. They stopped painting themselves together when they stopped being the only ones to look at, and see each other.

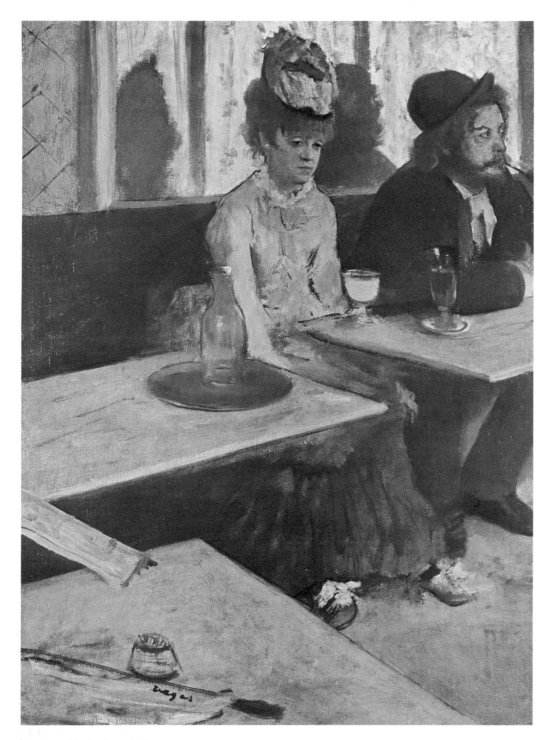

Degas: Absinth, 1876.

Just as at the Brasserie des Martyrs in the Rue des Martyrs, Courbet and his friends had forgathered, so at the Café Guerbois, 11 Grand-Rue-des-Batignolles, Manet's friends met. Manet dropped in almost daily on his way from his studio in the Rue Guyot to 34 Boulevard des Batignolles, where he lived until 1867; and his friends could be sure of finding him there every Friday evening. It was at the tables of the Guerbois that the artists decided to exhibit together *before* the Salon, so that their show could not be mistaken for another Salon des Refusés. After the war, they left the Guerbois for the Nouvelle Athènes, Place Pigalle.

Essential contacts were made in the cafés, and not only in the studio. At the café, a meeting place for conversation, comments and criticism, painting was analyzed and discussed. In the studio, at work on a subject, the artist painted as best he could; in the café, he decided how he would like to paint.

It was five o'clock and the group called for more beer. Habitués from the neighbourhood had invaded the nearby tables, and these bourgeois looked at the artists in the corner with side-glances in which disdain was mixed with an uneasy deference. They were well known, a legend was forming around them. They were talking now of stupid things, the hot weather, how hard it was to get a seat in the Odéon bus, their discovery of a wineshop where you could get real meat to eat. One of them wanted to start a discussion about a heap of wretched pictures that had just been hung in the Luxembourg Museum. But they were all of the same opinion: the frames were worth more than the canvases. And they had no more to say, and sat smoking, exchanging an occasional word and a smile of understanding...

Zola, *L'Œuvre*, Paris, 1886.

Degas spends his time talking at the Nouvelle Athènes café or in society. He would be better advised to do a little more painting. How right he is, a hundred times over, in what he says, how witty he is and knowledgeable about painting, nobody can have any doubt about that (and is this not the brighter side of his reputation?). But the fact remains that a painter's truest arguments are his painting, and however right he may be in all he says, he is at his truest in his work.

Gustave Caillebotte, letter to Pissarro,
24 January 1881.

Suzanne Valadon, c. 1880. Photograph.

The Café de la Nouvelle Athènes at Montmartre. Period photograph.

G.C.A., Paris **794 Montmartre. — La rue Pigalle — Nouvelle Athènes.**

131

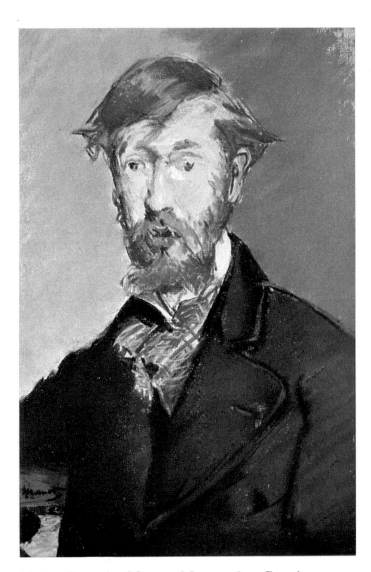

Manet: Portrait of George Moore, 1879. Pastel.

Manet on George Moore:
Is it my fault if Moore looks like a crushed egg-yolk and his mug is out of proportion?

Moore was a dandy of the Batignolles quarter of Paris. When Manet exhibited his famous pastel of him, the sitter shared with the painter the insults of the public. This thing, a portrait? A mere caricature: pink hair, the colour of barley sugar, with locks like stalactites, pale eyes making no mark in the pale face. Moore is wearing a high collar, turned down at the corners, a bow tie like Manet himself, and the pout of a sulky child which rejoices those who do not know this curious personage.

Jacques-Emile Blanche, *Mes Modèles*, Paris, 1928.

I did not go to either Oxford or Cambridge, but I went to the Nouvelle Athènes. What is the Nouvelle Athènes? He who would know anything of my life must know something of the academy of the fine arts. Not the official stupidity you read of in the daily papers, but the real French academy, the café. The Nouvelle Athènes is a café on the Place Pigalle. Ah! the morning idlenesses and the long evenings when life was but a summer illusion, the grey moonlights on the Place where we used to stand on the pavements, the shutters clanging up behind us, loath to separate, thinking of what we had left unsaid, and how much better we might have enforced our arguments. Dead and scattered are all those who used to as-

Around the fountain in the Place Pigalle, the painters found models waiting for them. One of them, Victorine Meurent, who posed for Manet's *Olympia*, became herself a painter: in 1876, her self-portrait was hung in the Salon, affording a subject for gossip at the Nouvelle Athènes. One day, Manet was worried lest their conversation should disturb a young man who was correcting proofs at a nearby table. It was George Moore, the future novelist. Twenty when he came from Ireland to Paris in 1872 to study painting in Cabanel's studio, Moore had been waiting for months for someone to speak to him. Every day he dropped into the Nouvelle Athènes and the studios of one painter or another; the same as Zandomeneghi, nicknamed Zando or the Venetian, who arrived in Paris a few weeks after the 1874 exhibition at Nadar's, and also Degas. In 1885, when Degas painted Suzanne Valadon, then a model, and his own portrait in the mirror under the reflected light from the globes of a chandelier, the Nouvelle Athènes was still the Impressionists' rendezvous. Jokes, advice and projects were among their topics. Their relations were many and various, ranging from the settlement of old scores to the exchange of compliments and help. The café was their Academy.

semble there, and those years and our home, for it was our home, live only in a few pictures and a few pages of prose. The same old story, the vanquished only are victorious; and though unacknowledged, though unknown, the influence of the Nouvelle Athènes is inveterate in the artistic thought of the nineteenth century.

How magnetic, intense, and vivid are these memories of youth! With what strange, almost unnatural clearness do I see and hear–see the white face of that café, the white nose of that block of houses, stretching up to the Place, between two streets. I can see down the incline of those two streets, and I know what shops are there; I can hear the glass door of the café grate on the sand as I open it. I can recall the smell of every hour. In the morning that of eggs frizzling in butter, the pungent cigarette, coffee and bad cognac; at five o'clock the fragrant odour of absinthe; and soon after the steaming soup ascends from the kitchen; and as the evening advances, the mingled smells of cigarettes, coffee, and weak beer. A partition, rising a few feet or more over the hats, separates the glass front from the main body of the café. The usual marble tables are there, and it is there we sat and aestheticized till two o'clock in the morning...

Zandomeneghi: At the Café de la Nouvelle Athènes
(Self-Portrait with Suzanne Valadon), 1885.

Degas: At the Louvre (Miss Cassatt),
c. 1879.
Pastel.

Mary Cassatt knew from experience that the Salon could not abide bright colours. In 1875 a portrait of hers was rejected; she darkened the background and in 1876 it was accepted. She saw Degas's work for the first time at the Durand-Ruel Gallery. In 1877 Degas invited her to exhibit with the Impressionists; she would not need to darken her palette any longer. She posed for Degas several times, at the dressmaker's and the Louvre. She passed the months of the Franco-Prussian war at home in America, at Philadelphia and Chicago. Since her return to Europe, she had copied picture in the museums of Italy, Spain, Belgium and Holland. A necessary apprenticeship. What the Salon offered was a strictly ordered and regulated hierarchy of kinds of painting. Galleries exhibited collections, pictures in the plural. What the Impressionists went to see in museums were pictures individually, in the singular. The Impressionists opened the eyes of the public to the truism that pictures are painted solely to be seen.

I dream of something well done, a well-ordered whole (Poussin style) and the old age of Corot.

> Degas, letter to Henri Rouart, New Orleans,
> 5 December 1872.

I cannot make an end of putting the final touches on pictures, pastels, etc. How long it is, and how sad to see my last good years trailing off into mediocrity! I often weep over my poor life.

> Degas, letter to Henri Rouart, Paris,
> 8 August 1873.

I've been on the point, a half a dozen times, of asking Degas to come and see my work, but if he were ill-disposed he would demolish me so completely that I should not be able to get over it in time to finish for the exhibition. Yet he is the only man I know whose opinion could be useful to me.

> Mary Cassatt, letter to Mrs Palmer,
> 1 December 1892.

I went and flattened my nose against that window [of the Durand-Ruel gallery] and absorbed as much as I was capable of. It changed my life. I then saw art such as I wished to see it.

> Mary Cassatt, letter to Mrs Havemeyer.

Degas on Mary Cassatt:
Someone who has the same feelings I have.

> Achille Segard, *Mary Cassatt*, 1913.

Yesterday I spent my afternoon in the studio of a painter named Degas. After many tentative efforts, pushing out in all directions, he has got enamoured of the modern, and in the modern he has focused his eye on laundresses and dancers. I cannot see that it is a bad choice, for in *Manette Salomon* I extolled these two professions as providing the most pictorial models of women for an artist of today... An original fellow, this Degas, morbid, neurotic, with eye trouble so serious that he is afraid of losing his sight, but by this circumstance a peculiarly sensitive man... Up to now he is the man I have seen who, in copying modern life, best catches the spirit of that life.

> Edmond de Goncourt, *Journal*, 13 February 1874.

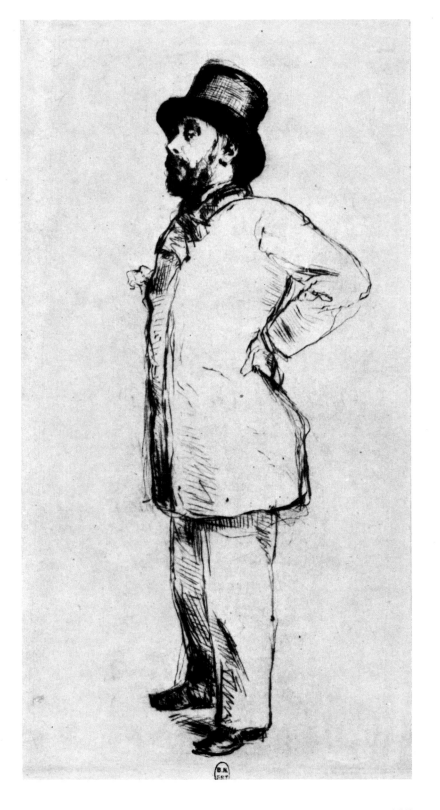

A truism
Degas
Mary Cassatt
Desboutin

Desboutin: Portrait of Degas, c. 1876. Etching.

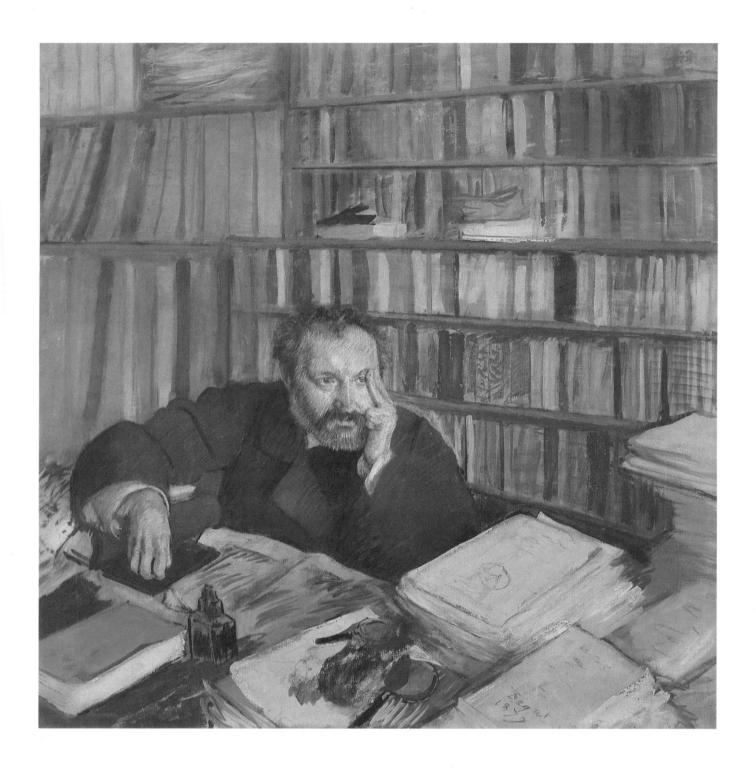

Cracks in the wall

Duranty
Martelli
Degas

In 1879, the first signs of the break-up of the impressionist group. Renoir held aloof from their exhibition at 28 Avenue de l'Opéra. His portrait of *Madame Charpentier and her Children* was acclaimed in the Salon. (This concession, regarded as cowardice and betrayal by some, set an example that would be followed.) Gauguin exhibited with the group for the first time, although his name was not in the catalogue. Public disapproval was less violent; Seurat and Signac were among the visitors. Degas wanted this fourth group show to be called "Exhibition of Independents," and it was the first that did not leave them in debt;

A score of painters owe their success to contact with Degas, for you could hardly approach him without getting in the way of the sparks.

<div align="right">Edmond Duranty in Gazette des Beaux-Arts, Paris.</div>

Study of the beautiful and study of the ugly are closely akin. And by his very nature Degas had to marry and balance out these two contraries in a wholly original expression of his own, where the primitives' sense of the "true" is adorned with the light and phosphorescent sparkle of our time.

<div align="right">Diego Martelli, "The Impressionists,"
lecture at Leghorn, 1879.</div>

I've had a visit from Desboutin and the Italian man of letters [Diego Martelli]. The latter is very enthusiastic about this painting. He esteems my art so highly that I'm bewildered and can hardly believe it. I myself scarcely understand what I am after. Can a stranger see more in it than I do myself? How very odd.

<div align="right">Pissarro, letter to Eugène Murer, 1878.</div>

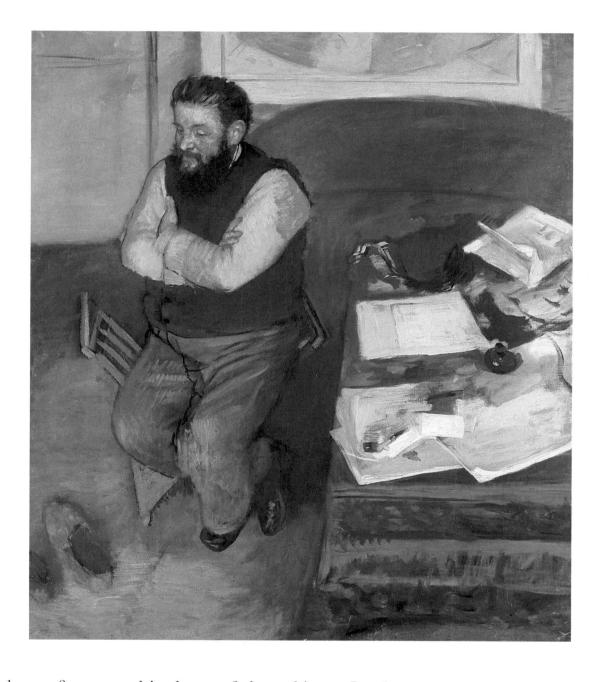

Degas:
◁ Portrait of Edmond Duranty, 1879. Tempera and pastel.

▷ Portrait of Diego Martelli, 1879.

indeed each exhibitor received 439 francs as his share of the takings. In the *Gazette des Beaux-Arts*, Duranty published an article praising each of them. Diego Martelli took notes for a lecture he had to give in Italy. Duranty, who had analyzed Impressionism in 1876 in his study on *The New Painting*, as Martelli had analyzed the Macchiaioli, considered Degas to be the most striking and decisive personality of the group. In 1879 the Salon was less impervious to novelty. Articles and studies defining Impressionism were being published; and the unity of the group was breaking down.

Friends from opposing sides

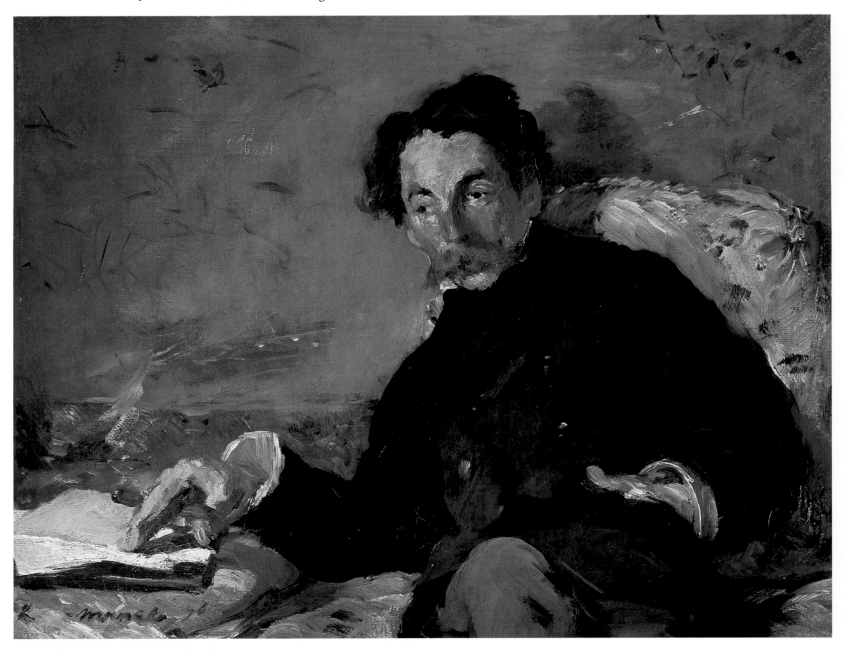

Manet: Portrait of Stéphane Mallarmé, 1876.

Manet had friendships which largely consoled him for these rebuffs. I am thinking now of his friendship with Stéphane Mallarmé. The latter was a shy and modest man. Armed with the sublime instrument of the poet, enamoured of fine prose, passionately fond of the rhythmed accords of pure elocution, he pursued his dream of a soaring imagination which was pleased with everything, and satisfied with nothing.

The first time I saw him was in Manet's studio. At that time he had the full beauty of youth. The eye was large, the nose stood out straight above a thick moustache set off by the clear line of the lips. Under the thick hair was a well-developed brow. The beard tapered down to a point, standing out against a dark tie which coiled round the neck.

We spoke of the poems of Edgar Allan Poe, which he had translated, and for which Manet was preparing illustrations. Mallarmé's voice was slow and sonorous. Words followed words, chosen with concern for the right tonality. The gestures were sweeping.

Manet
Mallarmé
Carolus-Duran

Literate in the highest sense of the term, in love with language, he was fond of pagan evocations, fond of restoring bygone Olympuses, and liked to enshrine his thoughts in phrases of an antique sobriety, but of so personal a turn that a single page of his, when one knows how to read it, tells you more than volumes spawned by the fecundity which pleases our age.

Antonin Proust, *Edouard Manet, Souvenirs*, Paris, 1913.

138

I go on to Carolus-Duran, and now it is a very different story. Few artists have been so lucky. His very first pictures were crowned with success, a noisy and ever increasing success. He draped himself in the pretensions of a great colourist, of a bold innovator, who carried boldness just far enough to intrigue the public. He belongs to that race of happy temperaments who seem on the verge of overthrowing everything, from top to bottom, but who in reality behave quite reasonably... To get credit for originality without having any–that is the peak of success! The public exclaims: God be praised, here is a bold, individual artist, but one that we can understand; here is originality that suits us! And nothing is so harmful to genui-

nely original artists as this sham originality, for the public is convinced that one can be a Delacroix without renouncing the pretty ways of Bouguereau.

Emile Zola, "L'Ecole française de peinture à l'Exposition universelle de 1878" in *Le Messager de l'Europe*, St Petersburg, July 1878.

Carolus-Duran is clever. He makes Manet comprehensible to the bourgeois; he takes inspiration from him only up to a point, and seasons him to the taste of the public.

Emile Zola, "Une exposition de tableaux à Paris" (Salon of 1875) in *Le Messager de l'Europe*, St Petersburg, June 1875.

Carolus-Duran: Portrait of Manet, 1877.
Etching.

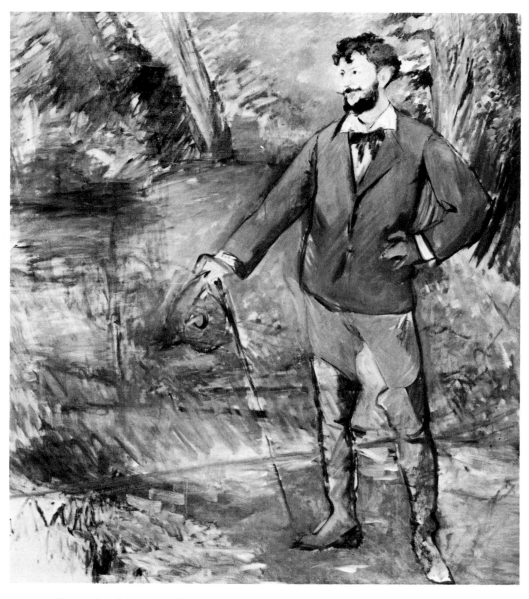

Manet: Portrait of Carolus-Duran, 1876.

Carolus-Duran, Salon medallist in 1866, 1869 and 1870, Knight of the Legion of Honour in 1872, Officer in 1878 and awarded a medal of honour at the 1879 Salon, garnered one distinction after another, gaining substantial orders for pictures. At the time of the Salon des Refusés, he sided with Manet. Since they first met at the Académie Suisse, the two men had been firm friends. They saw each other every day. And Manet saw Mallarmé every day also. He drew illustrations for Mallarmé's translation of Poe's *Raven* and made woodcuts for *The Afternoon of a Faun*, and when the Salon rejected Manet once again, Mallarmé

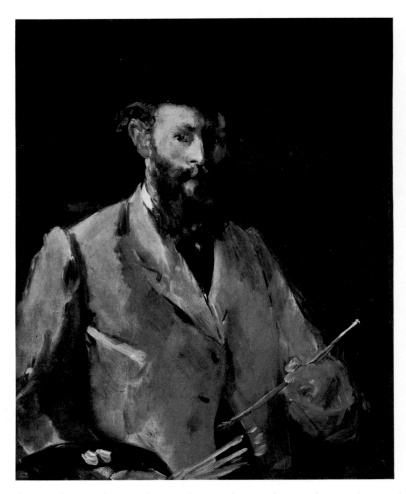

Manet: Self-Portrait with Palette, c. 1879.

Manet:
Monsieur Wolff? He and I fit together no better than pieces of the true cross, which seems to please this critic. Ten years from now all this won't be worth a farthing candle.

Antonin Proust, *Edouard Manet, Souvenirs*, Paris, 1913.

A strange make-up indeed is that of Monsieur Manet. He has a painter's eye, but not a painter's soul.

Albert Wolff in *Le Figaro*, Paris, 17 April 1875.

Their little annual show opened on the first of April in an untenanted mezzanine in the Rue des Pyramides. But I was in no hurry to go and see these things. There, apart from a few sketches of great interest, one beholds only worthless canvases, painted by madmen who take stones for fine pearls. I make an exception for Degas and for Berthe Morisot. All the rest is not worth looking at, not worth even talking about. It is pretentious and it is nothing. No skill, no studies, ill-proportioned figures, always the same empty daubing. These men do not change. They can forget nothing because they have learned nothing. Why does a man like Degas linger on in this cluster of nonentities? Why does he not do as Manet did, who deserted the Impressionists long ago? He could not be bothered to go on dragging behind him the tail of this detestable school.

Albert Wolff in *Le Figaro*, Paris, 9 April 1880.

wrote an article of protest in the *Renaissance Artistique et Littéraire* (12 April 1874). Carolus-Duran was an academic painter; Mallarmé, a revolutionary poet. Envying Carolus-Duran his success and recognizing the stern choice made by Mallarmé, Manet yearned to be like the latter, while enjoying the honours of the former. Manet painted the portrait of Albert Wolff, the *Figaro* critic, who poured scorn on him in article after article.

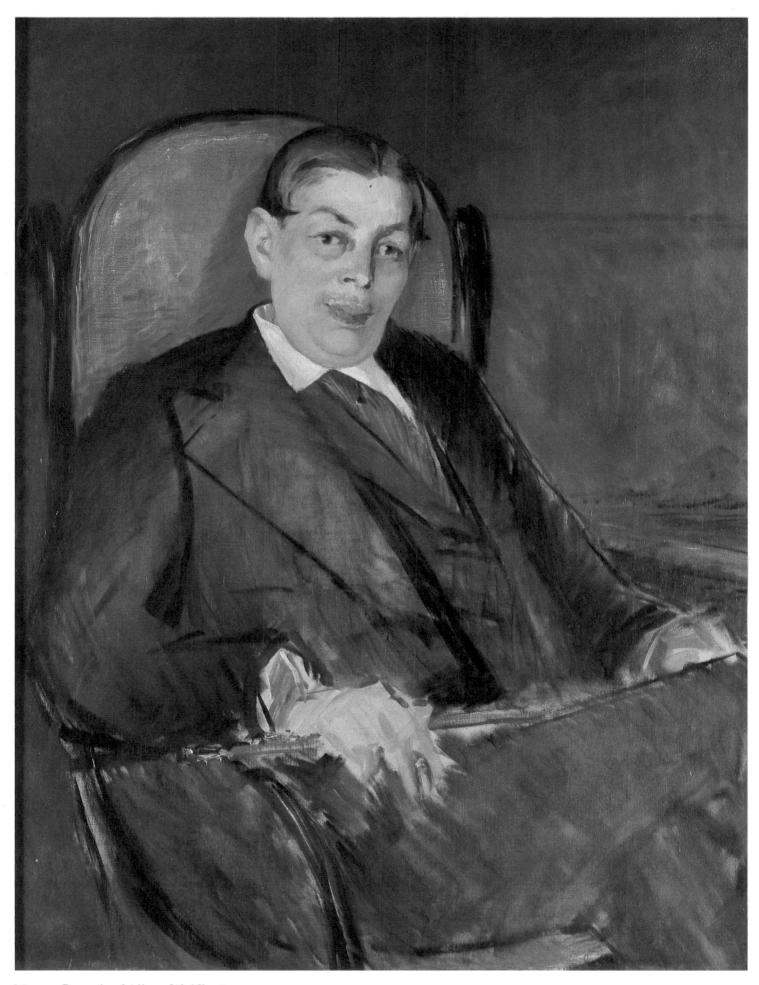

Manet: Portrait of Albert Wolff, 1877.

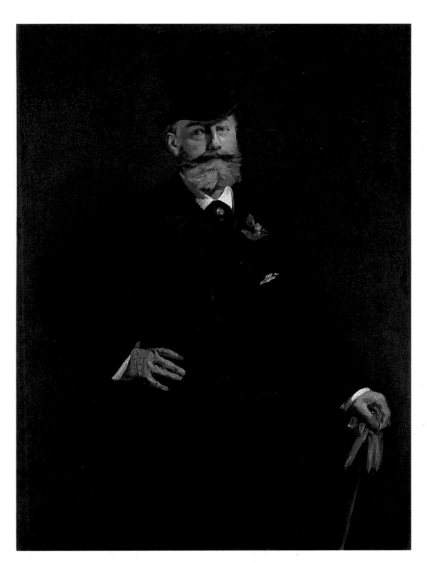

Manet: Portrait of Antonin Proust, 1880.

Edouard Manet has been one of the tireless workers of naturalism and he remains today its soundest talent, the one who has shown the subtlest, most original talent in the sincere study of nature. At this year's Salon he has a very remarkable portrait of Antonin Proust... Fourteen years ago I was one of the first to defend Manet against the foolish attacks of the press and public. Since then he has worked hard and is still struggling, but gaining recognition from men of intelligence by his rare artistic qualities, the sincerity of his efforts, the so bright and distinguished originality of his colour, the very naïveté which he has always had in front of nature. His is a life entirely and courageously devoted to art, and some day people will recognize the key position he has occupied in the transitional period which our French School is now passing through. He will stand out as its most characteristic, most interesting, most personal figure. But even now one can measure his importance from the decisive part he has played for twenty years. It is enough to note the influence he has had on all the young painters who have come after him.

Emile Zola, "Le naturalisme au Salon" in
Le Voltaire, Paris, 18-22 June 1880.

So, my dear friend, your portrait has been at the Salon for three weeks now, poorly hung on a narrow wall-strip near the door and even more poorly judged. But it's my fate to be disparaged and I take it philosophically. What no one realizes, my dear friend, is how difficult it is to set out a single figure on a canvas and focus all the interest on that one and only figure, without its ceasing to be alive and full. Doing two figures who draw their attraction from the duality of their presence is child's play beside that. Ah! the portrait with a hat, in which, they said, everything was blue! Well, I'm biding my time. I won't live to see it, but some day it will be acknowledged that I saw rightly and thought rightly. Your portrait is a work of the utmost sincerity. I recall as if it were yesterday the rapid, summary way I painted the glove in the ungloved hand. And when at that moment you said to me, "Please, not one stroke more," I felt that we were in such perfect agreement that I could not resist the urge to hug you. Ah! if only later on no one takes it into his head to stick this portrait into a public collection! I have always detested that mania for bunching up pictures without leaving any space between the frames, the way the latest novelties are set out on the shelves of fashionable shops. Well, there's nothing I can do about it. I leave it to fate.

Manet, letter to Antonin Proust, 1880.

Manet: My dear fellow, if there were no honours and awards, I would not invent them. But there they are. And when you can, you had better take anything that sets you apart from the crowd. That brings you one stage onward, and it is also a weapon. In this dog's life of ours, which is a daily struggle, you cannot be too well armed. I have received no awards. But that is not my fault, and I assure you that if I can get them I will! And I'll do whatever is necessary for that.
Degas (breaking in angrily and shrugging his shoulders): Of course you will. I haven't waited till now to find out what a bourgeois you are!

Joseph de Nittis, *Notes et Souvenirs*, Paris, 1895.

Edouard Manet, Manet the revolutionary, the intransigent, the insurgent of painting, Manet the terror of the academicians and the scarecrow of the bourgeois, this Manet bows down in delight before the medal which shines for him as the sun shines for everyone else! Bend your head, proud Sicambrian! You have as many medals as the common run of martyrs!

Jules Claretie in *Le Temps*, Paris,
24 June 1881.

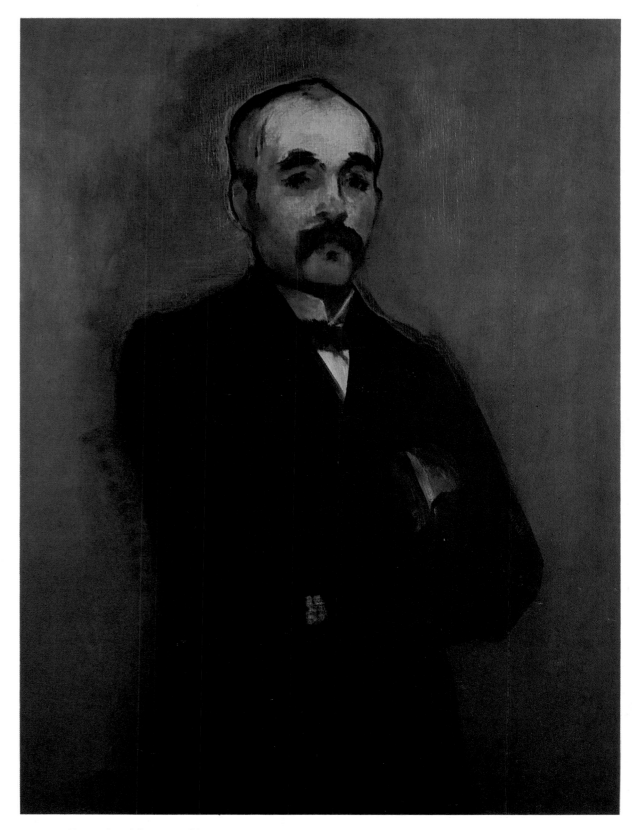

Manet: Portrait of Georges Clemenceau, 1879.

Manet's youngest brother, Gustave, was Clemenceau's alternate on the Paris Town Council. Antonin Proust, who became Minister of Fine Arts in November 1881, had been Manet's friend since they had met in Couture's studio. Gambetta was Prime Minister. Manet met Gambetta at the home of Commandant Lejosne, a cousin of Bazille. Madame Lejosne appears in *Concert in the Tuileries*. Gambetta and Proust proposed Manet for the Legion of Honour in the New Year's Honours list. The President of the Republic, Jules Grévy, refused his approval. Gambetta insisted: a decision incumbent on ministers alone could not be contested by the President. The President signed. Manet became a Knight of the Legion of Honour. Courbet had refused the same award. Manet accepted it, as he had accepted a second-class medal at the 1881 Salon.

History of a constraint

"A constant feature of the history of the Impressionists was their influence on each other and their mutual borrowings. United and launched on the same course, they developed side by side. Their influence on each other was not, however, the imitation practised by people who take over a completed process and copy it slavishly. The Impressionists were artists; they contributed their share to the common stock of invention day by day, each drawing on what the others had discovered but adapting and modifying it according to his temperament."

The history of the Impressionists was not as Duret described it. Their pictures were the outcome of both their exchanges and their differences. That is clear from the history of their only joint undertaking, their exhibitions, marked year after year by abuse, defamation, rivalries, desertions, intrigues and revenge.

Cézanne wrote to Pissarro (2 July 1876): "My dear Friend, I will conclude by saying, like you, that since there is a common tendency shared by some of us, let us hope that necessity will compel us to act together, and that interest and success will strengthen the bonds that good will has often proved unable to consolidate."

The eight impressionist exhibitions (1874 to 1886) only took place while "necessity" compelled the artists to join forces. Letters and comments reveal how difficult agreement was.

Degas to Caillebotte (1877): "Really, Maître Caillebotte, is there nothing to be done? Is that your last word?!!?"

Pissarro to Caillebotte (1878):

"We need men of talent, who are leaving us. We also need new pictures. My advice is that you should inform the parties concerned at once, so that they may set to work...

"Couldn't we hold our exhibition alone? We have to expect some more defections. Our union is a thing of the past. I should like to have seen Monet about this. It is all very regrettable. I fear a complete rout later on. You heard Monet himself; he is afraid to exhibit.

"If the best go away, what will become of our artistic union?...

"Isn't it better to paint good pictures, not to show sketches and to be very critical of our work? What do you think?"

Degas to Bracquemond (1880): "We open on the first of April. The posters will be put up tomorrow or Monday. They are in bright red letters on a green ground. There was a big fight with Caillebotte about including names. I had to give way and let them be included. When will the 'stars' stand down?... Common sense and good taste are helpless against the apathy of the others and Caillebotte's mulishness."

In an interview in *La Vie Moderne* (12 June 1880) Monet said: "I am an Impressionist, but I seldom see my colleagues, men or women. The little chapel has become a second-rate school open to any dauber who comes along."

Caillebotte to Pissarro (24 January 1881):

"My dear Pissarro, what is to become of our exhibitions? In my opinion, it is quite clear. We must go on and go on solely with an artistic aim, in reality the only aim that interests us all. What I want therefore is an exhibition of the work of all those who are or will be really interested in the matter. That will be you, Monet, Renoir, Sisley, Miss Morisot, Miss Cassatt, Cézanne, Guillaumin, Gauguin if you want, Cordey perhaps and myself. That's all, because Degas will refuse to take part in an exhibition on that basis... Degas has spread discord among us. It is unfortunate for him that he has such a cross-grained character...

"He wants us to keep together and be able to count on each other (and how!)...

"It would take a volume to tell all he has said against Manet, Monet and you. If art had been the only question we discussed, we should always have agreed. Degas is the one who has led us astray, and we should be very foolish if we let ourselves suffer on account of his follies. He certainly has immense talent; I am the first to admire him. But let's leave it at that. As a man, speaking of Renoir and Monet he even went so far as to say to me 'Do you receive people like that at home?' His talent is great but not his character. He carries disparagement to the point of rudeness.

"In short, would you like to have a purely artistic exhibition? I have no idea what we shall do a year from now."

Berthe Morisot noted in her diary: "Speaking of Caillebotte, Degas told me one day, 'His talent lies in his hunchback's doggedness'."

Pissarro replied to Caillebotte (27 January 1881): "I am altogether against your idea of treating the question as a matter of art. Art, in my view, is the only subject really fraught with difficulties and calculated to divide us all. It is by no means

certain that by this criterion you, I or even Degas for all his great talent, would be accepted by some artists who let their idiosyncrasies blind their better judgment.

"After your letter, I am afraid I see little chance of our being able to agree. One day perhaps you will realize how unstable are opinions in the world of art."

Caillebotte answered him the next day:

"I am sorry to see you cling to Degas's view, because I am convinced it can only land us in a mess.

"As for the question of art, which you consider the one most likely to divide us, I'm not yet of your opinion. I think we have enough sense to recognize the talent of those who differ from us most widely in sentiment, outlook, etc. I don't know what I shall do. I doubt whether it will be possible to have an exhibition this year."

Berthe Morisot wrote: "The terrible Pissarro has just visited me to talk about our next exhibition. These gentlemen do not seem able to agree."

Caillebotte to Pissarro (1882):

"Obviously we are not getting anywhere. In my view an exhibition as things are now, without Renoir and Monet, would be a bad exhibition. Better not have one at all.

"Even if we could agree, we would not manage to exhibit. It's most disheartening. I'm withdrawing into my shell like Degas (but not like him) to wait for better days."

And Pissarro to Monet (1882):

"I must confess I'm baffled. For the past two or three weeks I've been doing my utmost, with our friend Caillebotte, to find some way of bringing our group together again as homogeneously as possible.

"We can't expect everyone to have the same talent; it's already a lot if no one is obviously out of place.

"I'm too short of time to handle the matter better. We might be able to get together properly before next year. We must. We might also make our group exclusive, or at least make admission more difficult."

Caillebotte to Pissarro (1882):

"Let me tell you something. It's very simple. We have to go back to what I said last year. *It's impossible to arrange an exhibition with Degas.*

"Tell me if I wasn't right: Degas is the only one, *the only one*, who has set us all at loggerheads! What a talent, granted, but what a temper!"

The years went by without any change.

Pissarro to Monet (1885):

"I saw Sisley on Monday. We talked for a long time about exhibitions. He is strongly in favour of them. You know already what he thinks. He has told you the arguments he deems convincing. According to him, we have got to take a firm decision one way or the other within a month. It depends on Durand's attitude. The crisis continues; without an exhibition, we are liable to find ourselves worse off than we were last summer.

"We can hardly wait with folded arms for collectors to ask us for pictures. We can't offer them ourselves, that would be to invite disaster. As Sisley says, we have to exhibit as a means of putting them on offer. There's no other way. But then, the organizing costs have to be met!"

Again: "Degas, Guillaumin, Berthe Morisot, Miss Cassatt and two or three others would be an excellent nucleus for an exhibition. The problem would be to agree among ourselves. In my view, it would be wrong for us to do it on our own (that is to say, through Durand-Ruel); it would look as though we depended on Durand. The exhibition should be launched by the artists themselves and prove it by its composition."

Berthe Morisot to her sister: "This project is very much in the air. Degas's bad temper makes it almost impossible. People stand so much on their dignity in this little group that they make any agreement difficult. I seem to be almost the only one not petty by nature, which is a compensation for my inferiority as a painter."

In 1886 the group exhibition, the eighth and last, finally took place. A few months later Pissarro observed: "Hostilities continue and increase among the romantic Impressionists. They meet regularly. Even Degas turns up at the café. Gauguin has become his close friend again and often goes to see him. Strange, isn't it, this ebb and flow of interests!"

Pissarro (3 December 1886): "It's all over with the Impressionists... Impressionism was only a misunderstanding. The solidarity of the Impressionists was a constraint born of necessity. Impressionism disappeared with that necessity. It was not by chance that the two began and came to an end together."

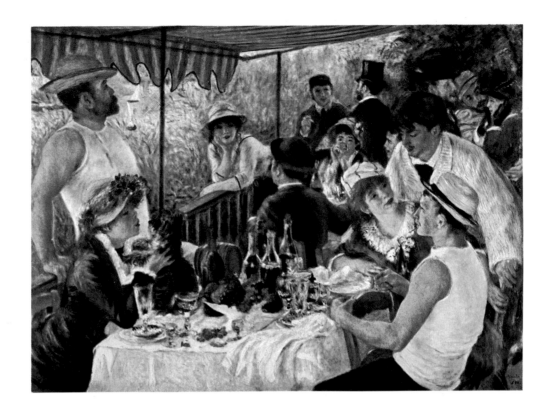

They had sun-darkened faces, and the chest covered only with a thin white cotton jersey which left their arms bare, sturdy arms like those of a blacksmith. They were two solidly built fellows, the picture of manly strength, but in all their movements they showed that elastic grace of limb which a man acquires by exercise, so different from the deformation stamped on the workman by a strenuous effort, always the same.

Guy de Maupassant, "Une partie de campagne" in *La Maison Tellier*, Paris, 1881.

Renoir: The Luncheon of the Boating Party, 1881.

Impressionist Exhibition at the Grafton Galleries, London, in 1905, organized by Durand-Ruel.

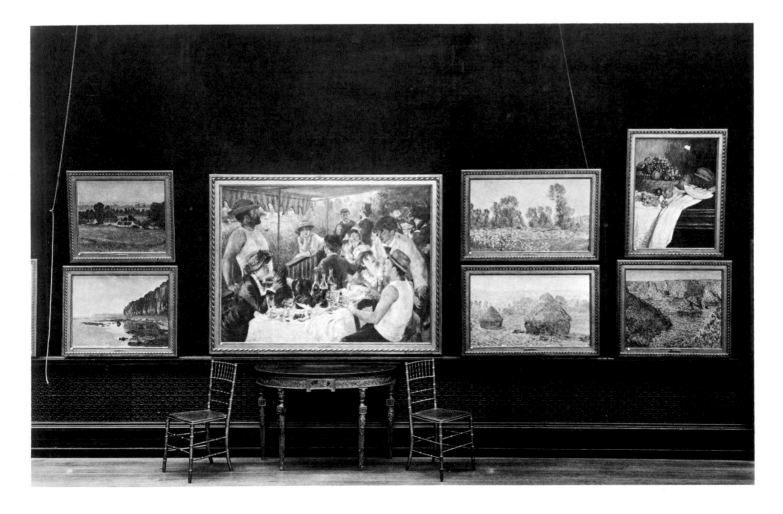

An explanation
Renoir

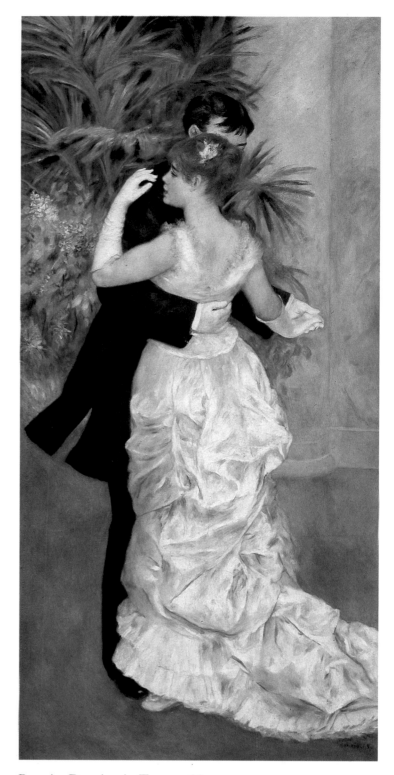

Renoir: Dancing in Town, 1883.

I'm still afflicted with the malady of research. I don't like what I do, and I paint it out, and paint it out again. I hope this mania will come to an end...

I'm like a child at school. The white page must always be evenly written and slap! bang! and there's a blot! I'm still blotting and I'm forty years old. I've been to see the Raphaels in Rome. They are very fine and I should have gone to see them sooner. They are full of knowledge and wisdom. Unlike me he didn't go in search of impossible things. But how fine it is. I prefer Ingres for oil painting. But Raphael's frescoes are admirable in their simplicity and grandeur.

<div align="right">

Renoir, letter to Durand-Ruel, Naples,
21 November 1881.

</div>

Renoir:
People still knew how to laugh in those days. Machines weren't everything in life. We had time to live and we did not fail to do so.

<div align="right">

Ambroise Vollard, *En écoutant
Cézanne, Degas, Renoir*, Paris, 1938.

</div>

Cézanne, like Renoir and Monet, took no part in the fifth group show in 1880. All three submitted works to the Salon. Cézanne was rejected; Renoir and Monet were badly hung. They protested. Cézanne wrote to Zola (10 May 1880) asking him to explain in the papers the importance of the impressionist group. Zola wrote a series of four articles which appeared in *Le Voltaire* (18 to 22 June). They were hardly a defence of the Impressionists. "They have plenty of weaknesses, they are much too careless in their technique, they are too easily satisfied with themselves, they are clearly immature, irrational, fantastic and impotent. Nevertheless, it is enough that they follow the style of contemporary naturalism for them to head a movement and have a prominent place in our school of painting." The *Luncheon of the Boating Party* was Renoir's "naturalist" reply to Zola.

Diverging paths

Renoir
Cézanne
Monet

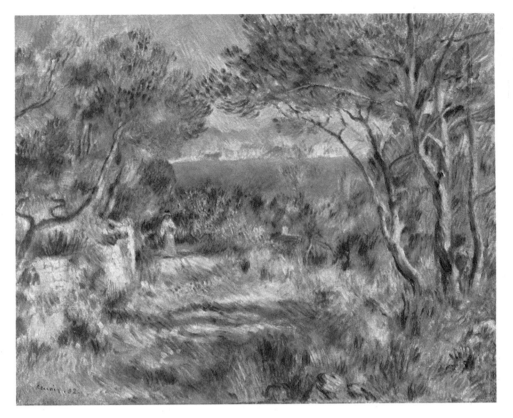

Renoir: L'Estaque, 1882.

L'Estaque, a small place like Asnières but on the seaside... I have met Cézanne here and we are going to work together.

> Renoir, letter to Durand-Ruel, L'Estaque, Hôtel des Bains, Monday, 23 January 1882.

Renoir:
About 1883 something like a break occurred in my work. I had reached the end of "impressionism," and I had come to realize that I did not know how to paint or draw. In short, I found myself in a deadlock.

> Ambroise Vollard, *Auguste Renoir*, Paris, 1920.

Cézanne:
The Sea at L'Estaque, c. 1882.

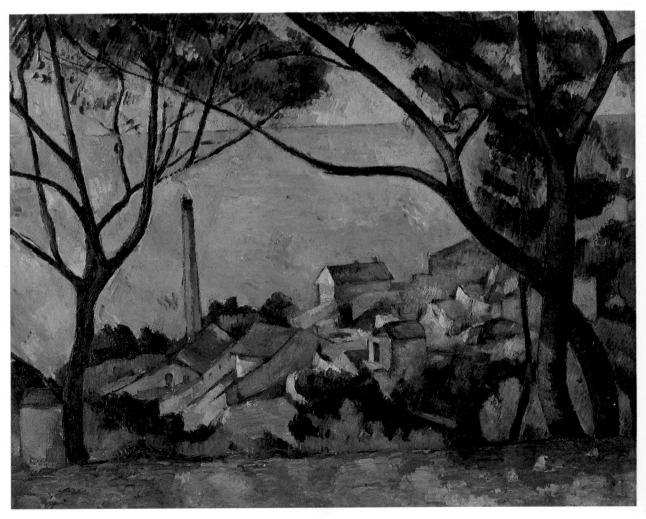

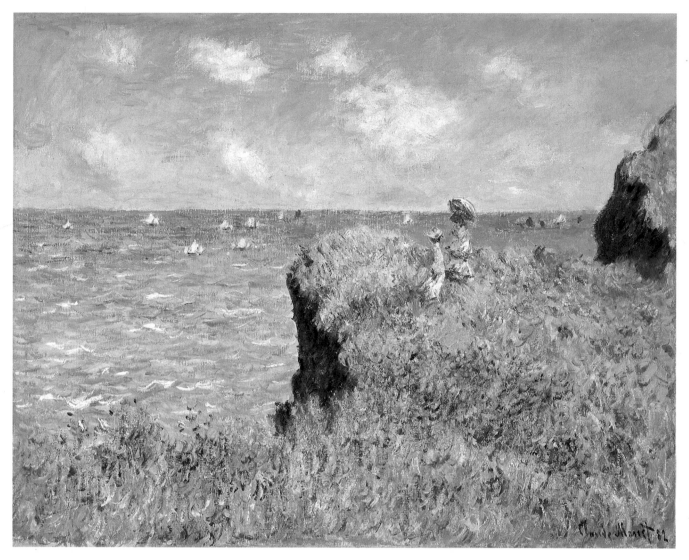

Monet: The Cliff Walk at Pourville, 1882.

After a few days of fine weather, now the rain has set in again, and again I have to put aside the studies under way. It drives me crazy and unfortunately I take it out on my poor canvases. I have destroyed a large flower picture which I had just done, together with three or four canvases which I not only scraped but knocked holes in. This is foolish, I realize, but I feel the time for my return coming, and I see nature being completely transformed. So I lose heart, seeing that I have spent money in advance without achieving anything.

<div style="text-align:right">

Monet, letter to Durand-Ruel, Pourville, 18 September 1882.

</div>

Don't imagine I wish to see my name in the newspapers. I am above that and don't care what the press and the so-called art critics may think; they outdo each other in stupidity. No, they make no difference from the artistic point of view. I know my own worth and I am harder on myself than anyone else could be... Believe me, it is not my ambition to be popular. I have no desire for the great fuss they make about the watercolourists and others. But I do think that we are not well enough known, that our pictures are not enough seen.

<div style="text-align:right">

Monet, letter to Durand-Ruel, Poissy, 7 March 1883.

</div>

On 7 April 1642 Poussin wrote to Chantelou: "I am naturally drawn to seek and admire things in good order, and repelled by muddle. Confusion is as contrary and alien to my character as light is to the obscurity of shadows." Cézanne was an admirer of Poussin. In January 1882 Renoir, back from four months in Italy, stopped at L'Estaque on the Riviera, where he joined Cézanne again. In Rome, Renoir had discovered Raphael. Painting views of L'Estaque together, Renoir and Cézanne disciplined themselves strictly, taking Raphael and Poussin for their models. Renoir, working beside Cézanne, developed a new severity of line and design. While the two painted together, Monet went back to the Normandy coast. Apart from their common cult of nature and the open air, their aims and specific qualities were no longer the same. Renoir stressed line; Monet, the passing moment; Cézanne, austerity.

Aloofness
Cézanne

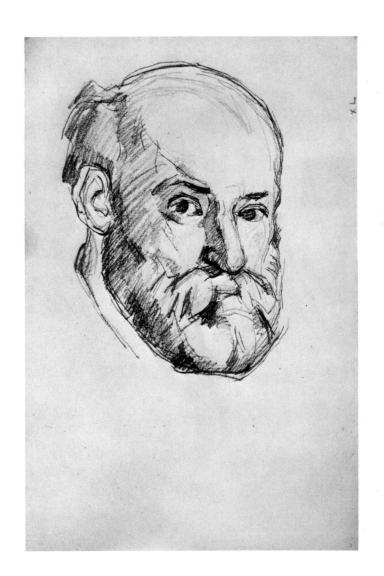

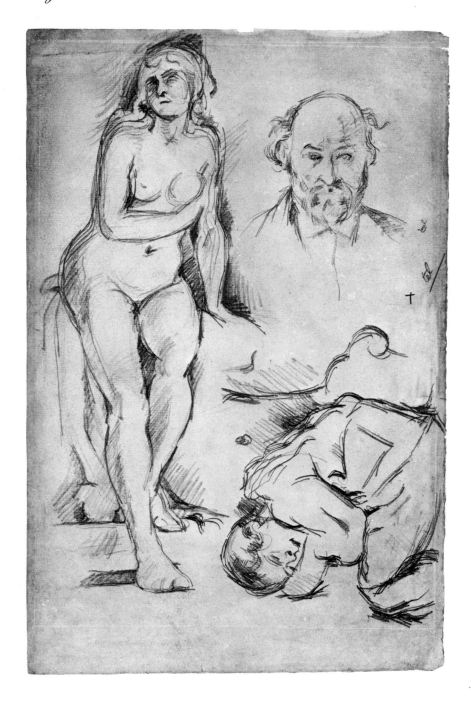

Cézanne: Self-Portraits, sheets of studies, 1880-1900. Pencil.

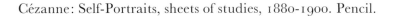

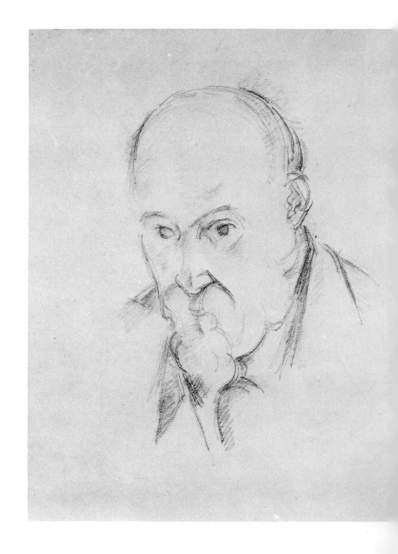

You say: "Cézanne is monochrome." You might just as well say polychrome or polyphonic. A matter of the eye and the ear!... "Cézanne stems from no one: he is content to be Cézanne!" There's some mistake, otherwise he would not be the painter he is. He is not like Loti, a man of no reading. He knows Virgil, he has looked understandingly at Rembrandt and Poussin.

Paul Gauguin, *Racontars de Rapin*, Paris, 1902.

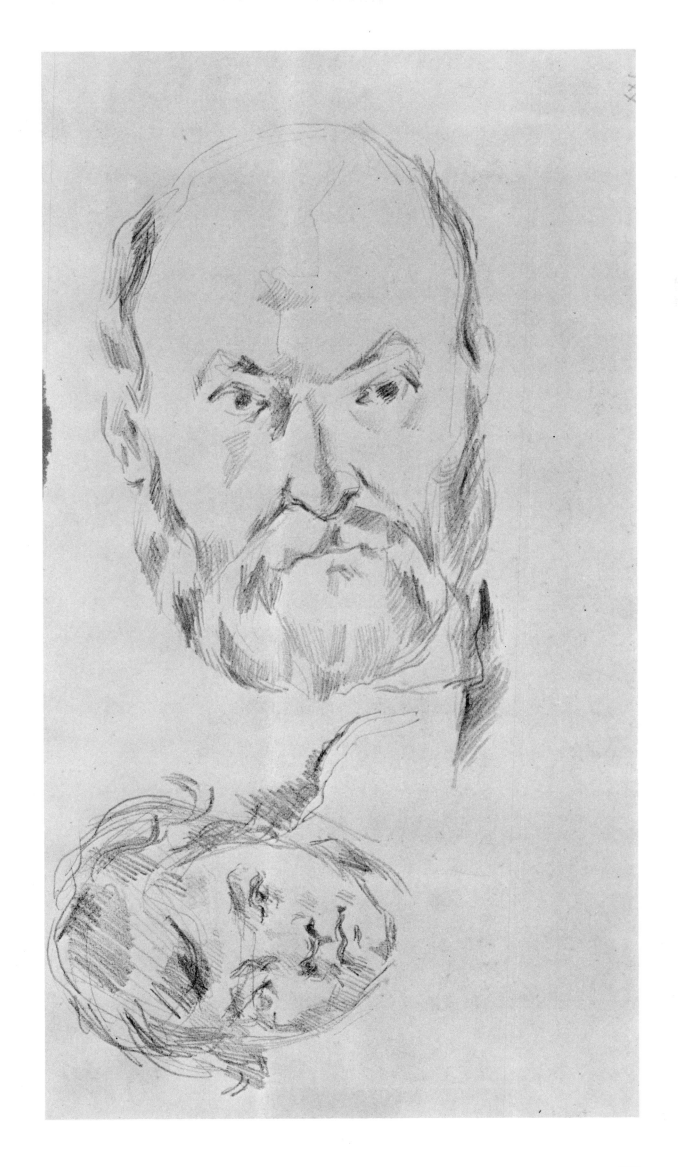

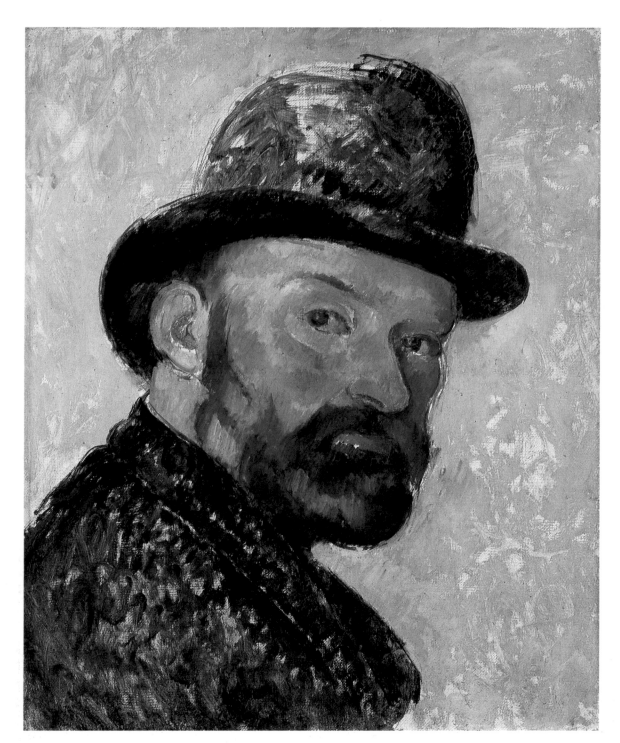

Cézanne: Self-Portrait with Bowler Hat, 1883-1887.

Honest and loyal, Pissarro was the only Impressionist who took part in every one of the eight group exhibitions. In 1879 he brought Gauguin into the group for the fourth exhibition. In 1883, when Gauguin gave up stockbroking for art, Pissarro was the member of the group he chose to associate with. Pissarro was also the one with whom Cézanne painted regularly, year after year, at Pontoise, Auvers-sur-Oise and Osny. In 1884, when Pissarro moved to Eragny-sur-Epte, their friendship, mutual respect and admiration remained as firm as ever. Pissarro alone was convinced of Cézanne's powers, as he had been since their first meeting at the Académie Suisse in 1861. It was thanks to Pissarro that Cézanne had taken part in the first impressionist exhibition in 1874. In 1904, a few months after the death of Pissarro, Cézanne paid him the tribute of saying that he had been his pupil. Pissarro's integrity was not obstinacy, any more than indecision was the reason for his changes; both were the outcome a moral attitude.

Gauguin and Pissarro: Self-Portraits, c. 1880.
Charcoal and coloured pencils.

Gauguin worries me. He is a terrible customer, with his bargaining preoccupations. I dare not tell him how wrong it is, how pointless for his art. He has very great needs, and his family is used to luxury, that's true, but it will do him great harm. Not that I think that one shouldn't try to sell, but I believe it's a waste of time to think only of that; you lose sight of your art, your overrate yourself. It's better to go on selling at low prices for a while, which in fact is easier, especially when one's work is good and original, and then move up little by little, as has happened with all of us.

What will Gauguin think when I tell him about the talk I had with Monet about exhibiting in Paris? We are absolutely against it, and so is Renoir. The Parisians have reached saturation point. Let's lie low for now.

Pissarro, letter to his son Lucien, Rouen, 31 October 1883.

Gauguin I don't understand. I see well enough what he owes to Puvis de Chavannes, Cézanne and the Japanese, but I don't see anything of his own. He's a man I've never taken seriously.

Monet, after 1891.

Pissarro in his Studio at Eragny, c. 1884. Photograph.

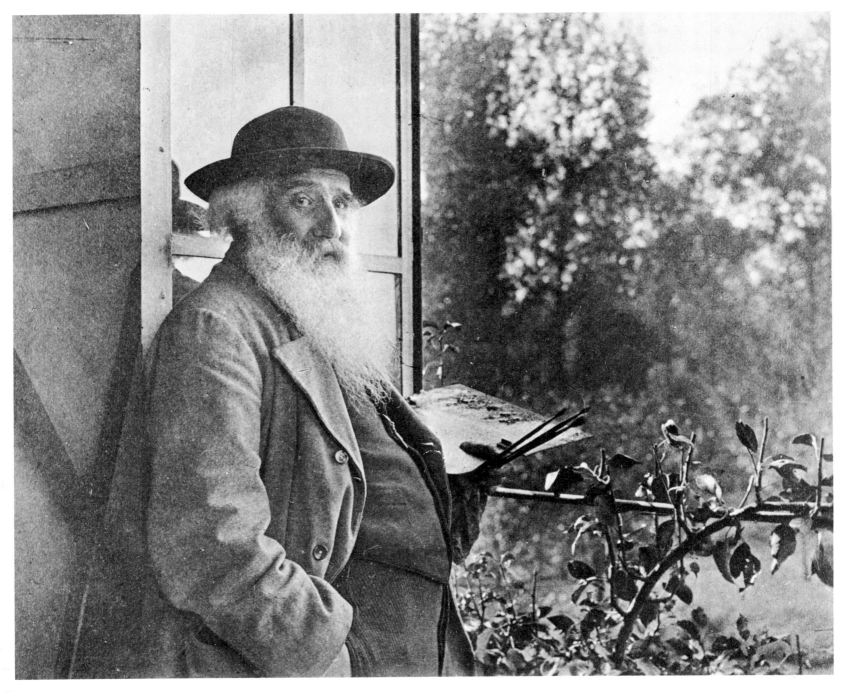

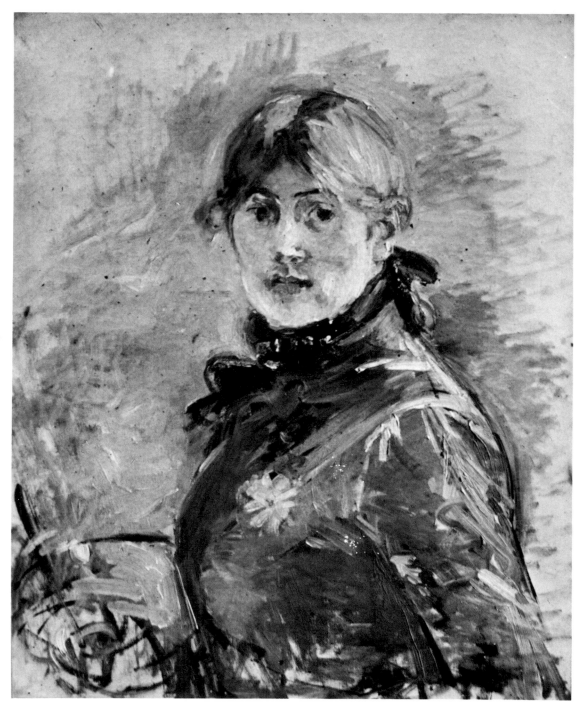

Berthe Morisot: Self-Portrait, 1885-1886.

The last few days were very trying, atrociouslyy painful for poor Edouard! His death agony dreadful! Death in one of its most awful forms which once again I have seen from close at hand!

Add to these almost physical emotions the long-standing friendship that united me with Edouard, a whole past of youth and hard work thus collapsing, and you will understand that I am shattered.

Marks of sympathy have been heartfelt and universal. His nature compelled you to like him for his happy gifts and also for a certain grace of spirit and ease of manner, an indefinable something which brought it about that on the day of his funeral all those people, ordinarily so cool, seemed like a large family grieving for one of its own.

I can never forget the old days of friendship and intimacy with him, when I sat for him and his charm and wit kept me on the alert for long hours.

Berthe Morisot, letter to her sister Edma, Paris, May 1883.

Our poor dear friend Manet is on his death-bed... We are losing a great painter and a delightful man.

Pissarro, letter to his son Lucien,
Paris, 29 March 1883.

I hear now, at this moment, the terrible news of our poor Manet's death.

Monet, letter to Durand-Ruel, Giverny,
1 May 1883.

God knows how well I liked Edouard Manet! The thought of belittling Manet cannot occur to one who witnessed his struggles, to one who never ceased to defend him.

Albert Wolff in *Le Figaro*, Paris, 7 February 1884.

On the 2nd of May we conducted him to the little cemetery at Passy. There was a large crowd. Myself, remembering the whole past, I saw him again when, so gay and hopeful, he made that series of studies of Nina Faillot, or when he was so eagerly painting the portrait of Eva Gonzalès. He had such eloquent enthusiasms for anything that captivated him! And life captivated him so much!...

Our friendship dated from schooldays and he was so faithful a friend that no one else can pay so complete a tribute to the sureness of his relationships, to the charming good humour of his spirit, above all to the inexhaustible good nature that won him so many and such vigorous sympathies. A master, he revealed himself as such on the day when, impelled by his passionate love of life and his eager desire to render in full light the most vivid and most modern impressions, he broke away from the ties of a tradition perhaps too much attached to the cult of bygone things...

His was a spirit continually in search of new approaches, and out of that effort were born works which have their place marked out for them alongside the finest and boldest productions of French painting...

Antonin Proust, *Edouard Manet, Souvenirs*, Paris, 1913.

Death of a symbol
Manet

Manet's Tomb in the Parisian Cemetery of Passy. Photograph.

The ataxia from which Manet had suffered for years grew worse. During the summer of 1882, at Rueil, in the suburbs of Paris, he was no longer able to walk more than a few steps in the garden. On 19 April 1883 his left leg, gangrenous below the knee, had to be amputated. After the operation, the fever never left him. He died on 30 April at seven in the evening. The funeral took place at noon on 3 May at the Paris church of Saint-Louis-d'Antin. According to the *Figaro* obituary, Manet's brothers, Eugène and Gustave, and his cousin and executor, Jules de Jouy, headed the funeral procession, and Antonin Proust, Emile Zola, Philippe Burty, Alfred Stevens, Théodore Duret and Claude Monet were the pallbearers. At Passy cemetery, Antonin Proust delivered a funeral speech. In *La République française*, on the same day, Burty wrote that Manet had been "the standard-bearer of the younger painters." Since the scandal over his *Déjeuner sur l'Herbe* at the Salon des Refusés twenty years before, he had maintained that position of leadership, sometimes in spite of himself.

Break-up

Zola
Cézanne

It was a panic flight, and the last ties were broken, in amazement at suddenly finding themselves strangers and enemies, after a long youth of fellowship. Life had disbanded them on the way, and their deep disparities had appeared. All that was left them was the bitter taste in the throat of their old inspiring dream, their hope of battle and victory side by side, which now increased their rancour.

Zola, *L'Œuvre*, Paris, 1886.

I grew up, almost from the same cradle, with my friend, my brother, Paul Cézanne, a great but stunted painter whose flashes of genius are only now being discovered. I moved among a whole group of young artists, Fantin, Degas, Renoir, Guillemet, and still others, whom life has scattered and sown at various stages on the road to success. And I too have gone my own way, straying from friendly studios, carrying my passion elsewhere.

Zola, "Peinture" in *Le Figaro*, Paris, 2 May 1896.

Renoir:
I have always disliked what he writes. When you want to depict a milieu, you have to begin, it seems to me, by putting yourself in the place of those who move in it. All Zola does is to open a small window and cast a glance outside, and he imagines that he has depicted the common people when he tells you that they smell bad. And what about the bourgeois? But what a fine book he could have written, not only as a historical reconstruction of a highly original art movement, but also as a "human document" (since it is under this name that he sells his wares), if in his novel *L'Œuvre* he had only taken the trouble to tell quite simply what he had seen and heard at our gatherings and in our studios. For with us he found himself really living the life of the men he took for his models. But at bottom Zola did not care about representing his friends as they actually were, in other words to their own advantage.

Ambroise Vollard, *Auguste Renoir*, Paris, 1920.

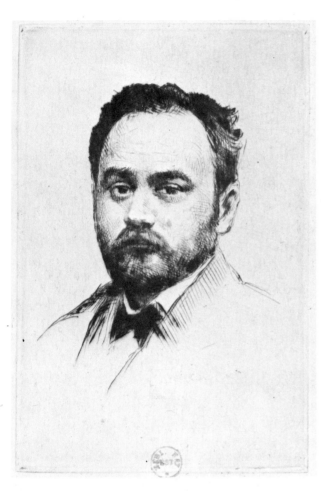

Desboutin: Portrait of Zola. Etching.

In 1886 Zola published *L'Œuvre*, a new novel in his Rougon-Macquart series. In it, the writer Sandoz announces: "I'm going to take a family. I'll study its members, one by one, where they come from and where they are going, and how they react to each other... I'll put my characters in a specific historical period, giving me an environment and events, a fragment of history. D'you get me? It will be a series of novels, fifteen or twenty volumes of episodes that hang together, each of them, however, having its own setting, a serial of novels to build me a house for my old age, if they don't wear me down first!"
Zola's own Rougon-Macquarts were the family Sandoz described. If Sandoz and Zola can be confused, the painter Claude Lantier, the central character of *L'Œuvre*, could hardly fail to be taken for one of the painters Zola had supported since 1866. But his convictions of 1866 had become doubts in 1880. The suicide of Claude Lantier—it makes no difference which of the Impressionists had served as the model for him, he has something of all of them—meant that Zola saw Impressionism as a failure, and the painters were disappointed. In the spring of 1886 the eighth impressionist exhibition opened. It did not belie the sad ending of Zola's story: it was to be the last.

Cézanne: Self-Portrait, 1883-1885.

Cézanne:

There was never actually a quarrel between us. I was the one who simply stopped going to see Zola. I was no longer at ease in his home, with the rugs on the floor, the servants and him there working now at a desk of carved wood. It all gave me the feeling that I was calling on a Minister. If you will excuse the expression, which is not meant in bad part, he had become a filthy bourgeois... So I seldom went to Zola's any more; it pained me to see him turning into such an ass. Then one day his servant told me that the master was not at home for anyone. I don't think that order was aimed at me in particular, but after that I spaced out my visits even more. And then Zola published his novel *L'Œuvre*... You cannot expect a man who doesn't know to say sensible things about the art of painting. But good God!... How can he dare to say that a painter commits suicide because he has painted a bad picture? When a picture is not worked out, you throw it into the fire and you start another one!

Ambroise Vollard, *En écoutant Cézanne,*
Degas, Renoir, Paris, 1938.

Georges Seurat, c. 1885. Photograph.

Seurat: A Sunday Afternoon on the Island of La Grande-Jatte, 1884-1886.

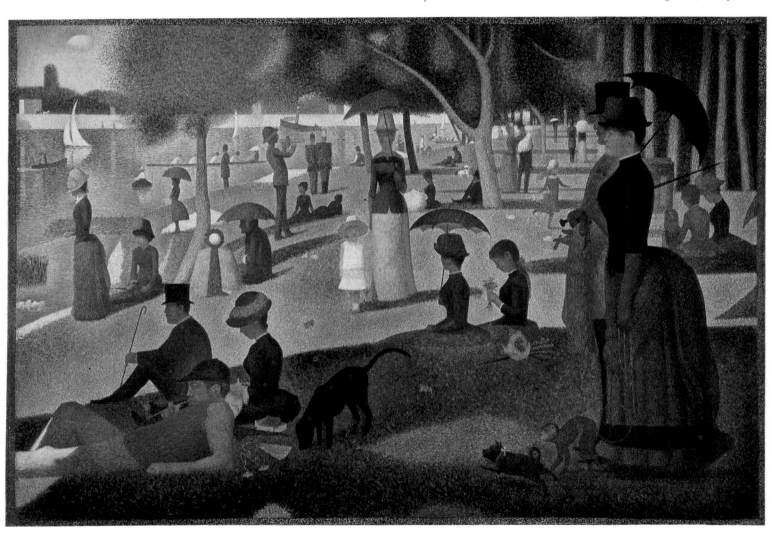

When the twenty-six-year-old Seurat met Pissarro, in October 1885, he was not, as Gauguin had been, a kind of pupil. His new technique of Pointillism owed nothing to Pissarro. Seurat had worked it out himself after reading Charles Blanc's *Grammaire des arts du dessin* (1867), Chevreul's *La loi du contraste simultané des couleurs* (1839), scientific studies by David Sutter, Helmholtz, Maxwell, Dove and Rood, and Hubert de Superville's *Essai sur les signes inconditionnels dans l'art.*

My dear Monsieur Durand-Ruel,

I send you herewith the notice you asked me to write out about my new art theories.

You may complete it by consulting the pamphlet recently published by Félix Fénéon under the title *Les Impressionnistes en 1886*, on sale at Soiret's in Montmartre and in the main bookshops.

If your son issues a publication on this subject, I wish him to make it quite clear that the first to have the idea and to apply the scientific theories after a thorough study of them, is Monsieur Seurat, an artist of great value. I have done no more than follow Seurat's example, as have my other confrères, Signac and Dubois-Pillet. I hope that your son will render me this service, for which I shall be really grateful.

Theory

Work out the modern synthesis by scientific means, these being based on the Theory of Colours discovered by Chevreul, in accordance with Maxwell's experiments and N.O. Rood's measurements.

Substitute the optical mixture for the mixture of pigments. In other words: break down the tones into their constituent elements. Because the optical mixture creates much more intense luminosities than the mixture of pigments.

As for the execution, we consider it a matter of small account. Art does not enter into it at all, according to us. The only originality consists in the character of the drawing and the vision peculiar to each artist.

Here is my biography: Born at St Thomas (Danish Antilles) on 10 July 1830. Sent to Paris in 1841 to attend the Savary boarding school at Passy. At the end of 1847 I returned to St Thomas, where I began drawing while being employed in a business house. In 1852 I gave up business and left with Fritz Melbye, a Danish painter, for Caracas (Venezuela) where I stayed till 1855; I went back to the business at St Thomas. Finally I returned to France at the end of 1855, in time to see, for three or four days, the Paris World's Fair.

Since then I have lived in France. As for the rest of my story as a painter, it is connected with the Impressionist group.

Pissarro, letter to Durand-Ruel, Eragny,
6 November 1886.

Camille Pissarro, c. 1895. Photograph.

Nature and the responses of the Impressionists were not a theory. They were an emotional demand. Seurat's painting was a programme. It was not a matter of feeling, but a demonstration. Pissarro adopted Seurat's theory, because for him, as for Renoir or Cézanne, Impressionism had nothing more to offer. *La Grande Jatte* was not a pointillist *Grenouillère*, it was the death certificate of Impressionism.

Manet: Olympia, 1865-1867. Etching.

Monet to Berthe Morisot, 13 November 1889:
The subscription is proceeding beyond my hopes. It amounts now to 18,000 francs, so the sum aimed at will be easily reached. All the principal painters have contributed, which is a good thing for its success, though I have learned from different quarters that a strong effort is being put forth to make it miscarry. Antonin Proust seems to be holding aloof.

Berthe Morisot replied:
The rumours that have reached me confirm the administrative opposition to which you refer. I have no influence with the authorities, and even if I did I feel that the intervention of the family [i.e. of Berthe Morisot herself, who was Manet's sister-in-law] would change the character of the subscription. You alone, with your name and authority, can break through the obstacles if anyone can. I've been told that someone (who, I don't know) went to see Kaempfen [director of the National Museums] and sound him out, and that Kaempfen flew into a rage, stating that as long as he was there no Manet would enter the Louvre, and at this his caller got up, saying: "Very well, we'll see to it that you go, and afterwards that Manet gets in."

Monet in his Garden at Giverny. Photographs.

Late in 1888 Sargent warned Monet that Manet's widow was about to sell *Olympia* to an American collector. Monet decided at once to open a subscription. The Louvre was the place for *Olympia*. Zola had said so in 1867. The public outcry that had followed the sight of this picture at the 1865 Salon had made it the symbol of a new school. Lying naked, like Titian's *Urbino Venus*, Goya's *Naked Maya*, or the fashionable oriental odalisques, she was neither a goddess nor an odalisque. She was a prostitute. Monet collected 19,415 francs which he gave to Suzanne Manet. (Manet had priced *Olympia* at 20,000 francs in 1872.) One name was missing in the list of some ninety subscribers, friends of Manet, who signed Monet's letter of 7 February 1890 to Fallières, Minister of Education and Fine Arts, making on their behalf a gift of *Olympia* to the State: the missing name was Zola's. *Olympia* went to the Luxembourg Museum. It was another seventeen years before the Louvre opened its doors to the Impressionists.

On behalf of a group of subscribers, I have the honour of offering Edouard Manet's *Olympia* to the State... By common consent of the great majority of those who take an interest in French painting, the role played by Edouard Manet was useful and decisive. Not only was his a great individual role, but in addition he was representative of a great and fruitful evolution.

There is no question, it has seemed to us, but that such a work should enter our national collections, and the master have his place where his disciples have already gained admission. We have further noted, with anxiety, the incessant movement of the art market, the growing competition of America as a purchaser, and the readily foreseeable departure for another continent of so many works of art which are the joy and glory of France... Our desire is to see this picture take its place in the Louvre among the productions of the French School... We hope that you will give your support to an endeavour to which we have applied ourselves with the satisfaction of simply accomplishing an act of justice.

> Letter from Monet to Armand Fallières,
> Minister of Education and Fine Arts,
> Paris, 7 February 1890.

John Singer Sargent: Monet Painting at the Edge of a Wood, c. 1890.

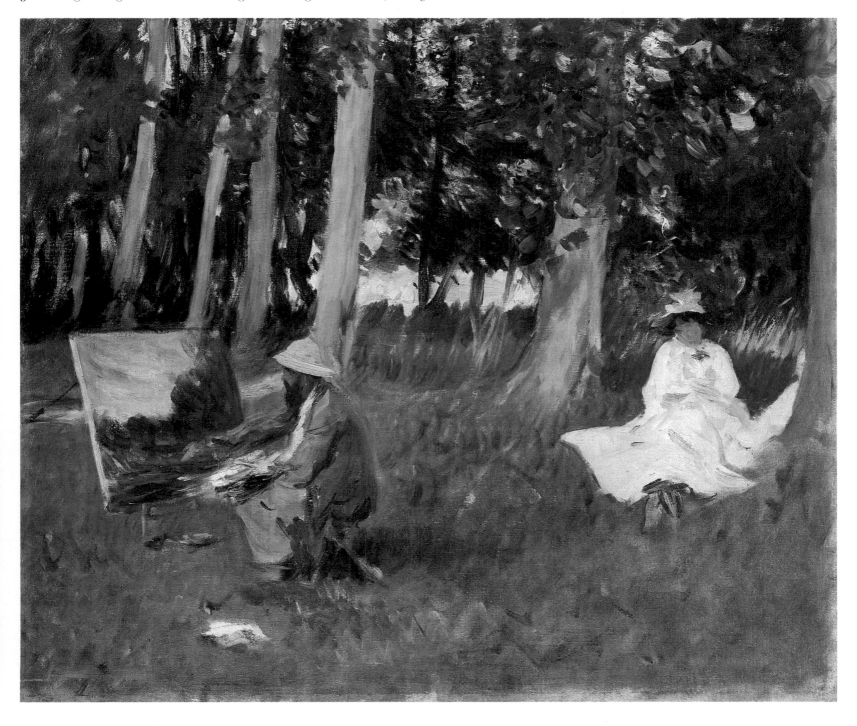

163

But before his money losses, was Degas any different from what he is today? Ask all those who have known him, yourself first of all. No, he is a bitter man. He does not occupy the great place that his talent entitles him to occupy, and though he will never admit it he has a grudge against the whole world.

Gustave Caillebotte, letter to Pissarro,
24 January 1881.

Yes, I'm becoming ungrateful, and becoming so in a comatose state that makes this disorder incurable. After I have cut art in two, as you remind me, I shall cut off my own fine head and Sabine will preserve it for form's sake in a jar.
Is it the country, is it the weight of my fifty years that makes me so dull, so sick at heart? I am thought to be cheerful because I smile idiotically, with resignation. I'm reading Don Quixote. Ah, what a happy man and what a fine death!

Degas, letter to Albert Bartholomé,
16 August 1884.

Glory and bitterness
Degas

Renoir:
If Degas had died at fifty, he would have left the reputation of being an excellent painter, and nothing more. It was after the age of fifty that his work broadened out and he became Degas.

Ambroise Vollard, *Auguste Renoir*, Paris, 1920.

Degas: The Apotheosis of Degas (parody of Ingres' Apotheosis of Homer), 1885. Photograph.

You will see that Degas in later life will be more wretched than the others, the victim of wounded vanity at not being the first and only one. A day will come when he will rail at all mankind.

Gauguin, letter to Pissarro, Copenhagen, 1885.

Despite their cliques, rivalries and disputes, the Impressionists held another exhibition together in 1886. It was the last. Degas's nudes were considered indecent. He refused to exhibit again, except once at the Durand-Ruel Gallery in 1892, when he showed landscapes and pastels. Degas stood alone. He became an outsider. His eye trouble increased, his misanthropy, bitterness and fits of rage as well. He sold enough pictures to enable him to become a collector and bought paintings by Ingres, Delacroix, Daumier and Gavarni, prints by Utamaro, Hiroshige and Sukenobu, an El Greco and a Tiepolo, and drawings, prints and paintings by Berthe Morisot, Manet, Sisley, Renoir, Cézanne and others. Although himself a collector, he could not forgive anyone, who, no matter what the reason, parted with a work of his. A sale was a betrayal. Impressionist dinners at the Café Riche, Mallarmé's Tuesday evenings, and Berthe Morisot's Thursdays, were still regularly attended, but were no longer the expression of a common will in the face of the same challenge.

Mary Cassatt

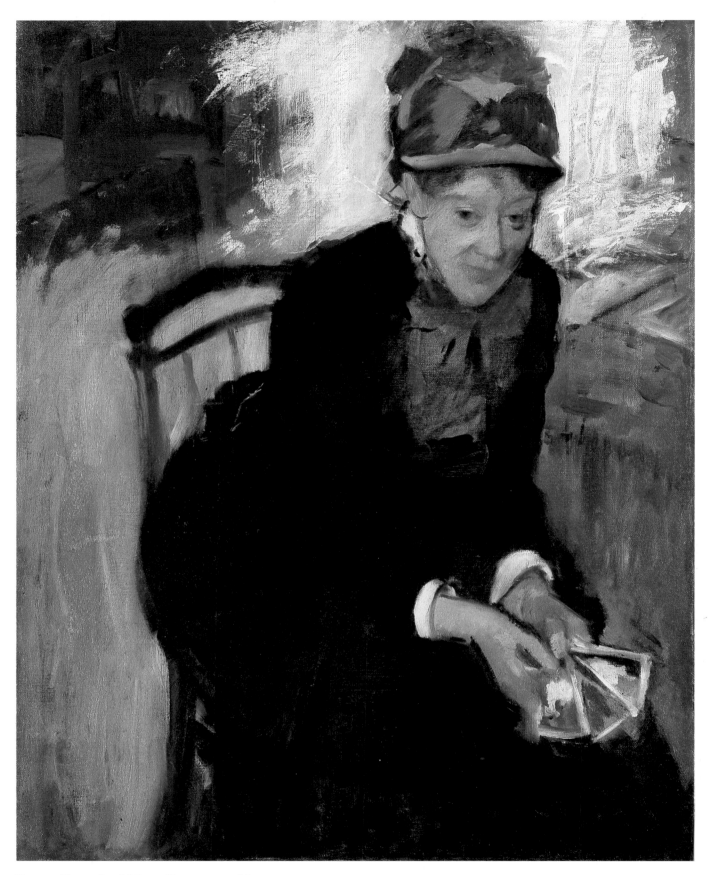

Degas: Portrait of Mary Cassatt, c. 1884.

Dear Sir,

What I chiefly wish to part with is the portrait Degas did of me, which is hanging in the room next to the drawing room (my studio).

The canvases you saw lying on the floor were left there accidentally. Those are things of mine that went wrong, and I should burn them.

As for the portrait by Degas, I especially desire not to leave it to my family as being me. It has artistic qualities, but is so painful and represents me as a person so repugnant that I would not wish it to be known that I posed for it. The picture is framed and there is a glass over it. The fan in my opinion is the prettiest thing that Degas painted. I suppose it is worth a certain price, I thought twenty-five thousand, as it dates from the period of the dancers at the rail... If you think my portrait saleable, I should like it to be sold abroad but without my name being attached to it.

Mary Cassatt, letter to Durand-Ruel, Grasse, late 1912.

Catalogue of the 1882 Impressionist Exhibition,
Caillebotte's last appearance with the group.

We have just lost a sincere and devoted friend: Caillebotte has
died suddenly of brain paralysis. This is a man whom we can
mourn for, he was good-natured and generous and, what does
no harm, he was also a talented painter.

Pissarro, letter to his son Lucien, Paris,
1 March 1894.

Lecomte du Nouy: To admit to the Luxembourg Museum the
pictures you tell me about would be to set a deplorable exam-
ple, for young artists might be deterred by them from doing
any serious work... It would be madness.
Charles Maignan: If they contrive to undermine authority and
occupy the preponderant place they claim, then the conscien-
tious and serious painters of the day, like Delaunay, Jean-
Paul Laurens, etc., will be unjustly belittled.
Léon Gérôme: Sir, we live in a century of debasement and imbe-
cility... For the government to accept such rubbish would be
a sign of great moral decay.

Quoted in *Journal des Artistes*, Paris,
8 and 15 April 1894.

An unwanted legacy
Caillebotte

First Will
I desire that, from my estate, there be taken the sum of money
necessary to hold in 1878, in the best conditions, the exhibi-
tion of painters known as Intransigents or Impressionists. It
is difficult today to fix that sum; it may amount to thirty or
forty thousand francs or even more. The painters who will
figure in this exhibition are: Degas, Monet, Pissarro, Renoir,
Cézanne, Sisley, Miss Morisot. I list these names without rul-
ing out others.
I give the State the pictures that I own. Only I want this
donation to be accepted, and accepted in such a way that the
pictures go not into an attic or a provincial museum, but to
the Luxembourg Museum and later to the Louvre. It is there-
fore necessary for a certain time to elapse before this clause is
carried out, time enough until the public, I do not say under-
stands, but admits this painting. This period of time may be
twenty years at most. Meanwhile my brother Martial or,
failing him, another heir, will take custody of them.
I ask Renoir to be my executor and to accept a picture of his
choice; my heirs shall insist on his taking an important one.
Made in duplicate, Paris, 3 November 1876.

Gustave Caillebotte.

My dear Martial,
I've been wanting to write to you but I'm working hard at the
moment and this has delayed me. I received this morning the
photographs of Gustave [Caillebotte], which give me great
pleasure. I thank you kindly, and also thank you for sending
the one with both of you in it.
Now that everything is settled with the Fine Arts administra-
tion, I hope they will soon take possession of the pictures
which are to be hung in the Luxembourg Museum.
When you set about the organizing and hanging of Gustave's
exhibition, do not fail to let me know and have no fear of
making use of me. You know how happy I shall be to do
anything for his memory.
With friendly greetings to you.

Monet, letter to Martial Caillebotte,
Giverny, 22 May 1894.

In 1894 Caillebotte died, aged forty-six. He bequeathed sixty-seven pictures to
the State, five Cézannes, seven Degas's, four Manets, sixteen Monets, eighteen
Pissarros, eight Renoirs and nine Sisleys. The legacy was embarrassing. The
academicians protested. The staff of the Ecole des Beaux-Arts threatened to
resign. The government administrators procrastinated. It was suggested that
the pictures should be stowed away in the reserve collections at Compiègne and
Fontainebleau. The notary refused. Lack of hanging space was put forward as
a pretext. Two years went by. The government authorized acceptance of a

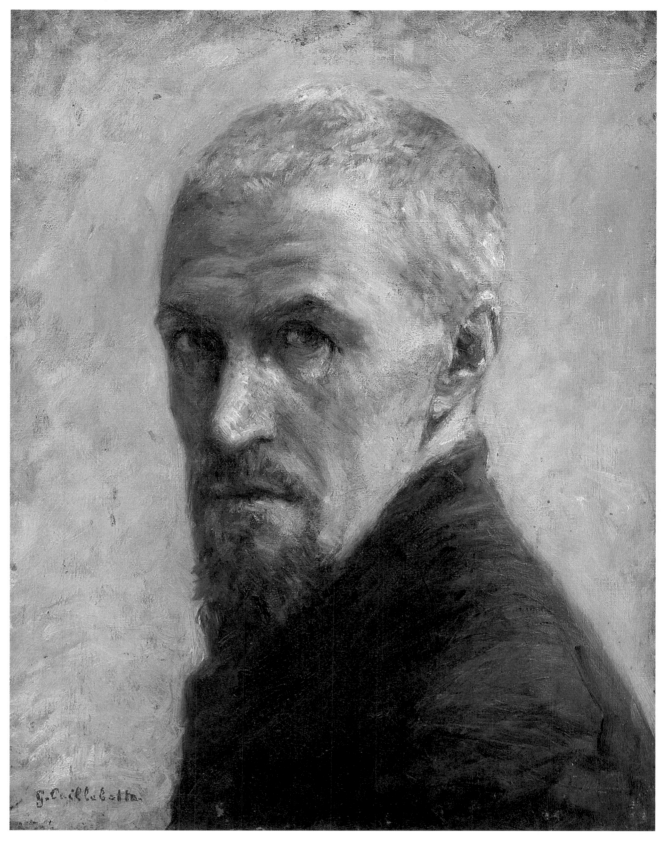

Caillebotte: Self-Portrait, c. 1889.

selection of the paintings. Twenty-seven were rejected, among them three Cézannes, two Manets, seven Monets, eleven Pissarros, two Renoirs and four Sisleys. Finally, the Administration proposed to build an annex to the Luxembourg Museum to house them, in order, it was said, to make it possible to keep them together. The inauguration took place in February 1897, accompanied by fierce criticism, anger and threats. Hervé de Saisy in the Senate denounced it as an insult to France. Gérome and eighteen other academicians protested. For the last time, hostility united the Impressionists.

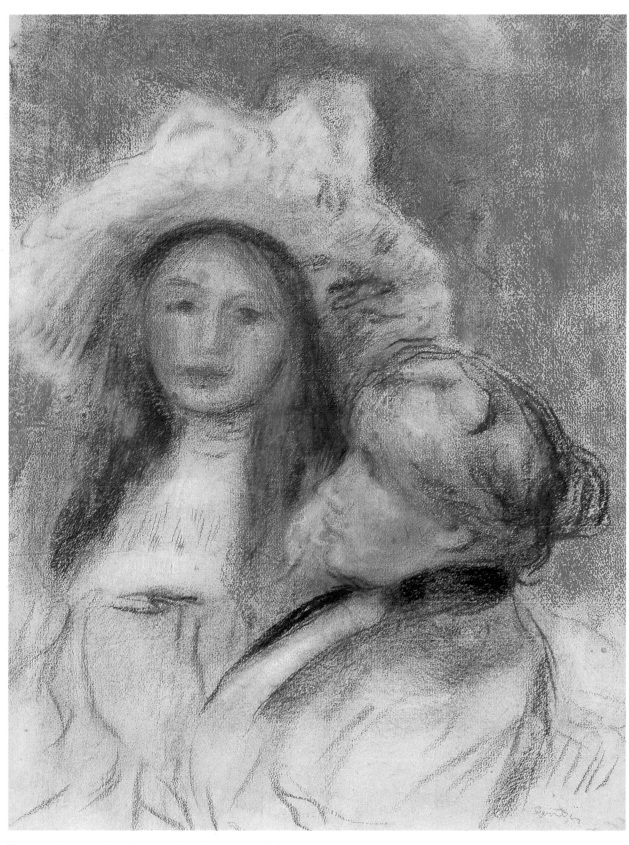

Renoir: Berthe Morisot and her Daughter Julie, 1894. Pastel.

Instead of doing Julie alone, I should like to paint her with you, if that is not too disagreeable to you. But here is the troublesome part of it. If I come to you, I will always have something to prevent me from working. But if you could give me two hours, that is two mornings or afternoons a week, I think I could do the portrait in six sittings at most. Tell me yes or no.

> Renoir, letter to Berthe Morisot, 1894.

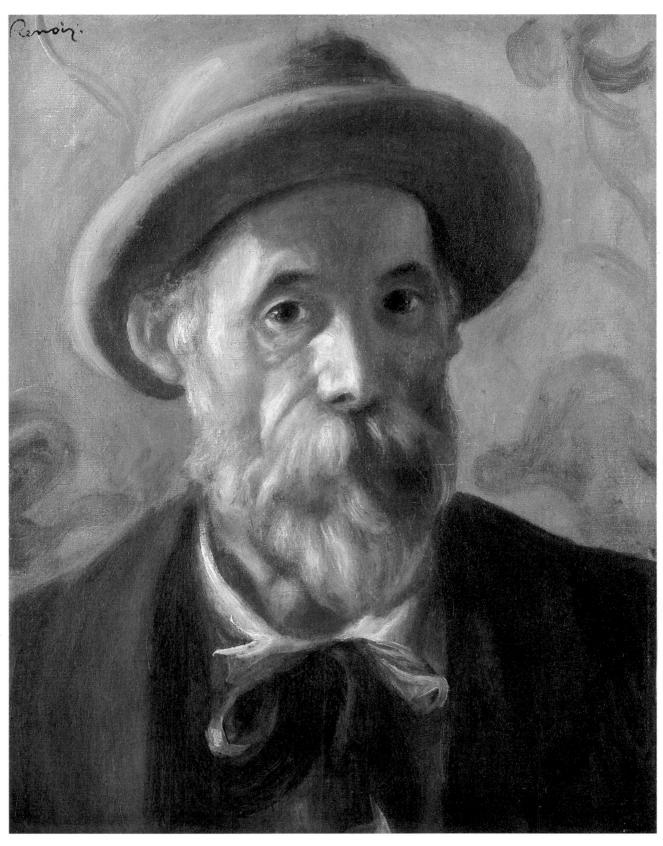

Renoir: Self-Portrait, 1897.

Renoir:

Progress in painting, there's no such thing! No progress in ideas and none either in procedures. To give you an example. One day I went and changed the yellow on my palette. Well, the result was, I floundered for ten years. On the whole, the palette of today's painters is the same as the one used by the painters of Pompeii, coming down by way of Poussin, Corot and Cézanne: I mean that it is no richer. The ancients employed clays, ochres and ivory black, and with that you can do everything. There have been attempts to add a few tones; but how easily one could have done without them! I told you about the great invention that was supposed to have been made, substituting blue and red for black; but how far this mixture is from giving the fineness of ivory black, which moreover does not compel the wretched painter to look for difficulties where there are none! With a limited palette, the older painters could do just as well as today (one must be polite for one's contemporaries), and without any doubt what they did was sounder.

Ambroise Vollard, *Auguste Renoir*, Paris, 1920.

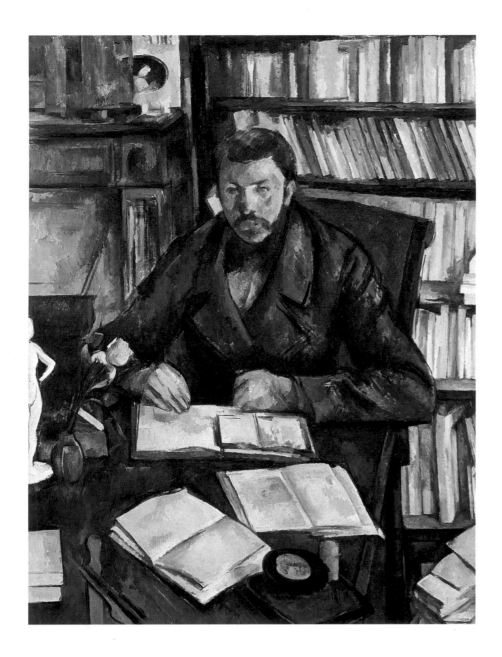

Cézanne:
◁ Portrait of Gustave Geffroy, 1895.
▷ Portrait of Ambroise Vollard, 1899.

Dear Monsieur Geffroy,
The days are getting longer, the temperature is getting milder. I am unoccupied every morning till the hour when civilized man sits down to table. I intend to go up to Belleville in order to shake your hand and submit a project to you which I have now entertained, now abandoned, and which I sometimes take up again.
Very cordially yours,
Paul Cézanne, painter by inclination.

Cézanne, letter to Gustave Geffroy,
Paris, 4 April 1895.

Geffroy was a fervent admirer of the Impressionists. He probably discovered them through Clemenceau when, in 1880, at twenty-five, he joined the staff of his paper *Justice*. The sarcastic criticism levelled at Monet and Cézanne brought Geffroy to their defence. He met Cézanne at Monet's home in the autumn of 1894. In the spring of 1895 Cézanne began Geffroy's portrait; he abandoned it in June or July. At the end of that year, Vollard held Cézanne's first one-man show at his Rue Laffitte gallery. In 1899, after Vollard had posed at one hundred and fifteen sittings, Cézanne abandoned his portrait, too.
These portraits were the unfinished works of a dedicated painter so constituted that he could only take as models persons who genuinely cared for his pictures.

170

Cézanne:

Understand me, Monsieur Vollard, I have learned a great deal with the portrait I'm doing of you... After all, my canvases are now being put into frames!

<div align="right">

Ambroise Vollard, *En écoutant Cézanne,*
Degas, Renoir, Paris, 1938.

</div>

Once he had seated me–and with what precautions he did so!–I took good care to make none of those movements known as false ones. Much more, I sat motionless. But this very immobility finally brought on a sleep against which I struggled victoriously for a while. In the end, however, my head drooped on my shoulder, and I lost all sense of the outside world. With that, my balance failed, and the chair, the box and myself all fell to the floor. Cézanne ran up to me: "You wretch! You have upset the pose! I tell you in fact that you must sit there like an apple. Does an apple move?"...

After one hundred and fifteen sittings Cézanne abandoned my portrait and went back to Aix. "I'm not dissatisfied with the shirt front," he told me as he left. He made me leave in the studio the clothes I had posed in, as he wished on his return to Paris to repaint certain parts of them. "Between now and then I shall have made some progress. You understand, Monsieur Vollard, the contour escapes me!"

<div align="right">

Ambroise Vollard, *En écoutant Cézanne,*
Degas, Renoir, Paris, 1938.

</div>

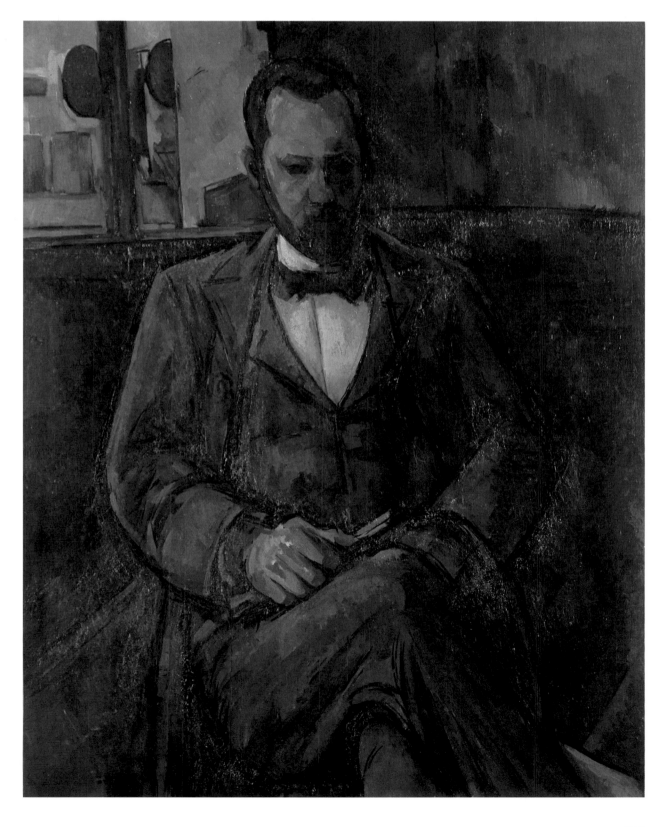

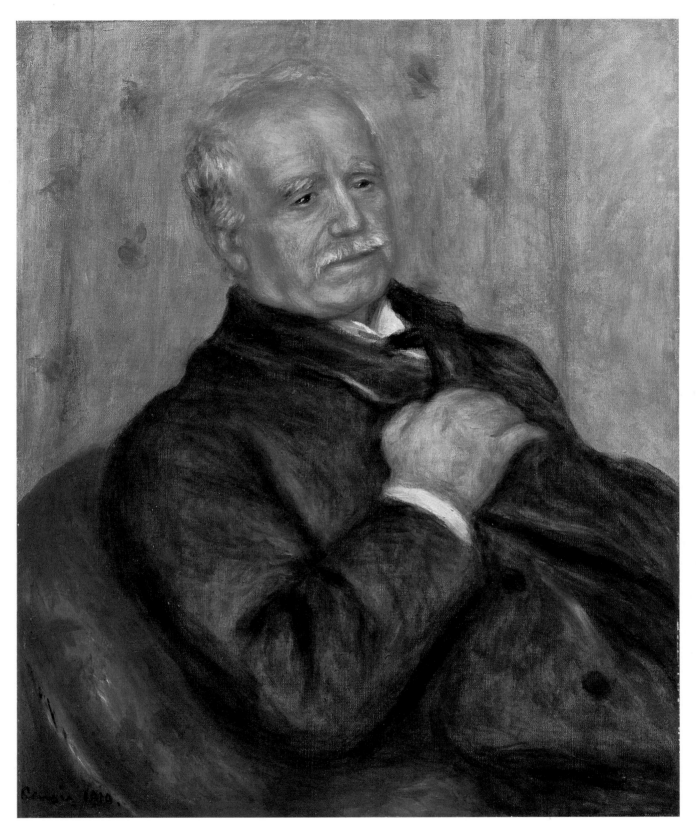

Renoir: Portrait of Paul Durand-Ruel, 1910.

Since 1871, when Monet and Pissarro were introduced to him by Daubigny in London, and since meeting Renoir through them on their return to Paris, and since the day he first met Manet and bought twenty-seven canvases from him, the dealer Durand-Ruel had been the mainstay of the group. Despite dissensions, financial setbacks and criticism, the failure of the first public auction at Drouot's, where he had been the valuer, the jeers and insults showered on him at his Rue Le Peletier gallery during the second impressionist exhibition in 1876, and despite the failure in January 1882 of the Union Générale bank which had seen him through the slump that had lasted since 1874, Durand-Ruel nevertheless rented the rooms for the seventh impressionist exhibition in 1882 and began

Constancy

Renoir:
The tragic thing is that any progress we may think we make is a step towards the grave!... One wants to live on a bit longer and produce the masterpiece.

Ambroise Vollard, *En écoutant Cézanne, Degas, Renoir*, Paris, 1938.

Dear Monsieur Durand-Ruel,
What a life you lead and when do you get a rest from all these battles? You go on torturing yourself without any apparent wounds, and when will you be coming back? You probably don't know yourself. It is very good of you to have found a few moments to write to me amidst all these worries. I wish, on my side, that I could tell you something interesting, but I don't see many people. Your shop is a gloomy place without its Master and it distresses me to see those sad canvases hanging sadly along the walls. And what canvases! You must come back and restore life to them, for I'm afraid of seeing you lose the substance for the shadow with your American venture. But I have no intention of giving you advice which you would not follow anyhow. You have your plan, go on and carry it out. But to drop Paris is rash of you, it seems to me, when you only meet the same difficulties elsewhere.

The exhibition at the Petit Gallery is open and is said to be going on pretty well. But it is difficult to find out what is happening. I think I have made a step towards the public esteem, a small step. But that is always something. Monet stands firm at his post. In short, the public seems to be coming on. I may be wrong, but that is what I hear on all sides. Why this time and not the others? I can't make it out. But I won't go on any longer, for I only write to wish you good luck and a prompt return. But let's not wander from the point. I look forward to seeing you and to seeing again some good pictures in your shop. Do not allow yourself to be forgotten.

Renoir, letter to Durand-Ruel, Paris, 12 May 1887.

Monsieur Durand, I know that you are a man of courage and have faith in us.

Monet, letter to Durand-Ruel, Poissy, 5 March 1883.

Do not imagine that I have doubts about you. No, I know that you are a man of courage and energy, but I do have doubts about the others.

Monet, letter to Durand-Ruel, Paris, 30 December 1883.

Renoir at Le Cannet returning from a painting expedition, 1901. Photographs.

a series of one-man shows for members of the group. Neither liquidation in 1884, nor the dissatisfaction of his painters because of commitments he had been unable to fulfil to the letter and because they had no faith in the success of the impressionist exhibition he was organizing in New York in 1886, nor the united front of the New York galleries against him on his return to the United States in 1887, made Durand-Ruel falter. The success of the American exhibition at the National Academy of Design in 1887 and a review, *Art in the Two Worlds*, founded by him in 1891, finally established his position in the international market. Of all the artists he had helped, Renoir was the only one who had been loyal from start to finish, unreservedly.

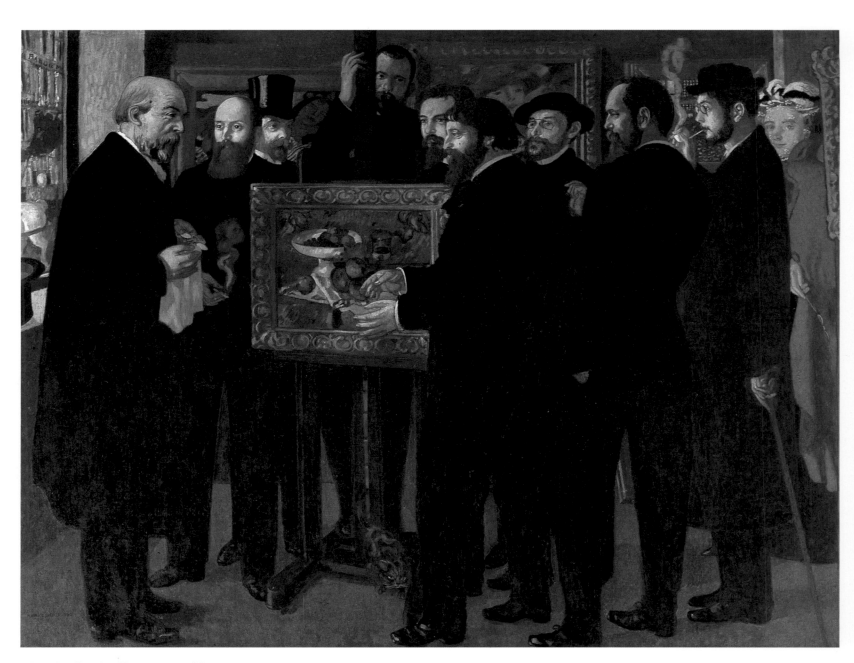

Maurice Denis: Homage to Cézanne, 1900.

In 1900, at the turn of the century, Vollard alone had been exhibiting Cézanne for the past five years. Gathered round one of the master's still-life studies, Maurice Denis brought together Odilon Redon, Vuillard, Ranson, Roussel, Mellerio, Bonnard and Sérusier, and painted his own portrait with them, just as thirty-six years earlier Fantin had brought together round the portrait of Delacroix the painters and critics who admired him and looked, through him, for a new style of painting. Like Delacroix's, Cézanne's work became decisive for subsequent generations. In 1864 the example of a Romantic had been the starting point for the realists and later the Impressionists; in 1900, that of an Impressionist pointed the way to the Nabis and Cubism.

I have achieved some progress. Why so late and so laboriously? May it be indeed that Art is a ministry, one requiring pure men who belong to it heart and soul?

Cézanne, letter to Ambroise Vollard, Aix,
9 January 1903.

I may have come too soon. I was the painter of your generation more than my own.... You are young, you have vitality, you will impress your art with an impulse that only those who have emotion can impart to it. I am growing old. I shall not have time to express myself... Let us go on working...
The reading of the model and its realization is sometimes very slow to come.

Cézanne, undated letter to a young artist.

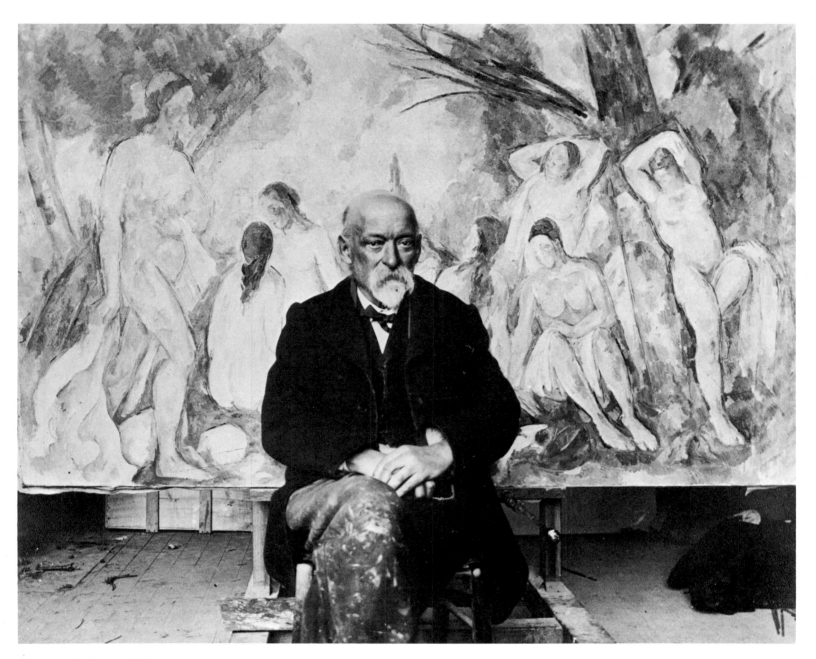

Cézanne in front of his Large Bathers. Photograph taken in the Lauves studio at Aix by Emile Bernard in 1904.

Dear Sir,
I have learned from the press about your picture, now being exhibited at the salon of the Société Nationale des Beaux-Arts, which manifests your artistic sympathy for me.
I write now to ask you to accept this expression of my keenest gratitude and to convey it to the artists who grouped themselves around you on this occasion.

Cézanne, letter to Maurice Denis, Aix, 5 June 1901.

Dear Sir,
I am deeply moved by the letter which you have kindly written to me. Nothing could be more agreeable to me than to know that, in the depths of your solitude, you are aware of the stir that has been made around my *Homage to Cézanne*. Possibly you may thus gain some idea of the position that you hold in the painting of our time, of the admirations that follow you, and of the enlightened enthusiasm of some of the younger men, of whom I am one, who can rightly call themselves your pupils, for it is to you that they owe whatever they have understood about painting; and we can never sufficiently acknowledge this.

Maurice Denis, letter to Cézanne, Paris, 13 June 1901.

175

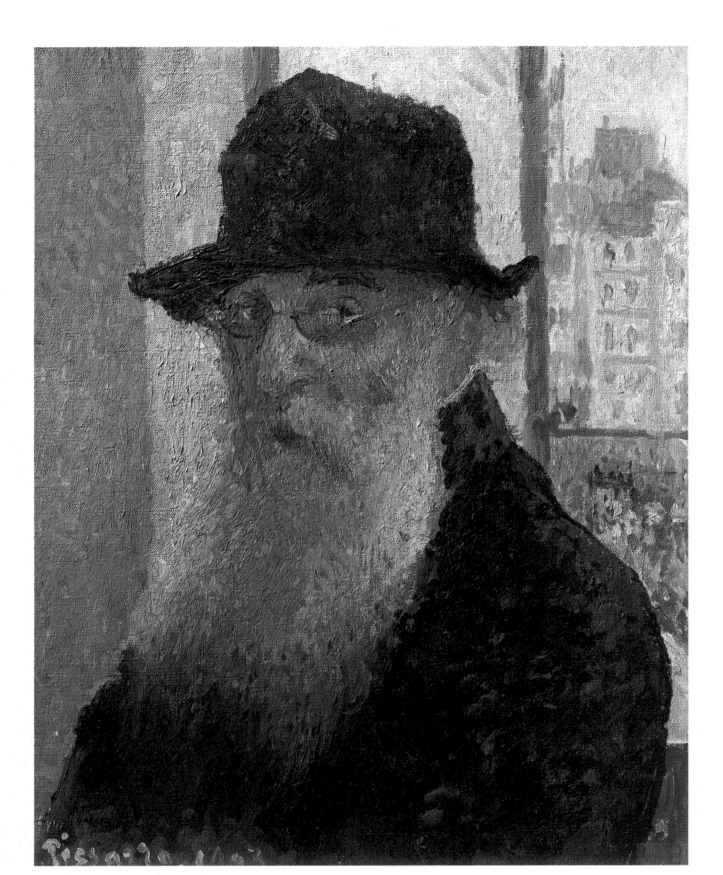

Pissarro: Self-Portrait, 1903.

Old age was accompanied by tributes, honours and glory. Renoir was decorated with the Legion of Honour in 1900. He was President of the Autumn Salon in 1905 and honorary President in 1907. In 1911 he was promoted Officer of the Legion of Honour, and Commander in 1919. After 1908, visitors came one after another to pay tribute to the master in his retirement at Les Collettes, Cagnes. His pictures were shown throughout the world, in Venice, St Petersburg and New York. With the Isaac de Camondo legacy, several of them found their way into the Louvre. And Renoir went on painting, like Pissarro.

Remember that the primitives are our masters because they are naïve and skilful.

Pissarro, letter to his son Lucien, Paris, 9 December 1883.

My Dear Friend, I have let myself be decorated [with the Legion of Honour]. Believe me, I'm not acquainting you with this for you to tell me whether I've done rightly or wrongly. I'm acquainting you with it so that this bit of ribbon won't stand in the way of our old friendship. Abuse me if you like, in the most disagreeable terms. That is all one to me, but no banter please. Whether I've done a foolish thing or not, I value your friendship. So much that I don't care about the others.

Renoir, letter to Monet, Louveciennes, 20 August 1900.

My Dear Friend, I realize now, and even before now, that I wrote you a stupid letter. I was ailing, nervous, pestered; one should never write at such times. What the devil does it matter to you whether I've been decorated or not? You have your own line of conduct, and an admirable one it is. For myself, I've never been sure one day what I will do the next. You may well know me better than I do myself, for very probably I know you better than you know yourself. Let's say no more about it and love each other.

Renoir, letter to Monet, Louveciennes, 23 August 1900.

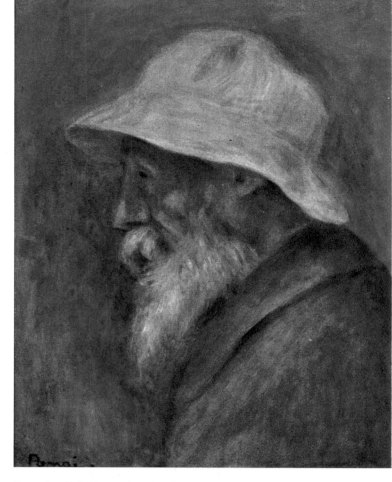

Renoir: Self-Portrait with White Hat, 1910.

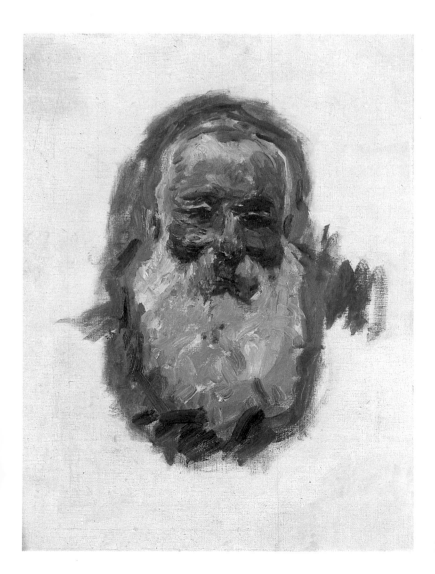

As for Renoir, he is a splendid fellow. He is said to be very ill and then all at once we hear that he is working stoutly all the same. He is quite simply wonderful.

Monet, letter to Georges Durand-Ruel, Giverny, 13 December 1916.

Monet: Self-Portrait, 1917.

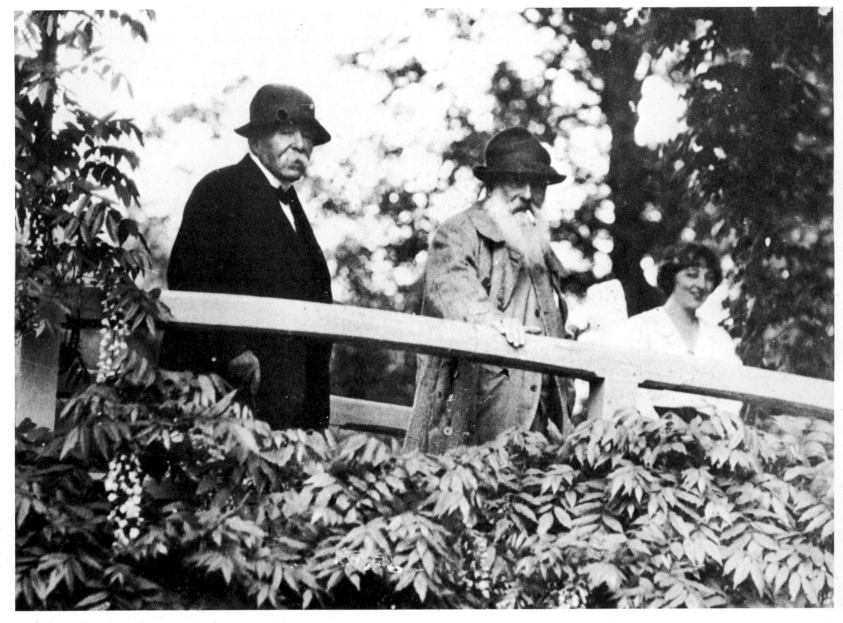

Clemenceau and Monet on the Japanese bridge in Monet's garden at Giverny. Photograph.

On 18 November 1918 Clemenceau announced to Monet that the French government had accepted his decorative paintings of Water Lilies.
Clemenceau: And now, what shall we do next?
Monet: Well, the next thing to do is to put up a monument to Cézanne!

Clemenceau, who made the Louvre accept *Olympia* in 1907, went regularly from his home at Benouville to visit Monet at Giverny. After settling there in 1883, Monet made the garden the principal theme of his paintings. Young artists from all over the world put up in nearby inns in order to work beside the master. On 18 November 1918 Clemenceau, fresh from one victory, informed Monet that his *Water Lilies* would be permanently housed in the Musée de l'Orangerie, in the gardens of the Tuileries. Another victory.
The wheel came full circle. A few days earlier, on 9 November, Guillaume Apollinaire had died. In the many articles he had written from 1902 to 1918 he had only mentioned Monet a bare six times. In 1912 he had expressed surprise at the impressionist master's sober, almost dull technique in his paintings of Venice. At that time, other painters whom Apollinaire defended, Braque, Picasso, Gris and Duchamp, were generally scorned.

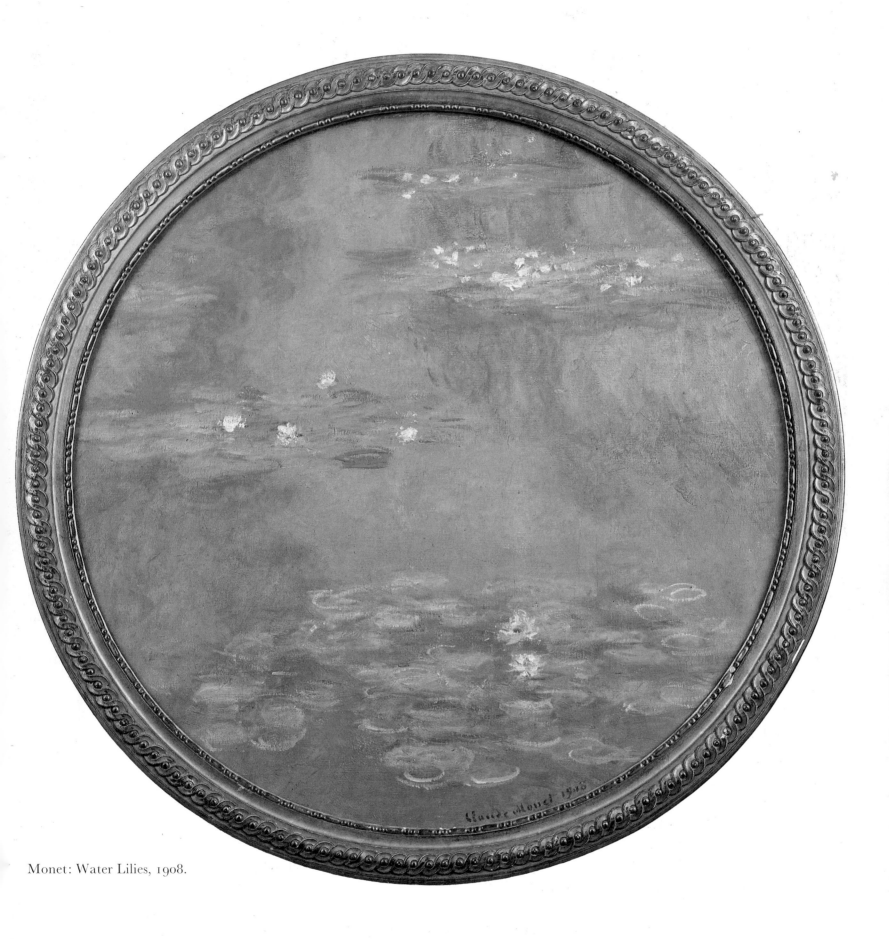

Monet: Water Lilies, 1908.

Cézanne at work,
c. 1905.
Photographs
taken at Aix
by Emile Bernard.

Pissarro painting *Jubilee Rejoicings, Bedford Park, London*, 1897. Photograph.

Monet at work, July 1915. Beside him, Blanche Hoschedé-Monet.

Degas in the Boulevard de Clichy, Paris, c. 1910.
Photograph.

Continuing...

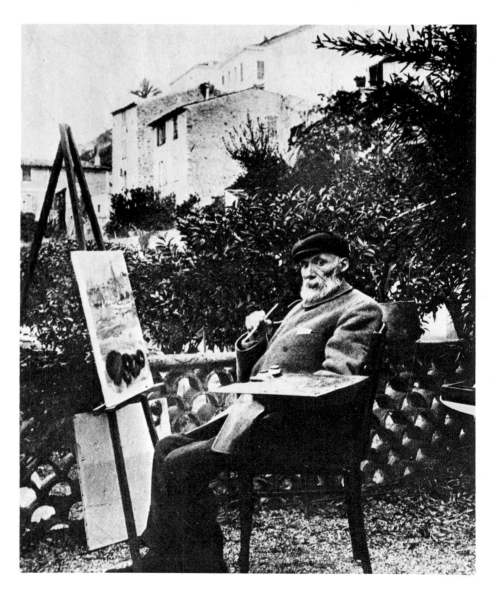

Renoir at Cagnes, c. 1905. Photograph.

Berthe Morisot

died in Paris in 1895

Alfred Sisley

died at Moret-sur-Loing in 1899

Edgar Degas

died in Paris in 1917

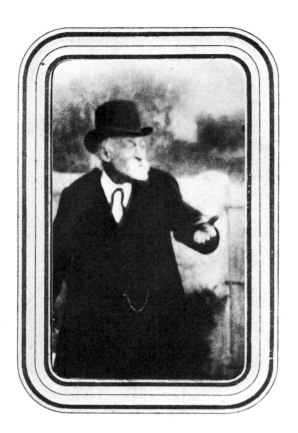

Paul Cézanne

died at Aix-en-Provence in 1906

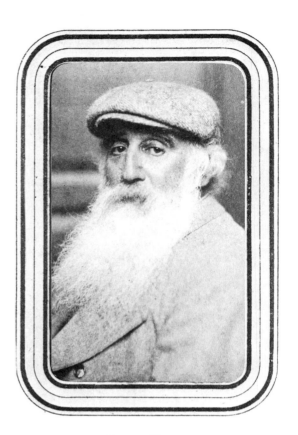

Camille Pissarro

died in Paris in 1903

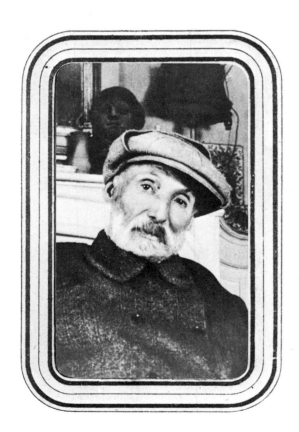

Auguste Renoir

died at Cagnes-sur-Mer in 1919

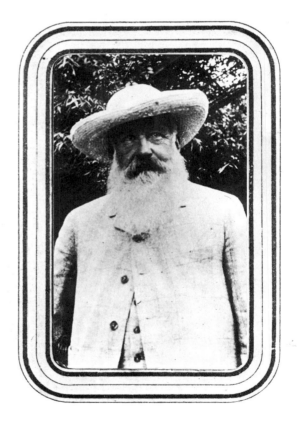

Claude Monet

died at Giverny in 1926

Short Bibliography

On Impressionism:

C.P. BARBIER, *Documents Stéphane Mallarmé*, Vol. VI, Paris, 1977. – Charles BAUDELAIRE. *Œuvres complètes*, Paris, 1968; in English, translated and edited by Jonathan MAYNE: *The Mirror of Art. Critical Studies by C.B.*, London, 1955; *The Painter of Modern Life and Other Essays by C.B.*, London 1964; and *Art in Paris, 1845-1862. Salons and Other Exhibitions reviewed by C.B.*, London, 1965. – J.E. BLANCHE, *Mes modèles. Souvenirs littéraires*, Paris, 1928. – CHAMPFLEURY, *Le Réalisme*, Paris, 1973. – G. CRAUK, *Soixante ans dans les ateliers d'artistes*, Paris, 1900. – J.P. CRESPELLE, *La vie quotidienne des impressionnistes du Salon des Refusés à la mort de Manet (1863-1883)*, Paris, 1981. – Théodore DURET, *Les Peintres impressionnistes*, Paris, 1919. – Félix FÉNÉON, *Les impressionnistes en 1886*, in *La Vogue*, Paris, 13-20 June 1886, reprinted in *Œuvres plus que complètes*, edited by Joan U. Halperin, Vol. I, Geneva-Paris, 1970. – Pierre FRANCASTEL, *L'impressionnisme*, Paris, 1937; *Monet, Sisley, Pissarro*, Geneva, 1943. – Paul GACHET, *Lettres impressionnistes au Dʳ Gachet et à Murer*, Paris, 1957. – Edmond and Jules de GONCOURT, *Manette Salomon*, Paris, 1979. – J. HARDING, *Les peintres pompiers*, Paris, 1984. – J. LETHÈVE, *Impressionnistes et symbolistes devant la presse*, Paris, 1959. – Julie MANET, *Journal (1893-1899). Sa jeunesse parmi les peintres impressionnistes et les hommes de lettres*, Paris, 1979. – François MATHEY, *Les impressionnistes et leur temps*, Paris, 1959. – Guy de MAUPASSANT, *Contes et nouvelles*, Paris, 1974; *Chroniques*, Paris, 1985. – Octave MIRBEAU, *Des artistes*, Paris, 1922 and 1924. – Henri MONDOR, *Mallarmé, Documents iconographiques*, Geneva, 1947. – George MOORE, *Confessions of a Young Man*, London, 1886. – Gustave PLANCHE, *Portraits d'artistes*, 2 volumes, Paris, 1853. – John REWALD, *The History of Impressionism*, 4th edition, New York, 1973. – J. ROBIQUET, *L'impressionnisme vécu*, Paris, 1948. – Lionello VENTURI, *Les archives de l'impressionnisme*, 2 volumes, Paris-New York, 1939. – Emile ZOLA, *L'Œuvre*, Paris, 1966; *Les Rougon-Macquart*, Paris, 1967; *Le bon combat. De Courbet aux impressionnistes: anthologie d'écrits sur l'art*, edited by Gaëtan Picon and J.P. Bouillon, Paris, 1974.

Frédéric BAZILLE:

J. CLAPARÈDE and G. SARRAUTE, *Bazille*, exhibition catalogue, Galerie Wildenstein, Paris, 1950. – François DAULTE, *Frédéric Bazille et son temps*, Geneva, 1952. – J. Patrice MARANDEL and François DAULTE, *Frédéric Bazille and Early Impressionism*, exhibition catalogue, Art Institute of Chicago, March-April, 1978. – G. POULAIN, *Bazille et ses amis*, Paris, 1932.

Gustave CAILLEBOTTE:

Marie BERHAUT, *Caillebotte l'impressionniste*, Lausanne, 1968; *Caillebotte. Catalogue raisonné*, Paris, 1977; *Caillebotte: sa vie, son œuvre*, Paris, 1978.

Mary CASSATT:

A.D. BREESKIN, *Mary Cassatt: A Catalogue Raisonné of the Oils, Pastels, Watercolors, and Drawings*, Washington, 1970; *Mary Cassatt: A Catalogue Raisonné of the Graphic Work*, 2nd edition, Washington, 1979; *Mary Cassatt: Pastels and Color Prints*, exhibition catalogue, Smithsonian Institution, Washington, 1978. – Nancy HALE, *Mary Cassatt*, New York, 1975.

Paul CÉZANNE:

Correspondance, edited by John Rewald, Paris, 1978; *Letters*, New York, 1984. – Emile BERNARD, *Souvenirs sur Paul Cézanne et lettres inédites*, Paris, 1921. – P.M. DORAN, *Conversations avec Cézanne*, Paris, 1978. – John REWALD, *Cézanne et Zola*, Paris, 1936. – Ambroise VOLLARD, *En écoutant Cézanne, Degas, Renoir*, Paris, 1985.

Edgar DEGAS:

Degas, photographe amateur, in *Gazette des Beaux-Arts*, Paris, January 1963. – Ian DUNLOP, *Degas*, London, 1979. – M. GUÉRIN, *Lettres de Degas*, Paris, 1931; *Dix-neuf portraits de Degas par lui-même*, Paris, 1931. – Daniel HALÉVY, *Degas parle*, Paris-Geneva, 1960. – Antoine TERRASSE, *Degas et la photographie*, Paris, 1983. – Ambroise VOLLARD, *En écoutant Cézanne, Degas, Renoir*, Paris, 1985.

Edouard MANET:

Edouard Manet, lettres de jeunesse (1848-1849), voyage à Rio, Paris, 1929. – Georges BATAILLE, *Manet*, Geneva-New York, 1983. – M. BEX, *Manet*, Paris, 1948. – Pierre COURTHION, *Manet raconté par lui-même et par ses amis*, Geneva, 1945. – Pierre DAIX, *La vie de peintre d'Edouard Manet*, Paris, 1983. – Théodore DURET, *Quelques lettres de Manet et Sisley*, in *Revue Blanche*, Paris, 15 March 1899; *Histoire d'Edouard Manet et de son œuvre*, Paris, 1919. – Jean GUIFFREY, *Lettres illustrées d'Edouard Manet*, Paris, 1929. – Jacques MATHEY, *Graphisme de Manet (essai de catalogue raisonné des dessins)*, 3 volumes, Paris, 1961-1966. – Etienne MOREAU-NÉLATON, *Manet graveur et lithographe*, Paris, 1906; *Manet raconté par lui-même*, 2 volumes, Paris, 1926. – Antonin PROUST, *Edouard Manet, Souvenirs*, Paris, 1913. – Adolphe TABARANT, *Une correspondance inédite d'Edouard Manet. Lettres du Siège de Paris*, Paris, 1935; *Manet et ses œuvres*, Paris, 1947.

Claude MONET:

Georges CLEMENCEAU, *Claude Monet*, Paris, 1929; *Claude Monet. Cinquante ans d'amitié*, Paris-Geneva, 1965. – J.P. HOSCHEDÉ, *Claude Monet, ce mal connu*, Geneva, 1960. – J. JOËTS, *Lettres inédites de Pissarro à Claude Monet*, in *L'Amour de l'Art*, III, Paris, 1946. – Claire JOYCE, *Monet at Giverny*, London, 1975. – P.H. TUCKER, *Monet at Argenteuil*, New Haven-London, 1982.

Berthe MORISOT:

M. ANGOULVENT, *Berthe Morisot*, Paris, 1933. – M.L. BATAILLE and Georges WILDENSTEIN, *Berthe Morisot*, Paris, 1961. – Denis ROUART, *Correspondance de Berthe Morisot avec sa famille et ses amis*, Paris, 1950.

Camille PISSARRO:

Janine BAILLY-HERZBERG, *Correspondance de Camille Pissarro*, Vol. I: 1865-1885, Paris, 1980. – Camille PISSARRO, *Lettres à son fils Lucien*, edited by John Rewald, Paris, 1950; *Letters to his Son Lucien*, 4th edition, London, 1980. – L.R. PISSARRO and Lionello VENTURI, *Camille Pissarro, son art, son œuvre*, 2 volumes, Paris, 1939.

Auguste RENOIR:

J. BAUDOT, *Renoir, ses amis, ses modèles*, Paris, 1949. – François DAULTE, *Auguste Renoir. Catalogue raisonné de l'œuvre peint. I: Figures (1860-1890)*, Lausanne, 1971. – Théodore DURET, *Renoir*, Paris, 1924. – John HOUSE et al., *Renoir*, exhibition catalogue, London, 1985. – Ambroise VOLLARD, *Renoir*, Paris, 1920; *En écoutant Cézanne, Degas, Renoir*, 1938, new edition 1985.

Alfred SISLEY:

Raymond COGNIAT, *Sisley*, New York, 1978. – François DAULTE, *Alfred Sisley. Catalogue raisonné de l'œuvre peint*, Lausanne, 1959; *Alfred Sisley*, Munich, 1975.

List of Illustrations

SKIRA

Text and colour plates printed by
IRL Imprimeries Réunies Lausanne S.A.

Binding by
Mayer & Soutter S.A., Lausanne